MODERN LITHOGRAPHY

MODERN LITHOGRAPHY

IAN FAUX

MACDONALD & EVANS LTD
8 John Street, London WC1N 2HY

1973

First published March 1973

©

MACDONALD AND EVANS LIMITED

ISBN: 0 7121 1362 2

This book was produced by the Richard Clay Group

*Filmset in 11 on 12 pt. Photon Times by Richard Clay (The
Chaucer Press), Ltd, Bungay, Suffolk; printed on a Crabtree
Mann NP56 sheet-fed offset perfecting press by Fletcher & Son,
Ltd, Norwich, on text paper Paladin 85 gsm by Star Papers;
Litho plates Howson-Algraphy Marathon presensitised nega-
tive working; and bound by Richard Clay (The Chaucer Press),
Ltd, Bungay, Suffolk*

Printed in Great Britain

PREFACE

DURING the last decade considerable changes have taken place in the printing world. The specialised craft of lithography has emerged as a major printing process due to the influence of modern technology. With this change has come the need to raise the standards of technical education, and many mature craftsmen are now involved in retraining and refresher courses. This volume has been written to provide comprehensive and essential information suitable for those who are studying for the lithographic craft and technician's certificates of the City and Guilds of London Institute, and a starting point for students of the Higher National Diploma. The craftsman on the shop floor will also find this book useful as a working handbook for both platemaking and printing techniques.

The text and illustrations are the fruit of a number of years teaching lithography to craft apprentices and mature journeymen in colleges of technical education. The subjects covered are an enlargement of the material used in lectures, and the style of the text is purposely didactic, with individual subjects outlined to make rapid reference easy. All the subjects begin at an elementary level, and those students who have little scientific knowledge should work through the chapter on science carefully if they wish to understand the applications of science to the craft. Having made a start I do advise the student to make use of the Bibliography at the end of the book to enlarge his reading.

With the printing trade shot through with many obscure terms and expressions, one could wish that a fresh start be made formulating correct terminology. I have introduced one or two new expressions, the classification of surface and sub-surface plates for example, to clarify obscure points. The glossary however will serve to aquaint the student with most of the terms used in lithography and the allied processes.

Metric units (SI) are used throughout the book. SI is the symbol for Système International d'Unites (International System of Units), the modern form of the metric system finally agreed at an international conference in 1960, and now being adopted by the printing industry in the U.K. and in many parts of the world.

The rapid changes taking place in the printing industry at the present have influenced the manner in which information in this book is presented. I have endeavoured to outline the basic principles of platemaking and printing techniques which I believe will be of greater value than the inclusion of specific information on machines and equipment which may be obsolete in a few years' time.

The success of this work will be due to a number of lithographers who have directly influenced my approach to its compilation. Especially do I want to mention Mr. Les Easter, Senior Lecturer at Twickenham College of Technology, who laid a solid foundation of craft knowledge when I was his student many years ago. My thanks also to Mr. Ron Burnett, Senior Lecturer at the London College of Printing, who gave me such an encouraging start to my teaching career when we worked together at the London North-Western Polytechnic.

My friend and colleague Mr. Allan Wood-Thompson, Senior Lecturer at Watford College of Technology, with great patience examined and checked the draft manuscript of the book and made many helpful suggestions which have influenced the final layout. I wish to thank him for his encouragement. I am also grateful for the assistance given by Miss Mary Sweeney, M.Sc., of the Liverpool Polytechnic, who helped me to prepare the chapter on science and spent many hours checking tables and formulae, and imperial to metric conversions.

Finally I wish to thank the large number of companies which have been instrumental in supplying information, diagrams and photographs which are used in this book.

January 1973 I.F.

ACKNOWLEDGMENTS

Baker Perkins Ltd. Halley-Aller web offset presses.

C. F. Casella and Co. Ltd. Scientific instruments for research and industry.

Coates Brothers Ltd. Lithographic inks and bi-metal plates.

Colormetal. Zurich. Sheet fed lithographic presses.

Cornerstone. Hawthorn Baker Ltd. Planning and platemaking equipment.

Crabtree-Mann Ltd. Sheet fed lithographic metal decorating and paper printing presses.

Crosfield Electronics Ltd. Electronic equipment for the printing industry.

W. P. Evans & Son Ltd. Nim-cor Air shafts.

Felvic Industries Ltd. Sword hygrometers.

Graphic Arts Equipment. M.A.N. lithographic web and sheet fed presses.

Harris-Intertype Ltd. Harris, Cottrell and Aurelia web and sheet fed offset presses.

Hoe-Crabtree Ltd. Lithographic web-offset presses.

Howard Panton/Warren Seymour Ltd. Mount Hope web tension controls.

Howson-Algraphy Ltd. Litho plates, platemaking and planning equipment.

Kodak Ltd. Register punch systems.

Krisson Equipment Ltd. Planning equipment.

S. R. Littlejohn & Co. Ltd. Reflection densitometers and platemaking equipment.

Mander-Kidd Ltd. Offset litho printing inks.

Miehle-Goss-Dexter Ltd. Web-offset lithographic presses.

The Monotype Corporation Ltd. Pictorial Machinery step and repeat machines and platemaking equipment.

Moore & Wright (Sheffield) Ltd. Engineers' micrometers.

N.V. Tools Ltd. Baldwin recirculating fountain controls, Curastat static elimination equipment.

Price Service & Co. Ltd. Solna and Roland lithographic offset presses.

Protocol Engineering Ltd. Punch register planning equipment.

The Shore Instrument & Mfg Co. Inc. Shore durometers.

Tintometer Ltd. Lovibond pH comparators.

Wiggins Teape Ltd. Manufacturers of offset lithographic papers.

CONTENTS

Atomic theory; Acids and alkalis; Solids, liquids and gases; Relative humidity; Surface tension; pH; Electricity; Theory of light and colour; Colour; Reflection densitometer; Photoelectric cell; Artificial light sources

Handling photographic film; Planning—tools, materials, equipment; Principles of planning; Positive planning techniques; Punch-register systems; Stepping up multiple images; Mechanical step and repeat methods; Imposition; Poster sizes and layouts

Surface chemistry of the lithographic plate; Plate surface treatments; Dichromated coloids; Albumen process; Deep-etch process; Presensitised plates; Plates sensitised by the platemaker; Bi-metallic plates; Plate corrections; Quality controls in platemaking; Use of platemaking equipment; Platemaking by projection; Proofing

APPENDIXES

LIST OF FIGURES

SCIENCE AND ITS APPLICATION TO LITHOGRAPHY

No lithographer will deny that his craft requires some understanding of science. Lithography was first called "chemical printing" because of the number of chemicals which were used to make the process work. Modern lithographers will need to understand more about the science of lithography because of the advance of technology and its influence on the printing trade.

A number of excellent books on printing science are available and are listed in the Bibliography at the end of the book. This chapter is designed to give the craftsman an introduction to that aspect of science which is applicable to lithography, and it will serve to make scientific terms used in printing readily understood.

ATOMIC THEORY

Of the millions of different substances which are known to man, there are just over one hundred *elements* from which all the other substances are composed. An element may be described as the "simplest form which a substance can be reduced to." Hydrogen and oxygen are both elements, but water is not, because it is composed of hydrogen and oxygen, hence the chemical symbol for water, H_2O. Gold, silver, zinc and aluminium are also elements. The factor which makes one element differ from another in form, colour, weight, etc. is the very small particle called the "atom." The *atom* is so minute that it cannot be seen with the human eye. A piece of aluminium weighing 1 g is calculated to consist of about 22 300 000 000 000 000 000 000 atoms. If these atoms were the size of a child's marble their number would form a layer over the entire surface of the Earth deep enough to cover St. Paul's Cathedral!

Despite its small size, however, scientists have been able to

ascertain a good idea of the structure of the atom and its important behaviour in chemical and physiological functions.

STRUCTURE OF THE ATOM

Look at the diagram of an atom shown in Fig. 1. The centre core called the "nucleus" is made up of particles, *protons* and *neutrons*. In orbit round the nucleus are smaller particles called *electrons*. You will note how similar the arrangement is to our own solar system.

The atom contains an electrical field. The protons in the nucleus carry a positive electrical charge, and the electrons carry a negative

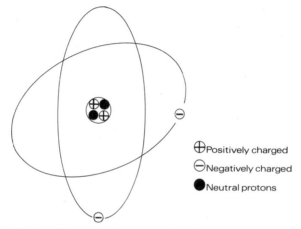

⊕Positively charged

⊖Negatively charged

●Neutral protons

Fig. 1.—Schematic of an atom showing the nucleus and orbiting electrons.

electrical charge, both of which are indicated in the diagram with the signs + and − respectively. When the atom has the same number of electrons and protons, the electrical charge of the atom is neutral. If, however, there are more electrons than protons, the electrical charge of the atom will be predominantly negative. If there are more protons than electrons, the atom will contain a positive electrical charge. Atoms which are charged in this way are known as *ions*.

Each individual element is given a number which indicates the number of protons in each atom in that element. A few sample elements are listed here to give you some idea how this works out:

Element	Protons	Electrons	Atomic number	Symbol
Hydrogen	1	1	1	H
Helium	2	2	2	He
Carbon	6	6	6	C
Oxygen	8	8	8	O
Aluminium	13	13	13	Al
Chlorine	17	17	17	Cl
Calcium	20	20	20	Ca
Copper	29	29	29	Cu
Zinc	30	30	30	Zn
Uranium	92	92	92	U

You will note that as the atomic number rises, so the number of protons in the nucleus increases by the same proportion. This increase in the number of protons makes the core larger and heavier;

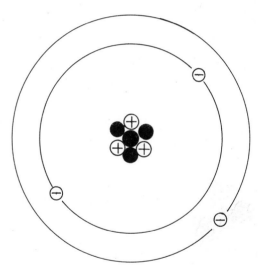

Fig. 2.—Schematic of a lithium atom showing the energy levels.

the increase in the number of electrons, however, is accommodated by dispersing the electrons in orbits which vary in distance from the core. The diagram of the lithium atom (Fig. 2) serves to show how these orbits are arranged. These varying orbits are called *energy levels*.

MOLECULES

Atoms are not normally found in isolation. Combinations of two or more atoms are common, and when these represent the smallest portion of a substance they are called *molecules*. The term "molecule" is used extensively in science, often synonymous with the word "atom."

COMPOUNDS

When the molecules of one element join the molecules of another element, a certain amount of rearrangement takes place among the electrons until the new partnership is settled. This rearrangement of electrons may result in a release of energy in the form of heat (and when this occurs with speed the result is a bang!). This type of molecular combination is known as chemical change, and the resulting new substance formed is called a *compound*.

When molecules combine to form a compound, they always do so in fixed proportions by a law of nature. For example, when hydrogen molecules form a partnership with oxygen molecules to make the compound water, they always do so in the proportions two molecules of hydrogen to one molecule of oxygen; hence the symbol for water: H_2O.

MIXTURES

Mixtures of substances differ from compounds because no chemical change takes place. This means that the separate substances do not make a partnership between their molecules but remain as separate components of the mixture. For this reason mixtures can usually be separated into their original components with little difficulty, and they can be mixed together in any proportions.

SOLUTIONS

A solution is a mixture of two or more substances in liquid form. The liquid is often water, but may be other liquids such as alcohol, spirit, etc. The liquid of a solution is called the *solvent* and the substance dissolved in the liquid is called the *solute*.

When a solution is made, the molecules of the solute are dispersed in the solvent and the density of the solution rises as more solute is added. This rise in density may go on until the solvent can no longer support the molecules of the solute. Any increase in solute after this

point will not disperse but settle at the bottom of the container—the solution has reached *saturation* point.

The temperature of the solution also affects the saturation point of a mixture because warmer solutions will hold more solute in dispersion than will a colder solution.

When the solvent of a solution is removed, the dissolved solute will begin to revert to its former solid state and in doing so the solute molecules may form a geometric structure known as *crystals*, the reverting process itself being called *crystallisation*.

ACIDS AND ALKALIS

A number of solutions used by the lithographer are classified as "acids" or "alkalis." As many of these solutions are clear like water, and corrosive, it is important that the lithographer knows how to handle them, identify them, and knows how to determine their potency.

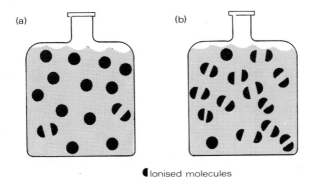

◀ Ionised molecules

Fig. 3.—How the potency of an acid is determined by the degree of hydrogen ionisation. (*a*) Weak acid, with a low level of ionisation. (*b*) Strong acid, with a high level of ionisation.

An *acid* is defined as a solution which contains molecules of hydrogen which are ionised, the ions having a positive electrical charge (symbol H^+). A strong acid such as hydrochloric acid has a great number of its molecules in an ionised state, whereas a weak acid like lactic acid has only a few of its molecules ionised. The potency of an acid depends upon the relative number of ionised molecules in the solution (Fig. 3).

Alkalis are defined as solutions which contain hydrogen and oxygen combined to form hydroxyl ions which have a negative electrical charge (symbol OH⁻). The potency of an alkali solution depends upon the proportion of hydroxyl ions present in the solution. The more hydroxyl ions in the solution, the stronger the alkali. Distilled water is neither acid nor alkali because the proportion of hydrogen ions and hydroxyl ions are equal, as can be seen by the symbol for water: H_2O or H^+OH^-.

SOLIDS, LIQUIDS AND GASES

If we were to examine closely the molecules of a substance, even a solid substance, we would see that they are in constant motion. This motion or vibration of the molecules is of course invisible to the eye, yet it is responsible for the behaviour patterns of many substances.

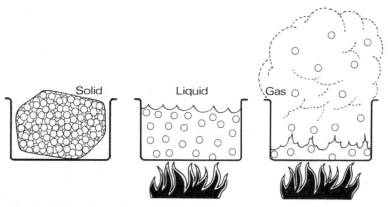

Fig. 4.—Schematic of the three states of matter illustrated with ice, water and steam.

Many substances for example have the ability to change their state from a solid to a liquid form and also to a gas or vapour. The molecules in a solid substance such as ice (Fig. 4) are closely packed and vibrate at low velocities. When heat is applied to the ice, the molecules absorb the heat energy which causes their vibrating velocities to increase and results in the molecules moving apart from each other. The solid changes to liquid. The increased velocities of the molecules would cause them to fly apart from each other were it not for the forces of *cohesion* among the molecules which still hold them

together. By applying more heat, however, the vibrations of the molecules become so great that the cohesive force is overcome and the molecules fly off in every direction. The substance has now changed to gas or vapour.

The temperature at which substances change their state varies with each substance. You are aware that iron requires a great deal more heat than ice to reach the liquid state. Some substances will not turn from a gas to a solid unless the temperature is lowered considerably.

RELATIVE HUMIDITY

The molecules in water are also in a constant state of motion. Water turns to vapour at a comparatively low temperature with the result that at normal temperatures the air contains a considerable number of water molecules. The measurement of the amount of water in the air is known as the *absolute humidity* and is a measure of the grammes of water vapour per cubic metre of air.

An increase in the air temperature allows the air to support more water vapour and this may be taken to the point where the air becomes saturated and the excess vapour will condense out in the form of visible moisture—it rains. The vapour saturation point of the air, therefore, depends upon its temperature. Raise the temperature, and it holds more moisture; lower the temperature, and moisture will condense out. On nights when the sky is clear the temperature of the earth drops and the air close to the ground cools, causing the moisture to condense out as dew. The *dew point* can be obtained at any temperature so long as the vapour in the air begins to condense out as visible moisture.

For practical use it is more important for us to know how much water vapour there is present in the air relative to how much the air can support at that temperature, than to know just how much water vapour there is in the air. *Relative humidity* (r.h.) is such a measurement. As an example let us assume that the air temperature is 20 °C and at this temperature the air can support as a maximum 17·12 g of water per cubic metre of air. If the amount of vapour present is 8·56 g/m³, the relative humidity is therefore:

$$\frac{\text{Water vapour (absolute humidity) } 8\cdot56}{\text{Vapour saturation point } 17\cdot12} \times 100\% = 50\% \text{ r.h.}$$

METHODS OF MEASURING R.H.

Sword hygrometer

This is a purpose-built hygrometer in which the sensing hair is located in a perforated flattened tube similar in shape to a sword

Courtesy: Felvic Industries Ltd.

Fig. 5.—Sword hygrometer.

(Fig. 5). The sword is inserted between the sheets of a pile of paper and detects the r.h. of the air in contact with the paper.

Wet- and dry-bulb hygrometer (psychrometer)

This instrument has two thermometers mounted side by side, one of which has a bulb covered with a muslin wick dipping into a small reservoir of water. As the moisture evaporates from the muslin the temperature of the "wet bulb" is lowered, depending on the dryness of the surrounding air. By comparing the temperature of the "dry bulb" with the "wet bulb" on specially prepared tables, the r.h. can be obtained. Two types of this hygrometer are common:

1. *Wall mounted.* In order to obtain a correct reading the air round the hygrometer should be disturbed by fanning for a minute or two before reading (Fig. 6).

Fig. 6.—Wall-mounted wet- and dry-bulb
hygrometer.

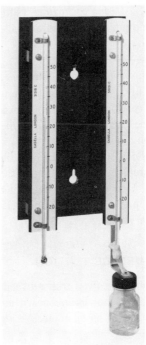

Fig. 7.—Hand-whirling hygrometer.

Courtesy: C. F. Casella & Co. Ltd.

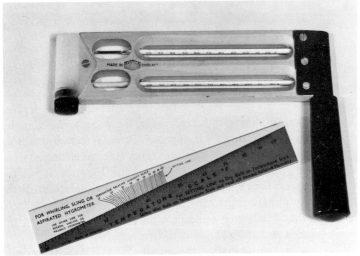

Courtesy: C. F. Casella & Co. Ltd.

2. *Hand whirling* (sling psychrometer). The hygrometer is mounted on a handle which allows it to be whirled in any part of the room (Fig. 7).

Hair and paper hygrometers

This type of instrument functions on the principle of the hygroscopic expansion of hair when in a moist atmosphere. As the r.h. increases the hair expands and by means of a simple dial r.h. readings can be obtained.

Paper hygrometers utilise the same principle with specially prepared paper acting as the r.h. sensor.

Hair and paper hygrometers are liable to deteriorate due to atmospheric impurities, and periodic cleaning and adjustment are necessary.

SURFACE TENSION

The cohesive force between the molecules of a liquid can be seen in the phenomenon known as *surface tension*. Let us take a drop of water as an example. As a tap drips the water forms into a globule.

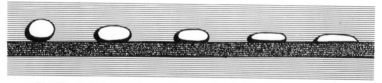

Fig. 8.—A variety of shapes produced on liquids by surface tension.

The shape of the globule is always spherical because the cohesion of the molecules draws them together into the centre of the liquid. If the water drips on to a piece of waxed paper, the water forms globules because it has little affinity for the greasy surface. If the water falls on to a surface for which it does have an affinity (such as clean glass) the shape of the globule changes to a flatter shape. Figure 8 shows the various shapes which may be formed. When the molecules of the surface material have a greater attractive force on the molecules of the water than the water molecules have among themselves, the globules flatten and are said to *wet* the surface.

When the scientist studies the affinity of a liquid for a solid substance such as a lithographic plate, he measures the angle of the

drop of liquid on the surface and this is known as "measuring the *contact angle*" (Fig. 9). The lower the angle of contact, the better wetting of the surface by the liquid.

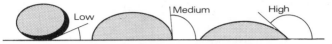

Fig. 9.—How the contact angle is measured and related to wetting. High: no wetting. Medium: poor wetting. Low: good wetting.

When the temperature of a liquid is raised, the surface tension is lowered. A liquid with a high surface tension may have its surface tension lowered by mixing a proportion of another liquid which has a lower surface tension with it. This technique is frequently employed by pressmen by lowering the surface tension of the fountain solution with alcohol to improve the damping qualities of the system. When this is done the molecules of the two solutions combine, the solution with the lower cohesion having its molecules on the outside of the combined molecule.

pH

In the section on acids and alkalis we noted how the potency of these solutions was directly related to the ionisation of the hydrogen and hydroxyl molecules in the solution. pH is a means of measuring the amount of ionisation which has taken place in the solution.

The pH measurement scale is shown in Fig. 10. The scale is logarithmic to the base of ten, which means that each unit of the scale differs from the next by a factor of ten. For example, pH 5 is 10 times stronger than pH 6, and 100 times stronger than pH 7. You will see from the diagram that as the hydrogen ion concentration becomes less, so the hydroxyl ion concentration increases. Where both H^+ and OH^- are in equal quantities at the unit of seven the solution is neutral.

HOW TO MEASURE pH

Coloured indicators

This method utilises the characteristics of certain substances which change colour when the pH of the solution in which they are dissolved is changed. Substances which react like this are called

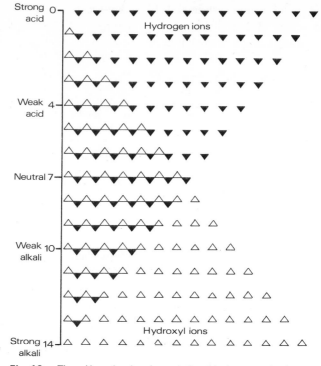

Fig. 10.—The pH scale showing relationship between hydrogen and hydroxyl ions.

indicators because they indicate by colour the ionisation of the solution. A considerable number of different indicators are combined to cover the pH scale from 0 to 14. The colour range normally progresses gradually from red for acid solutions through shades of orange, yellow, green, blue and violet for alkali solutions. Colour indicators suitable for use by the lithographer are as follows:

Permanent glass comparator. In this instrument a number of coloured glass discs each corresponding to a unit of pH are compared with the colour of a test solution which has been mixed with a small quantity of indicator. The test liquid (such as fountain solution) is poured into two test-tubes. The indicator is added to one of the tubes and the coloured glass discs are rotated until the colour of the test solution is matched to the disc viewed through the other test-tube.

Indicator papers. These are strips of suitably absorbent paper impregnated with an indicator, which change colour when immersed in an acid or alkali solution. The colour change is compared with a printed colour scale which gives the pH unit. Small books of indicator papers can be obtained which cover a wide or narrow range of the pH scale. These books because of their simplicity are in common use among pressmen and platemakers for checking working solutions.

The coloured indicator method has the disadvantage of not being suitable for use with highly coloured or dense solutions which will mask the colour change of the indicator.

Electrical measurement of pH

The measurement of coloured and dense solutions is made possible with the use of a specially designed instrument which consists of a glass electrode and a meter. The electrode is placed in the test solution and the electrical potential of the ionisation is sensed giving a reading on the meter dial. Since the meter gives continuous readings, a solution may be adjusted to the required pH by adding acid until the meter needle moves to the required pH point. The pressman will see how valuable this is in the regulation of fountain-solution acidity.

The pH meter is a delicate and expensive instrument which requires careful handling. Because of its sensitivity the meter has to be calibrated regularly by checking the instrument against a buffer solution which has a standard pH rating.

To sum up, the points to note when taking pH measurements are as follows:

1. If the test solution is poured into a glass test-tube for use in the permanent glass comparator, ensure that the tube is thoroughly clean and dry before use. This will prevent any possibility of the solution becoming contaminated.

2. When testing a solution which has been standing for some time, or is freshly made up, check that it is thoroughly stirred and mixed before testing.

3. When using indicator papers, make allowance for the colour change which may have occurred in the printed comparison chart.

ELECTRICITY

If we were able to look closely into the atomic structure of many solid materials we would see that the electrons on the outer orbits of certain atoms are free to leave the atom and return. These "free" electrons are called "valence electrons" and they are responsible for the electrical characteristics of the material.

1. Materials like metals are constructed with an atomic lattice which allow the free electrons to move about within the structure. These materials are called "conductors."

2. Another group of materials such as selenium contain electrons which become free to move about only under certain conditions such as when the material is illuminated. These materials are called "semi-conductors."

3. Many materials such as plastics are so constructed that the atoms will not permit the electrons to move at all within the material. These are called "insulators."

If a piece of metal wire is connected to the positive terminal of a battery (which is a cell containing atoms with few electrons), and the other end of the wire is connected to the negative terminal (in which is a cell containing atoms which have a surplus of electrons), the

Fig. 11.—The potential difference between two tanks of water and how it is related to electricity.

electrons will use the wire like a pipe-line and flow out of the negative cell into the positive cell. This movement of electrons is called "electricity" and the flow or current will continue until all the atoms in the positive cell have obtained sufficient electrons to make them neutral; at this point the current stops and the battery is said to be "flat."

The flow of electricity is often compared to the flow of water.

Figure 11 shows two tanks connected by a single pipe. When tank A is full the water will flow through the pipe into the partly filled tank B. If the pipe is of narrow diameter the flow through the pipe is restricted, but if a larger diameter pipe is used more water is able to flow through. Applying this illustration to electricity, the difference in the levels of the tanks is called "potential difference" and is measured in volts. The rate of flow of electricity is measured in amperes, and will depend on the amount of resistance, which is measured in ohms.

When a potential difference is placed across a conductor which is a solid material the atoms remain in position but the electrons move through the atomic structure. When an electrical current is passed through a liquid, however, the atoms of the liquid are not in fixed positions and there is a general movement of negatively charged ions and positively charged ions.

ELECTROLYSIS

The movement of ions within a liquid is utilised in the process of electrolysis to make bi-metal plates and produce anodised surface

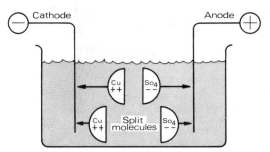

Fig. 12.—Electrolysis, showing the migration of copper cations and sulphate anions.

plates for lithography. When an electric current is passed through a solution of water and copper sulphate the copper sulphate molecules split (or dissociate) into copper ions, Cu^{++}, and sulphate ions, SO_4^{--}, which immediately drift through the solution towards the terminals (called "electrodes") of the battery which are resting in the solution (Fig. 12). The copper ions having a positive electrical charge move to the negative terminal which is known as the "cathode." On arriving at the cathode each copper ion obtains electrons and becomes a

B

neutral atom of pure copper which becomes attached to the cathode. After a time, the cathode becomes covered with a layer of pure copper, and if a plate of stainless steel were to take the place of the electrode the plate itself would become "plated" with a copper layer, thereby making it suitable for use as a bi-metal printing plate. Because a copper sulphate solution cannot contain sufficient copper to electroplate large plates, a solid copper electrode is used as an anode. During the passage of electricity through the solution the copper anode dissolves away and the copper passes through the solution to be deposited on the cathode. Special terms are used in the process of electrolysis. The solution through which the current passes is called an "electrolyte," or an "electrolytic solution." The current enters and leaves the solution by "electrodes," the negative electrode carrying the name "cathode" and the positive electrode is called the "anode." The entire unit consisting of a tank electrolyte, electrodes, etc. is called an "electrolytic cell" or "voltameter." The ions which move in the direction of the cathode are called "cations," and those ions moving towards the anode are called "anions."

The process of electrolysis is used to construct layers of copper and chromium metal on bi-metal plates, and also to produce an oxide layer on the surface of aluminium plates known as "anodising." Electrolytic graining is also produced by this process.

STATIC ELECTRICITY

Those materials which do not permit free movement of the electrons are called "insulators." Many of these insulator materials, however, do lose or gain electrons from their outer surfaces, leaving the surface with a positive or negative electrical charge which cannot move away. An accumulation of such an immobile charge is called a "static electrical charge," which is something most platemakers and pressmen have experienced.

In the case of plastic sheet used for lithographic planning, the plastic surfaces contain atoms which may readily lose electrons and gain electrons thus producing static charges. This often occurs owing to friction between the plastic sheets during the packing stage and results in the electrons from one surface migrating to the surface of the upper sheet thus leaving both sheets with static charges of opposing polarity (Fig. 13). Since like charges repel and unlike charges attract, the sheets stick tenaciously together, but when separated will attract electrically charged particles (ions) which are present in the

air in the form of dust and fluff. The use of ultra-violet lamps for printing down also increases the ionisation of the surrounding air, which if dusty will aggravate the situation.

The same phenomenon occurs with paper, although to a lesser degree because the moisture in the paper acts as a conductor and dissipates much of the surface charge. Dry paper, however, will accumulate electrostatic charges with the result that the paper will not separate well on the feeder of the press, and present a problem of ink set-off in the press delivery when the charged sheets make close contact.

Charged sheet lifted

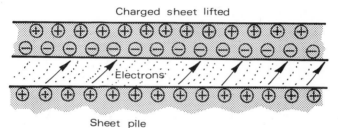

Sheet pile

Fig. 13.—How a sheet of plastic or paper obtains static electrical charges with opposite poles on each side of the sheet.

The accumulation of static charges can be overcome in the following ways:

1. By earthing the charges by trailing tinsel strips over the paper and conducting the individual charges to earth.

2. By making the surrounding air conductive by increasing the moisture content or by ionising the air molecules. This will not help to remove static charges from plastic materials, however.

3. By coating the plastic sheet with an anti-static solution which will act as a conductor to dissipate the charges.

THEORY OF LIGHT AND COLOUR

At this point we shall turn our attention to another interesting feature of the atom. Look at the diagram of the lithium atom (Fig. 14). When an atom is disturbed, the electron may jump out of its orbit to an orbit on a higher level. The electron will quickly return to its former orbit, however, but as it does so it emits a form of energy known as *electromagnetic radiation* (Fig. 15).

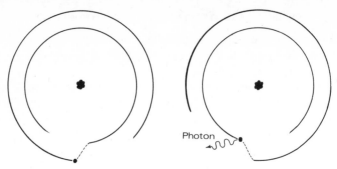

Fig. 14.—Diagram showing how a disturbed electron is raised to a higher energy level and emits radiation as it returns to its former orbit.

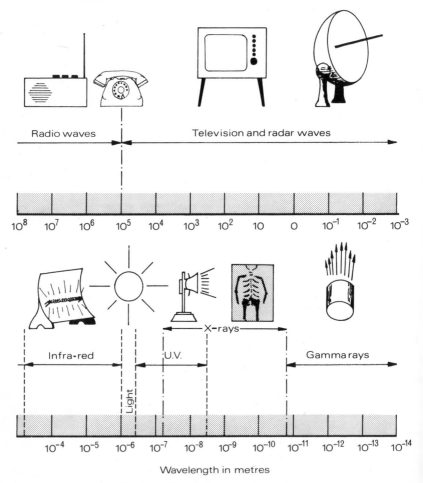

Wavelength in metres

Fig. 15.—The electromagnetic spectrum.

Electromagnetic radiation is mainly invisible and is propagated in the form of waves. It is by this means that energy from the sun travels across space to the Earth. The longer electromagnetic waves are called "radio waves" and may measure up to 9 km from one wave crest to the other. The shorter waves called "hertzian" are used in television and radar; these are followed by infra-red waves, then a short band which is visible to the eye called "light," and, as the wavelength becomes shorter, they pass through ultra-violet, X-rays and finally gamma rays.

Those waves which we can see comprise a number of different colours—red, orange, yellow, green, blue-green, blue and violet. When all these colours are mixed together the light appears white.

The length of light waves is relatively small, ranging from 700 nm for the red waves, to 400 nm for the blue waves (Fig. 16).

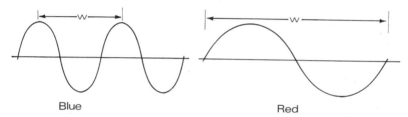

Blue Red

Fig. 16.—Comparison of the blue and red wavelengths and measurement of the wavelength W.

Human vision is dependent on light. Without light we cannot see and all appears blackness. When there is light we are able to see the objects around us because they reflect the light back to our eyes.

Light travels in straight lines. When it falls on a mirror it is *reflected* back into the plane from which it came. The speed of light is 3×10^8 m/s (300 million metres per second), and this is "bounced" off the surface of the mirror at the same speed when light is moving through air. Its speed, however, is slower in more dense mediums like glass; consequently when light passes through glass it changes direction slightly according to the density of the glass (Fig. 17). On leaving the glass, it assumes its normal speed again with the result that the ray of light continues on a parallel to its former path. This phenomenon is called *refraction*, and it is the principle behind the construction of the camera lens.

If light passes through an object, it is said to be *transmitted*, and

the object is said to be *transparent*. If on the other hand the object prevents the light passing through, the energy is absorbed, and the object is said to be *opaque*. Of course, many objects will reflect,

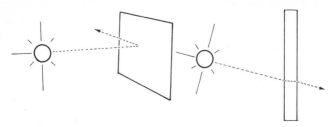

Fig. 17.—Reflection and refraction of light.

transmit and absorb light in part. For example, the continuous-tone step wedge used in platemaking quality control transmits and absorbs light according to its varying densities.

COLOUR

Colour is the sensation produced on the retina of the eye by the varying wavelengths of light. Any failure of the receptor cells of the eye, or malfunction of the optic nerves to the brain results in the individual's inability to assess colour correctly. Disease, sickness and ordinary fatigue may affect our ability in this way, but persons who have a permanent disability of this kind are called "colour blind." We have no means available to tell us whether we all see colour in the same way. In order to make it easier for us to describe colour, a number of its properties are classified as follows:

Hue
This term is used to describe the actual colour itself—red, blue, green, yellow, etc.

Brightness
This indicates the difference in the luminance of a light colour and a darker shade of the same colour.

Saturation
Used to describe the intensity of the colour, or its freedom from white. Two colours may have the same hue and brightness but differ from each other in fullness or saturation of hue.

Whiteness

The property of a non-luminous material which reflects or transmits white light without altering it in any way.

Greyness

The property of a non-luminous material which reflects or transmits white light but with reduced intensity.

Blackness

The property of a non-luminous material which will not reflect or transmit light in any way.

MIXING COLOURED LIGHT: THE ADDITIVE THEORY

The different colours produced by light radiation within the wavelengths 400 to 700 nm are classified for convenience into three main or *primary* hues:

<div align="center">RED, GREEN and BLUE</div>

The *secondary* colours are made by combining any two of these colours:

<div align="center">
RED + GREEN = Yellow light

RED + BLUE = Magenta light

GREEN + BLUE = Cyan light
</div>

When a secondary colour is mixed with a *complementary* primary colour the result is white light:

Secondary colour		Complementary colour		
Yellow	+	Blue	=	White light
Magenta	+	Green	=	White light
Cyan	+	Red	=	White light

MIXING COLOURS: THE SUBTRACTIVE THEORY

You may have noticed that the secondary colours of light are the same colours which are used for process colour printing. When we print a colour on to paper the colour itself has no luminance like that of a coloured electric bulb. In fact, the coloured print only reflects light to our eyes which it has received from the room lighting. If the illuminating light is white and the coloured print is yellow this means that the print has absorbed the blue wavelengths of the light and has

reflected the red and green wavelengths (red and green light make yellow). Look at Fig. 18. White light from the sun falls upon the flower and is reflected to the observer's eye. The flower head appears yellow because only the red and green wavelengths are reflected, producing a sensation of yellow. The leaves appear green because the blue and red wavelengths are absorbed and only the green wavelengths of light are reflected. In Fig. 19 the flower is illuminated at night by a street light of cold blue. If the light falling on the flower does not contain red or green wavelengths, the colour yellow cannot be reflected. The observer sees no colour but grey in the flower head.

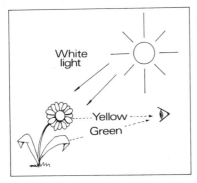 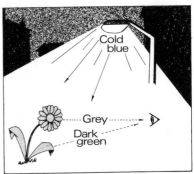

Fig. 18.—Flower viewed in sunlight. Fig. 19.—Flower viewed in artificial light.

The leaves cannot reflect green wavelengths because there is no green in the illuminating light. At best the observer will see dark green leaves.

All non-luminous materials are seen by the light they reflect. Those which appear white are reflecting all of the illuminating white light. Those materials which appear coloured appear so because they *subtract* from the light certain wavelengths and reflect others. Specially selected pigments and dyes are used in printing inks because of their ability to subtract from white light certain wavelengths and reflect others.

The *primary* colours of the subtractive pigments which are selected in this way are: MAGENTA, CYAN and YELLOW.

Magenta pigment subtracts Green from White light.
Cyan pigment subtracts Red from White light.
Yellow pigment subtracts Blue from White light.

The *secondary* colours are:

> Red (magenta and yellow)
> Green (cyan and yellow)
> Violet-blue (cyan and magenta)

When a secondary colour is mixed with a primary colour the result is black, that is, total non-reflection of light.

Secondary colour		Complementary colour	
Red	+	Cyan	= Black
Green	+	Magenta	= Black
Violet-blue	+	Yellow	= Black

The following important points are of interest to the printer:

1. The colour of ink is determined by the wavelengths of light which are reflected from the print.

2. Only when the print is viewed in white light of wavelengths 400 to 700 nm is its true colour seen.

3. The purity of colour reflected from the print will depend upon the selection of pigments which subtract precise wavelengths of colour from white light.

4. Paper which absorbs printing ink will reflect colour of lowered saturation.

5. Paper which reflects light well (coated paper) will give added brightness to the colour.

6. Only pure white paper can reflect a pure hue in ink.

7. Eye fatigue may affect the printer's appreciation of colour.

8. An instrument which will assess printed colour under standard lighting and in comparison with the paper which the colour is printed on, will be of considerable help to the colour printer.

REFLECTION DENSITOMETER

The traditional method of evaluating the weight of ink printed on a sheet has been the experienced eye of the pressman. This has its drawbacks because one man's estimate of colour may differ from another who takes over the press on the next working shift. With the shift system covering early morning to late evening (and sometimes the night, too), daylight and artificial light are used for viewing

colour prints. The change in the lighting may result in a change in printed colour over a long period. Another drawback to the traditional method is the gradual drying of the pass sheet, which is often accompanied by slight colour change. The pressman is left to assess what shade the colour was when the pass sheet was first printed.

The *reflection densitometer* is an instrument designed to take accurate measurements of the thickness or density of the printed ink film. Once the hue of an ink has been obtained by selection of

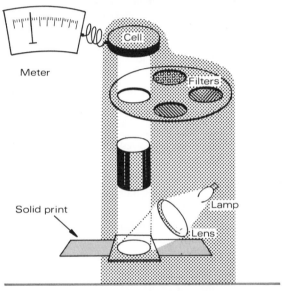

Fig. 20.—Principle of the densitometer.

pigments or mixing of inks, the printed colour will vary only if the thickness or density of the printed ink film alters during the press run. The densitometer (Fig. 20) supplies its own viewing light, thus overcoming the problem of normal light variations in the pressroom. It has an eye which is not subject to fatigue like the human eye. The eye is a sensitive photocell which is linked to a meter to give dial or print-out readings. The photocell views the reflected light from the print through a filter complementary in colour to the colour of the print. The filter is necessary because the photocell can only assess varying density of black to white, it is not sensitive to colour, therefore the complementary filter is used to render the colour viewed as black and white.

The densitometer indicates the density of the ink film in a series of units called *reflection density units.* If the sample reflects 100 per cent of the light which falls upon it the reflection factor is 1·0. Reflection less than 100 per cent is expressed as a decimal of 1·0. For example:

Reflection %	Reflection factor
50	0·5
10	0·1
5	0·05
1	0·01
0·1	0·001

To arrive at the scale of reflection density units used by the densitometer the following equation is used:

$$\log 10 \frac{1}{\text{reflection factor}} = \text{reflection density.}$$

For example, if the amount of light reflected from the print is 50 per cent the decimal factor will be 0·5:

$$\log 10 \frac{1}{0 \cdot 5} = 0 \cdot 3.$$

USING THE DENSITOMETER
In using the densitometer the following instructions must be adhered to:

1. Allow the instrument to warm up before use.
2. Use the complementary filter for each colour viewed.
3. When setting the meter for viewing white paper, ensure that the sample area is not veiled by an underlying dark surface.
4. Zero the instrument on the same paper as the print will be assessed upon. Check the zero setting when using the densitometer over a long period.
5. Light scatter from the paper grain may affect the density reading. See that the print is always measured with the paper grain running in the same direction.
6. Take density readings from fresh prints at a set interval of time. For example, always sample prints one minute after they leave the printing unit.
7. Use a solid area of printed colour only for taking readings.

The densitometer is a sensitive instrument and must be used with care. Avoid using the instrument on vibrating surfaces, and protect it from sharp movements when it is switched on.

PHOTOELECTRIC CELL

A number of light-sensitive devices are used in lithography for assessment and detection purposes. The photoelectric cell consists of a light-sensitive unit which may be used to evaluate the intensity of light, or may be used to operate a switch or solenoid. Two types are considered here.

PHOTOEMISSIVE CELL

This cell utilises a sensor such as caesium which is enclosed in a vacuum or gas-filled tube. The sensor forms the cathode electrode

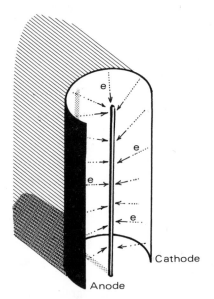

Fig. 21.—Schematic of a photoemissive cell.

and the anode is placed in such a way that it does not prevent light falling on the sensor (Fig. 21).

When light falls upon the sensor it emits electrons which are collected by the anode electrode. The flow of electrons from cathode to

anode is directly proportional to the amount of light falling on the sensor. This makes this type of cell suitable for use in light-measuring instruments such as the densitometer and the light integrator.

Because of its sensitivity to light, it may be used for side-lay and multicolour register printing on web-offset presses. A solid patch is printed on the web which is synchronised with the cell. Any excess movement of the printed patch is detected by the cell because of the fluctuation of reflected light from the web. The photocell emission triggers the correction motors which then bring the web back into correct lay.

PHOTOCONDUCTIVE CELL

This cell utilises a material such as cadmium sulphide (CdS) or lead sulphide (PbS), which is situated in an electrical circuit where it acts as a barrier to the flow of electricity as long as it is not illuminated.

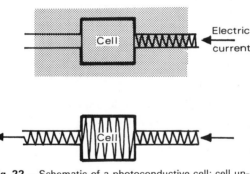

Fig. 22.—Schematic of a photoconductive cell; cell un-illuminated, electricity does not flow; cell illuminated, electricity flows.

When light of sufficient intensity falls on the cell, it loses its resistance and the electricity flows to operate a switch or solenoid (Fig. 22). The cell is used for web-break detectors where the web forms a barrier between the cell and a light beam. When the web breaks, the light falls on the cell and the current flows to actuate the press trip mechanism.

When used as no-sheet detectors on sheet-fed presses, the light beam is set at an angle to the cell. As the sheet is presented to the front lays correctly the light beam is reflected from the sheet surface into the cell. This allows the electrical current to flow, thus actuating the trip solenoids.

ARTIFICIAL LIGHT SOURCES

In the early days of photo-lithography it was not uncommon for exposures to be made by employing sunlight. Artificial light in the form of the oil-lamp, gas-lamp, electric arc-lamp and tungsten-filament lamp were all utilised to expose out light-sensitive coating materials. The carbon arc-lamps are still with us, but are being superseded by more modern forms of lighting.

CARBON ARC-LAMP

This lamp consists of an electrical circuit into which two carbon rods are incorporated. When an electric current is passed through the circuit, and the rods drawn apart, the electricity discharges across the gap. The heat generated burns away the tips of the carbon rods and emits radiation of high intensity at the blue end of the light spectrum. The *colour temperature* may be as high as 5000 °K with an output of 500 000 lm. (A 100 W tungsten-filament lamp has an output of approximately 1200 lm.) This high output, plus the short-wavelength emission has made the carbon arc-lamp popular among platemakers despite the disadvantages of the smoke, dust and heat produced.

DISCHARGE LAMPS

The term "discharge" is used to describe the passage of electricity through space. When the static electricity in storm-clouds flashes to the earth as lightning, an electrical discharge takes place.

The mechanics of the discharge tube are shown in Fig. 23. Elec-

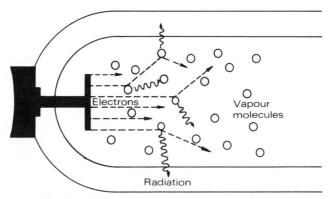

Fig. 23.—Schematic of the function of a discharge tube.

trical energy flows to the cathode electrode of the lamp, causing the cathode electrons to become so excited that they fly off into the space of the lamp. The electrons move in the electrical field which is present between the cathode and the anode electrodes. As the electrons move towards the anode they increase their speed. Also present in the tube is a gas or vapour. The speeding electrons have to pass through the gas to reach the anode electrode, and as they do so they collide with the molecules of the gas, so disturbing the atoms that they emit radiation in the form of light. The choice of gas in the tube determines the colour of the light emitted. For example, sodium vapour gives off orange light, mercury vapour gives off blue-green light, neon gas gives off orange-red light.

The rare gas xenon is used in high-pressure lamps now popular in platemaking exposure units. The colour temperature of this lamp is approximately 6000 °K with an output similar to that of the carbon arc-lamp. The pulsed xenon lamp is a further modification, in which the discharge through the gas takes place intermittently at about 0·001s one hundred times a second, similar to the electronic flash lamp.

FLUORESCENT LAMPS

The fluorescent lamp is a discharge lamp which functions in low-pressure mercury vapour. The spectrum emission is partly in the invisible region of the ultra-violet, and in order to utilise this, special compounds known as "phosphors" are coated on to the inside of the lamp glass. These phosphors fluoresce and glow brilliantly when ultra-violet radiation falls on them. The selection of phosphors determines the colour of the light emitted; daylight, warm white, colour matching and similar shades can be obtained. Some of these coating compounds contain beryllium which is highly poisonous. The greatest care should therefore be taken when handling a broken lamp to prevent the powder getting into a cut in the skin.

CHAPTER 2

PHOTOLITHOGRAPHIC PLANNING

THE majority of planning techniques used today are based on the use of photographic film negatives and positives. Reproduction of original copy by lithographic printing requires that the following series of operations are completed:

Preparation of copy. This may be original art work, photographs, transparencies or letterpress reproduction prints.

Photographs of the copy. This normally produces negative film from which positive film is made by contacting. The image formed on the film may be made larger or smaller than the original as required, and in the case of coloured originals, colour filters are used to produce "process colour separations."

Preparation of film for printing. This involves retouching, reducing the continuous-tone subjects into half-tone elements, stripping in of additional work and sometimes the production of photomechanical proofs.

Planning. The objectives of planning are as follows:

1. Arrange the individual film elements and position them in relation to the paper on to which the job will be printed. This will take into account the folding of the printed sheet, trimming, scoring and creasing operations which will follow the printing stage to produce the final product.

2. Relate the position of the paper to be printed with the printing plate itself. This operation is important for rapid press makeready and register.

The accurate assembly of the film elements and the transfer of these to the printing plate requires considerable expertise and personal skill on the part of the planner. In this chapter the basic principles of planning will be discussed, and a number of common planning techniques examined to give the reader a working knowledge of photolithographic planning.

HANDLING PHOTOGRAPHIC FILM

The photographic film used in planning consists of a transparent plastic substrate (such as polystyrene, polycarbonate and polyester films) which acts as a support for a thin layer of photographic silver emulsion. Film suitable for platemaking is known as "lith" film. This type of film produces areas of solid dense black with a sharp edge against corresponding areas of clear film; no graduations of density from black to clear film are formed. On examination under a magnifying glass the edges of the black areas should be relatively sharply defined without a fringe (Fig. 24). Half-tone dots which have a large

(a) (b)

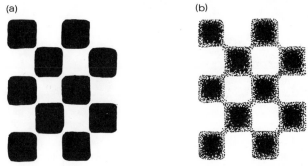

Fig. 24.—Types of half-tone dot. (*a*) Half-tone dot suitable for platemaking. (*b*) Half-tone dot with fringe, unsuitable for platemaking.

fringe round a solid centre are not suitable for platemaking because the intense light used for exposure passes through the fringe areas. These half-tone dots are usually produced in the process camera using a glass crossline screen and are called "camera dots" and "soft dots."

The photographic film has two sides. The side carrying the emulsion usually appears dull and is called "the emulsion side"; the reverse side is glossy and is called "the film side." When difficulty is experienced in identifying the emulsion side it can be located by scratching a corner of the film to remove the emulsion, or by placing the corner of the film between the lips and noting the tacky emulsion side.

Film used for platemaking is classified as *reverse reading*. This is identified by viewing the film from the emulsion side where the image will appear reversed as though seen in a mirror (Fig. 25).

The emulsion side of the film is delicate and can be damaged

Fig. 25.—Film viewed from emulsion side and classified as "reverse reading."

easily. If wetted the emulsion swells slightly and becomes tacky. When handling and working with film, therefore, the following points should be noted:

1. When cutting film with a knife this should be done from the film side using a number of light cuts to penetrate the film, rather than one heavy cut which may distort the film and leave ragged edges. Working from the film side will prevent accidental damage to the emulsion should the knife slip while cutting.

2. If a dull-edged knife is used, the extra pressure required to penetrate the film may produce a ridge at the film edge and hold it out of contact with the press plate during exposure.

3. A badly cut film will quickly pick up dirt and dust at the ragged edges and cause problems when printing down on positive working plates.

4. Red opaque is a water-soluble paint used for spotting out areas where it is undesirable for the light to pass through during plate

exposure. Because of its heavy consistency all general opaquing should be performed on the film side. This will make it easy to remove with water without swelling the emulsion, and there is no danger that it will hold the film out of contact with the press plate during exposure. Fine detail, however, should be opaqued on the emulsion side, preferably with black opaque which dries smoothly and does not require thick application.

LINE AND HALF-TONE IMAGES

Although all film produced for lithographic platemaking must have solid black and clear transparent areas, the following two types of image are formed on the film:

1. *Half-tone images.* These are made up of fine dots which are solid opaque elements. The highlight areas of the image are repre-

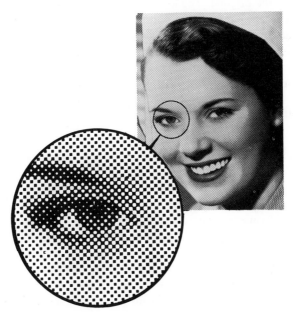

Fig. 26.—Half-tone screened subject.

sented by the fine dots, and the dense areas are represented by the larger joined dots (Fig. 26).

2. *Line images.* These consist of solid opaque lines which are of varying thickness.

NEGATIVE AND POSITIVE FILM

Exposed photographic film falls into the following categories:

1. *Positives.* These have the image formed with densities the same as the original. Planning with positives is comparatively easy because the planner can see through the clear areas of the film for locating the film elements over the layout. They have the disadvantages of requiring an extra step from the camera negative thus increasing costs. When used for platemaking great care must be exercised to eliminate the printing down of film edges and the pieces of dust and dirt which are attracted to the film surface due to static charges. Film edges and scratches in the clear film throw shadows on to the plate coating during exposure and will form lines in the non-image areas of the plate if not dealt with.

2. *Negatives.* These have the image formed with densities the reverse of the original. The use of negatives for platemaking has the advantages of simplicity, low cost and no problems with dust and film edges at the printing-down stage. Intricate planning with negatives, however, is a difficult task because the planner cannot see through the black areas of the negative to position the elements over the layout.

PLANNING—TOOLS, MATERIALS, EQUIPMENT

TOOLS

1. A stainless metal rule with engine-divided graduations in millimetres.

2. A large pair of dividers, preferably with jointed ends.

3. A good-quality compass.

4. A set square giving angles of 90°, 30° and 60°. Stout plastic set squares are regularly used, but greater accuracy is obtained with those made of metal.

5. A 4H pencil, fine ballpoint pen or draughtsman's ruling pen will be required for marking out the layout sheet. A needle mounted in a wooden handle is also useful for pinpointing accurate positions on the layout sheet.

6. An adjustable angle protractor.

7. A series of irregular curves.

8. A good-quality magnifying glass such as a linen-tester, giving 5× magnification and stand-mounted. In addition a collimating magnifier for register work to avoid parallax error.

9. A range of good-quality brushes in sable or camel hair for opaquing fine and heavy areas.

10. A beam compass.

11. Film-cutting knives.

MATERIALS

1. Adhesive tapes. These can be obtained in transparent red, brown and clear, made of Cellophane or polyester in 12- and 25-mm widths.

2. Goldenrod paper suitable for negative platemaking.

3. Clear plastic sheet to serve as the base for planning flats. Dimensionally stable, tear- and crack-resistant plastic should be used, the thickness varying between 0·13 and 0·18 mm depending on the size of sheet required.

4. Metal foil 0·025 mm thick for masking close to the image areas on film.

5. Petroleum jelly may be used as a non-permanent adhesive for the metal foil.

6. Masking strip film. This comprises a thin orange or red plastic film on a clear plastic sheet base. The film is cut and stripped away from the base to leave a sharp mask on the clear plastic sheet.

7. Film adhesive. An adhesive which sets rapidly but remains flexible should be used. Suitable commercial adhesives may be obtained which do not damage the film and can be removed easily from both film elements and plastic flats.

8. A water-soluble spotting-out paint known as "Opaque" which is suitable for brush and draughtsman's pen.

9. Non-toxic film-cleaning spirit. Avoid the use of the toxic solutions benzol and carbon tetrachloride.

10. Anti-static cloth or solution.

11. Plush weights for holding film elements in position prior to taping.

12. A selection of register marks, star targets and step wedges in positive and negative photographic film.

EQUIPMENT

1. A planning table of sufficient size to accommodate the largest layout sheet. The table should be of satisfactory working height, and preferably free-standing to allow the planner access to all sides of the layout. The top of the planning table will consist of a large glass area,

strong enough to support the leaning weight of the planner. The glass should have an opalescent finish with a diffused lighting beneath adequate to cover the entire area.

2. A precision ruling-up table is a boon to accurate layout preparation.

3. Cabinets large enough to store the largest flats either by hanging or in horizontal shallow trays. Film-storage cabinets and filing facilities.

PRINCIPLES OF PLANNING

A simple layout using a single image will serve as an example of how a layout should be planned and prepared.

Fig. 27.—Simple handout (one colour).

Figure 27 shows a simple handout which is to be printed in one colour.

The film is supplied as two pieces of lettering and a half-tone picture.

A dummy layout from the art department or customer indicates

the position of the lettering and picture which the planner will follow. The planner will ascertain the size of the finished job and the size of the paper to be printed.

The lettering must be positioned squarely with the picture and all measurements made correctly. For this the planner will use an accurate rule and set square, or he may plan the job on a light table which has an engraved grid (Fig. 28).

Courtesy: Krisson Equipment Ltd.

Fig. 28.—Krisson engraved glass grid used for planning table-top.

In order to centre the work on the sheet a vertical and a horizontal line are drawn through the sheet centre. The position of all the elements will now be measured from these centre lines because the edges of the sheet may not be square. This rule is always followed even for complex layouts: always locate positions of elements by measuring from the centre lines.

The next step is to place trim guide-lines on the sheet to indicate where the guillotine-cuts are to be made. The handout is slightly smaller than the sheet on which the job is printed.

When the sheet is conveyed through the press for printing it is

held securely by gripper fingers at the leading edge of the sheet. This portion cannot be printed upon and is, therefore, allowed for in the layout. It is called the "gripper allowance."

Finally, the sheet layout will have to be positioned on the printing plate in such a way that the pressman can make rapid makeready and registration of the work for printing. To do this correctly the

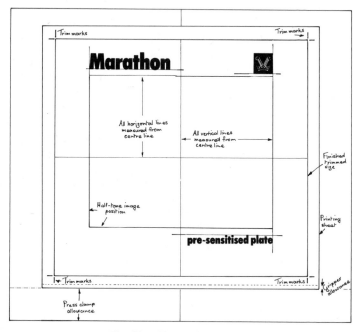

Fig. 29.—The finished layout.

planner must know how much of the plate at the leading and back edge will be taken up by the press plate clamps. In practice the leading clamp allowance only is required, although it is important that the planner knows how much of the plate area can be used for printing. The clamp allowance varies with the particular printing-press used. Figure 29 shows the finished layout.

PLANNING A LAYOUT

The principles of planning given above are for practical considerations followed in the reverse order as follows:

1. A stout sheet of dimensionally stable paper such as manilla is used for drawing the layout. The sheet should be slightly larger than the printing plate.

2. The correct plate clamp allowance is obtained and a base line drawn across the layout to correspond with this measurement.

3. A centre line is drawn vertically using a set square. This line will be used as a datum for all vertical measurements.

4. The outline of the printing sheet is now drawn on to the base line.

5. The gripper allowance and position of image elements, together with register marks and trim lines, are now drawn in the same manner as before.

Multiple images

Regular-shaped images are planned in the same way as the simple principles outlined above.

Irregular-shaped images such as labels, envelopes and die-cut displays require assembly to use the sheet size economically. If the sheet

Fig. 30.—Layout of irregular images with straight cuts.

is to be guillotined the images must be arranged to allow a straight cut for separating the prints (Fig. 30). If the sheet is to be die-cut then a die-cut dummy must be obtained from the finishing department. To find out the maximum number of irregular-shaped images which can be planned on the printing sheet the planner should obtain a cut-out

label or shape of the image. The trimming allowance between the images must be known. The irregular-shaped cut-out is positioned on the printing sheet in a number of experimental settings until it is clear how the images may be assembled for maximum sheet use.

Double cutting. This is a term used to indicate that the printed image is cut out of the printed sheet in one guillotine operation and is followed by a second cutting operation to bring the work to the required size. In the case of labels and irregular images the double cut is generally used, the first cut to dissect the sheet into manageable strips and the second to form the finished size.

Double cuts are normally used for images in which the image bleeds off the trim area, *i.e.* the image has no white margin at the edge of the finished sheet, the guillotine cut actually passing through part of the image.

In standard bookwork, double-cutting allowances are made on all edges of the page except the spine. The book sections are folded and cut once to form a signature, and when the complete number of signatures are gathered together, a second cut is made to give the edge of the book an even surface.

LATERAL REVERSAL OF LAYOUTS

There follows a number of planning techniques used in lithographic platemaking. In every case where film elements are assembled on a suitable support such as goldenrod paper and clear plastic sheet (called a "planning flat"), the layout must be drawn up to appear laterally reversed from the finished plate position of the images. This is necessary because the film elements are assembled on the flat with the film emulsion uppermost, and the flat is turned over from left to right (or laterally) to position it on the plate for exposure.

NEGATIVE PLANNING TECHNIQUES

The techniques here are presented in order of simplicity and accuracy for register, progressing to the methods used for a high degree of accuracy.

Projected-line layout

1. Having drawn the layout a window is cut through the layout paper at the position of the image register marks (Fig. 31).

2. In order to place the layout accurately on the plate, suitable

positioning lines are added and the paper cut in such a way as to make plate location simple.

3. Having positioned the layout on the sensitised plate the register marks are projected on to the surface of the plate by carefully drawing through the windows a continuation of the layout marks with a fine-point pencil or blue ballpoint-pen. Remove the layout sheet.

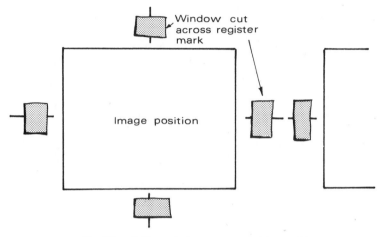

Fig. 31.—Cutting windows across register marks.

4. The film element is now positioned on the plate by registering the marks on film and plate. Cover the non-image areas of the plate with masking paper when using negative working plates and expose to light.

Photo template methods

An extension of the projected-line method, the use of a template to form register marks on the sensitised plate by printing down is commonly used. There are two methods as follows:

1. Goldenrod paper is used for drawing the layout and the register marks are cut as slits with a sharp knife. When positioned on the sensitised plate and exposed to actinic light the register marks are formed on the plate.

2. The layout sheet is pasted to a sheet of aluminium foil of about 0·2 mm thickness. The register marks are cut through as

slits with a sharp knife to make a template which is sufficiently stable and durable for frequent use.

When using these methods the plate must be coated with a light-sensitive solution such as dichromated albumen or a commercial wipe-on coating and the template exposed to form register marks. After processing the plate in the normal manner the plate must be recoated and the film elements located to the marks and exposed. Certain light-sensitive coatings give a visible image when exposed to light. If this type of plate is used the register marks may appear clear enough to register the film without further processing of the plate. An alternative method of forming register marks with the template is the use of Photo Blue.

Photo Blue

In the circumstances where the film elements lie closely together on the plate the register marks for each individual image may fall across the adjacent image. The Photo Blue process may be used with a template to form clear blue register marks or layout lines on to the plate which will not print up on the press. After forming the blue register marks on the plate it is coated with light-sensitive coating and the film positioned to the blue marks which will show through. The plate is then exposed and processed in the normal manner. The Photo Blue process requires the following steps to be taken:

1. Coat the plate in the whirler with the Photo Blue solution. The whirler speed should be about 40 rev/min. The formula for Photo Blue solution will be found in Appendix 1.

2. Locate and expose the template in the vacuum frame. Exposure time should be at least twice that used for deep etch. As a guide 8 min at 1 m, using a 60 A carbon arc-lamp, can be used.

3. Wash the plate with water after exposure and intensify the blue lines as required. The plate is now coated for normal processing.

Masking negatives

When using negatives for planning and platemaking the image is formed on the plate by the passage of light through the clear areas of the film. All non-image areas should be masked to prevent light falling on the sensitive coating. Masking material suitable for this use should be either completely opaque or coloured with dye or pigment

which will prevent the actinic light (blue and ultra-violet) passing through.

Opaque masking in the form of *tin or aluminium foil* is used for masking close to the image on the emulsion side of the film. The foil is approximately 0·025 mm thick and is used to reduce the amount of opaquing over a large area and to obtain straight masking edges. The foil is usually attached to the film with petroleum jelly which is applied in a thin coat by hand-roller to the film and the foil positioned subsequently.

Translucent red, orange and yellow paper is commonly used for masking and is called *goldenrod paper*. The best types are those which are dense papers, dyed all through with the colour. Goldenrod permits long-wavelength light to pass through which makes the paper suitable for planning over a light table where layout lines drawn on one side can be clearly seen from the other side.

Translucent red *masking strip film* consists of a thin red membrane supported by a transparent plastic sheet.

Goldenrod layouts

For small plates and work which does not require precise register, the popular goldenrod layout may be used for negative working plates as follows:

1. Draw out the layout on to goldenrod paper.

2. Position the negative film elements with the emulsion side uppermost (reverse reading), and fix temporarily with adhesive drafting tape.

3. Turn the layout over, and viewing the goldenrod with the light of the planning table on, cut away the goldenrod in those areas where light is intended to pass during exposure. When cutting the goldenrod with a knife take care not to cut through the film element underneath.

4. Secure the film with tape from this side and remove the temporary tape from the emulsion side of the film. This will avoid any possibility of the tape preventing good contact in the vacuum frame.

5. Where large windows are cut into the goldenrod paper, the over-all strength of the sheet may be weakened making it difficult to handle. In many cases this can be remedied by taping the negatives together. For greater stability and accuracy a sheet of masking strip film can be used in place of the goldenrod paper.

POSITIVE PLANNING TECHNIQUES

TRANSPARENT PLASTIC FLATS

For greater accuracy in register work, clear plastic flats should be used. Owing to the ease of planning in positive form it is more common to use clear plastic flats and positive working press plates for multicolour work.

1. The layout must be prepared by drawing it out in lateral reversed form, *i.e.* when turned over from left to right it will appear in the form which the printed sheet should appear.

2. The clear plastic sheet is placed over the layout and secured in position with tape.

3. Taking the layout as a guide the various elements of positive film are now attached to the flat in their respective positions. The film must be placed with the emulsion side uppermost (reverse reading) and attached with clear tape or clear plastic adhesive. All fixing tape should be at least 8 mm from the edge of the film images.

4. An exposure mask known as a *burn-out mask* may be prepared to crop oversize images and to expose out tape marks and film edges which often occur when the flat is exposed to the plate. The mask is made by cutting accurate pieces of goldenrod paper and attaching them to a separate sheet of clear plastic. Red or brown adhesive tape will also serve to mask narrow areas. Large masks can be quickly prepared by using masking strip film. This simply requires that the mask areas are lightly cut into the upper film layer, and the film stripped away from the base to leave masks in the areas required.

It is important that the burn-out mask and the flat should be accurately registered together, either by using locating lines or by the use of a punch register system.

KEY LAYOUTS ON PLASTIC SHEET

The job layout can be prepared on clear plastic sheet by using light blue transparent ink. Photographic film elements are fixed in position on this layout and exposed to the plate in the normal manner. The blue layout will not print down to form an image on the plate.

Another method is to prepare the first flat in the normal manner and to expose this in contact with a sheet of diazo-coated film. The

diazo film is developed in an ammonia-fume processor. The diazo print is usually coloured, making it a useful key layout for preparing further flats.

Blue key

This is a proprietary blue line process which is popularly used for preparing key layouts on plastic sheet. The blue key process requires the following steps to be taken:

1. The clear plastic sheet is coated with a light-sensitive substance such as Photo Blue for plastic sheet.

2. The sensitised sheet is placed over a laterally reversed layout with the coating uppermost.

3. The photographic film elements are positioned and fixed to the sheet with the emulsion uppermost.

4. The sheet is exposed in the vacuum frame.

5. The negative working process requires that the image is simply developed in water to form a blue image on the sheet.

6. The positive working process is similar to the deep-etch process, the image is developed away and the plastic sheet dyed with special blue. The stencil is then removed with water.

In both cases a blue key image is produced on the sheet which may be used directly as a flat. The blue key itself will not print down to form an image on the plate. With this type of key, process colour separations which do not have register marks can be assembled and printed down with complete accuracy.

PUNCH-REGISTER SYSTEMS

Accurate positioning of one flat upon another, positioning the flat to a determined place on the plate and obtaining precise register between process colour separation films are made simple by using a punch-register system. A typical system consists of a hand-punch which cuts a hole into plastic sheet or metal foil; and a male dowel-pin which closely fits the punched hole. The pins may be made of metal or plastic.

A pin bar consists of two or more male dowel-pins accurately positioned on a common base. The Kodak pin bar is a typical example (Fig. 32). The use of a pin bar requires that a punch which cuts holes to accurate distances is used (Fig. 33).

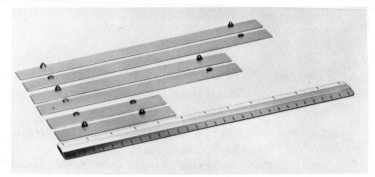

Courtesy: Kodak Ltd.

Fig. 32.—A selection of Kodak pin bars.

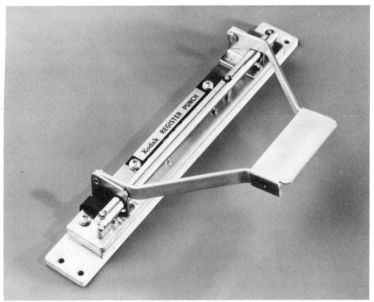

Courtesy: Kodak Ltd.

Fig. 33.—The Kodak punch.

When using the Kodak punch-register system for layouts the following steps are taken:

1. The gripper edge of the layout sheet is placed centrally in the punch taking care to push the sheet edge fully to the stops.

2. The layout is punched, and the plastic flats prepared in the same manner.

3. The high pin bar is placed under the layout sheet and the pins located. The wide edge of the pin bar should be nearest the planner.

4. The plastic flat is placed over the layout and located on the pin bar. The flat should be fixed to the layout with adhesive tape and the film elements positioned in the normal manner. Subsequent flats are prepared in the same manner.

5. Aluminium plates with a caliper less than 0·3 mm may also be punched along the gripper edge. With the use of the low pin bar the flat can be accurately positioned on to the plate and exposed in the vacuum frame with the pin bar intact. If plate-punching is feasible a separate punch should be used just for punching metal plates.

INDIVIDUAL PUNCH REGISTER

Packs of individual male and female punch-register elements can be obtained commercially. These offer a large range of possibilities for accurate registration of layouts and flats. A simple method is as follows:

1. Prepare the layout in the normal way. Position two or more male pins and tape them to the layout.

2. Place the plastic flat over the layout. Fit a female tab over each pin and secure them to the flat with adhesive tape. Do this with each flat.

This method will ensure that each flat is prepared to accurately fit the next, and is very suitable for making up flats for multicolour work and hairline register.

PUNCH REGISTER AND DOUBLE PRINTING

Double printing is commonly used for work in which negatives are combined to butt with each other, to overlap, or to be superimposed by a second negative. A combination of a half-tone negative and a

line negative can be made by double printing without making a combination negative.

A sample method of double printing is shown here. The planner will see the potential of this technique and will be able to exploit it for his own requirements.

 1. Draw the layout on goldenrod paper showing the position of half-tone elements.

 2. Place a second sheet of goldenrod paper with the first and punch both together along the gripper edge.

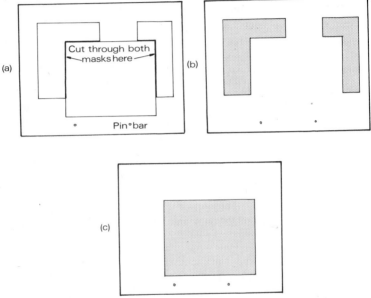

Fig. 34.—Double printing down using punch register. (*a*) Two masks cut together. (*b*) First mask cut out. (*c*) Second mask cut out.

 3. Locate both sheets on a high pin bar and cut through both sheets where the half-tones butt together (Fig. 34).

 4. Separate the flats and complete the windows in each.

 5. Mount the negatives in their respective flats and expose each one separately to the sensitised plate. If the plate is also punched, greater accuracy will be obtained.

The same method can be used to combine half-tones, line-work or tints.

STEPPING UP MULTIPLE IMAGES

When making printing plates containing a number of images from a single film element (for labels, etc.) both hand and mechanical methods can be used. Multiple images for single-colour work may not require a high degree of accuracy, but multicolour work will require as much precision as possible. The following methods for stepping up multiple images from a single film element are given in order of relative accuracy:

1. The projected-line method.
2. The template method.
3. Blue key.
4. The punch-register method.
5. Using the step and repeat machine.

The first three methods have already been described.

STEP AND REPEAT USING PUNCH REGISTER

Once the planner has mastered the use of a punch-register system he will quickly discover many uses for it in the accurate registering of tight-fitting jobs. A variety of step and repeat methods can be performed with the punch-register system, a sample method is as follows:

1. The film carrier. Cut out a suitable piece of clear plastic sheet on to which the film element is mounted with tape, emulsion side uppermost (Fig. 35).

2. Fix a female tab with tape to each side of the film carrier.

3. An old press plate slightly larger than the plate to be made will make an ideal base plate. Attach the layout to the base plate (Fig. 36).

4. Place the film carrier on to the layout and line up the film image with the layout image position. Tape the film carrier down temporarily.

5. Into each female tab insert a pin element and, using the female tab as a position guide, tape the pin to the base plate.

6. Step the film carrier to the next image position and repeat the operation. Repeat for each image.

7. Place the base plate in the vacuum frame and position the sensitised press plate to the layout.

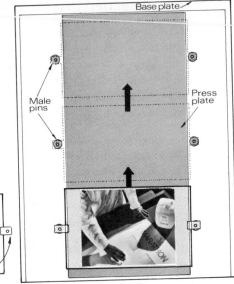

Fig. 35.—Step and repeat film carrier.

Fig. 36.—Step and repeat, layout of the base plate.

8. Locate the film carrier on the pins for the first image position. Mask out the remainder of the plate, and make the first exposure. Repeat for each step.

When stepping up multicolour work a film carrier for each colour separation film element will be required. To register the first film carrier with the subsequent carriers, the following method should be followed:

1. Locate two pins into the female tabs on the first film carrier, with the film emulsion uppermost.

2. Lightly tape down to the illuminated table-top. Make up the second film carrier and fix female tabs to correspond with the pins on the first carrier.

3. Carefully register the second film (emulsion uppermost) to the first and tape securely to the carrier.

4. The second film carrier may now be stepped up using the base plate to make a second plate in good register with the first.

For stepping two or more columns, the film carrier may be prepared with the tabs on one side only and the procedure repeated on each side of the plate.

MECHANICAL STEP AND REPEAT METHODS

For precision step and repeat work with high output, the use of the step and repeat machine cannot be equalled. These machines have been in use for a great many years, and today hand-set and fully automatic machines are in use. There are a large variety of these machines on the market which makes it impossible to cover all the design features of each. The basic principles, however, are similar and are as follows:

1. The machine has a platen to which the sensitised plate is positioned and fixed.

2. The film element is accurately positioned and fixed in a film carrier which has horizontal and vertical movement over the plate area. (Some machines have a stationary film carrier and a movable platen.)

3. The movement of the film carrier can be controlled to give fixed positions on the plate to tolerances of 0·001 mm in many cases.

4. Once a position for the carrier has been determined, it is locked into this position, the film moved into close contact with the plate surface, and normal vacuum contact obtained as with the vacuum printing-down frame.

5. The exposing lamp is positioned over the film carrier and the exposure made. A hood is fitted to the lamp to prevent extraneous light falling on the rest of the plate during exposure.

Various models of the step and repeat machine are available. The horizontal types are useful for large heavy plates, and the vertical models lend themselves to smaller plates and the saving of floor space.

Automatic step and repeat machines require little hand-setting and, therefore, offer high productivity. The basic design of these machines is similar to the hand-set machine, but the film-carrier positions are located, the vacuum contact made, and the exposure completed by the automatic motor drive. The automatic movements are controlled by a punched card or tape which is prepared by the operator who punches the tape according to his layout positions. Each hole punched in the tape, and its position on the tape, represents a horizontal or vertical position for the film chase. Speeds as high as 70 exposures an hour can be made with these machines which once set

do not require the attention of an operator until the plate is completed.

PREPARING STEP AND REPEAT LAYOUTS

When planning the positions which the film carrier must make, a rough layout should be prepared. It is not necessary to make it to scale so long as accurate carrier positions can be deduced from it.

Courtesy: Monotype Corporation Ltd.

Fig. 37.—The Lithoprintex step and repeat machine.

Courtesy: Pictorial Machinery Ltd.

Fig. 38.—Lining up the film carrier on the illuminated register unit.

The following example is related to the Lithoprintex Junior Mark II machine (Fig. 37) in which vertical carrier positions are taken from zero at the gripper edge of the plate, and horizontal carrier positions from the plate centre. The plate centre always corresponds to the horizontal machine centre which is 500 mm. The film carrier carries a glass vacuum screen on which the film is located in a central position by lining it up with an illuminated register unit (Fig. 38). All measurements on the step and repeat machine relate to the vertical and horizontal centres of the film in the carrier.

Vertical steps (Fig. 39)

The plate will have a clamp allowance of 70 mm, plus 14 mm for the paper gripper, plus the measurement to the centre of the image (to the register mark which is used to centre the film element in the carrier) which is half of $127 = 63 \cdot 5$ mm. The 5-mm margin is compounded in the gripper allowance.

Add these together and we have obtained the first vertical position from zero for the film carrier:

$$70 + 14 + 63.5 = 147.5$$

The second vertical carrier position is obtained by adding half the image measurement 63·5 mm plus 5 mm for the margin, plus 5 mm

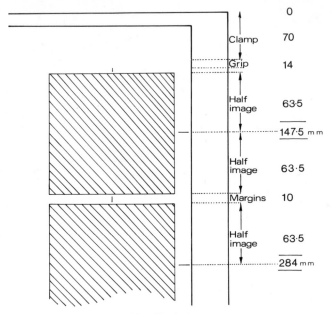

Fig. 39.—Vertical steps.

for the next image margin, plus half the measurement of the next image 63·5 mm:

$$147.5 + 63.5 + 5 + 5 + 63.5 = 284.5$$

Repeat for each succeeding position.

Horizontal steps (Fig. 40)

The figure 500 corresponds to the machine centre and the plate centre will line up with this.

Begin with the figure 500 and add 5 mm margin plus half the image measurement thus:

$$500 + 5 + 69.25 = 574.25$$

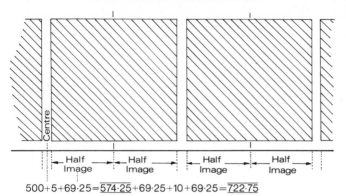

500+5+69·25=$\overline{574·25}$+69·25+10+69·25=$\overline{722·75}$

Fig. 40.—Horizontal steps.

This will be the first horizontal carrier position right of centre.

Add to 574·25 half the image measurement, 69·25, plus 5 mm for margin, plus 5 mm for next image margin, plus half the next image measurement. This will give the second image position right of centre:

$$574·5 + 69·25 + 5 + 5 + 69·25 = 723·00$$

IMPOSITION

Making a layout for the position of pages in a magazine or book will require the knowledge of folding techniques used by the finishing department. "Imposition" is the term used to describe the operation of planning the page positions in the layout in such a way that, when the printed sheet is folded, the pages run in numerical sequence. There are a number of imposition schemes used in standard book-work which the planner should record and file for reference. This section has been designed to introduce the planner to simple imposition schemes for sheet and web-offset printing.

TERMS USED IN IMPOSITION

1. A page in the shape of an upright rectangle is called a *portrait* page.

2. A page in the shape of a rectangle wider than it is high is called a *landscape* page.

3. When printed, page sections may be assembled one inside another and stitched through the back. This is called *saddle-stitching*.

Used mainly for magazines and inexpensive books with less than 128 pages (Fig. 41).

For standard bookwork, and magazines of high quality, page sections are gathered together by placing one section beside another and the whole stitched, stabbed or sewn through the side. This is called *side-stitching* (Fig. 42).

Fig. 41.—Sections inset for saddle-stitching (quirewise).

Fig. 42.—Sections gathered together for side-stitching, stabbing or sewing.

Magazines may be gathered in the same manner but the sections are trimmed along the backs and bound together with glue. This is called *unsewn binding*.

4. Terms used with the imposition layout (Fig. 43) are as follows:

> The *head* is the space between pages located with their tops together.
> The *foot* is the base of the page.
> The *tail* is the space between pages with their bases together.
> The *fore-edge* is the space on the outer edge of the page.
> The *gutter* is the space between pages with their fore-edges together.
> The *back* is the space between pages which forms the back of the book when folded.

5. When the book sections are gathered together a checking system called *collating* is used to ensure that the sections fall in correct sequence.

Fig. 43.—Imposition layout showing heads—H, backs—B, foot—F, gutter—G, tails—T, and fore-edges.

6. A *signature* is an alphabetical letter or figure placed on the first page of each section to facilitate collating. The signatures used in the compilation of this book can be seen on pages 15, 47, 79.

7. The *black-step* method is used to assist collating by placing black markers in the backs of the first and last pages of each section. Figure 44 shows how this appears in the finished form.

8. All bookwork sections are printed both sides. This is called *backing up* or *perfecting*. Presses which print both sides of the sheet in one pass are called *perfecting presses*.

9. A *dummy* is an accurately sketched mock-up of the book or magazine.

SECTION FOLDING

The position of the book pages will be determined by the manner in which the printed sheet will be folded by the finishing department or web-offset press folder. Web folding will be discussed later in this chapter. The correct folding of the section is fundamental to

Fig. **44**.—The black-step method used for collating book sections.

obtaining a correct imposition scheme. For example, a sixteen-page section can be folded at least eight different ways but only one of them will be correct.

A number of simple standard folds are as follows:

(Fig. 45 (*a*)) Eight-page landscape

Hold the sheet in the oblong position and mark page 1 in the bottom right-hand corner. This page should be kept to the front.

Fold the shortest edge in half away from you.
Fold the longest edge in half away from you.
Number through 1 to 8.

(Fig. 45 (*b*)) Eight-page portrait

Hold the sheet in the upright position and mark page 1 in the bottom right-hand corner. This page should be kept in front.

Fold the longest edge in half away from you.
Fold the longest edge in half away from you.
Number through 1 to 8.

(Fig. 45 (c)) Twelve-page concertina

Hold the sheet in the upright position and mark page 1 in the bottom right-hand corner. This page should be kept in front.

Fold one-third of the sheet from the top towards you.

Make a second parallel fold of one-third away from you.

Fold the longest edge in half away from you.

Number through 1 to 12.

Fig. 45.—Simple standard folds.

(a) Eight-page landscape.
(b) Eight-page portrait.
(c) Twelve-page concertina.
(d) Sixteen-page landscape.

(e) Sixteen-page portrait.
(f) Thirty-two-page landscape.
(g) Thirty-two-page portrait.

(Fig. 45 (d)) Sixteen-page landscape

Hold the sheet in the upright position and mark page 1 in the bottom right-hand corner. This page should be kept in the front.

Fold the longest edge in half away from you.

Make a second parallel fold in half away from you.

Fold the longest edge in half away from you.

Number through 1 to 16.

(Fig. 45 (e)) Sixteen-page portrait

Hold the sheet in the oblong position and mark page 1 in the bottom right-hand corner. This page should be kept in front.

Fold the longest edge in half away from you.
Fold the longest edge in half away from you.
Fold the longest edge in half away from you.
Number through 1 to 16.

(Fig. 45 (f)) Thirty-two-page landscape

Hold the sheet in the oblong position and mark page 1 in the bottom right-hand corner. This page should be kept to the front.

Fold the longest edge in half away from you.
Fold the longest edge in half away from you.
Make a second parallel fold in half away from you.
Fold the longest edge in half away from you.
Number through 1 to 32.

(Fig. 45 (g)) Thirty-two-page portrait

Hold the sheet in the upright position and mark page 1 in the bottom right-hand corner. This page should be kept to the front.

Fold the longest edge in half away from you.
Fold the longest edge in half away from you.
Fold the longest edge in half away from you.
Fold the longest edge in half away from you.
Number through 1 to 32.

To make page-numbering of the folded section possible cut a V shape with a sharp knife through the middle of the section (Fig. 46).

Fig. 46.—Cutting a V into the section
to make numbering easier.

SHEET WORK

This method of printing bookwork requires a separate plate to print each side of the sheet. *The outer* carries the first and last pages, *the inner* is the back-up plate (Fig. 47). Always note the gripper edge on the plate. The *short cross* is the line crossing the centre of the shortest

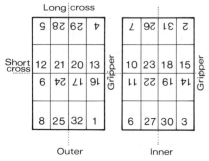

Fig. 47.—Outer and inner plates.

dimension of the sheet. The *long cross* is the line crossing the centre of the longest dimension of the sheet. To perfect the printed outer section the sheet is turned over on the axis of the short cross, thus using the same gripper edge of the sheet.

WORK AND TURN (HALF-SHEET WORK)

This method of printing requires one plate from which both sides of the sheet are printed. The inner and outer sections are both planned on the plate in such a way that when the printed sheet is turned over on the axis of the short cross and backed-up it can be cut into two

Fig. 48.—Work and turn imposition.

copies. For accurate register the same gripper and side-lay edge of the sheet is used for backing-up. This requires that the press side-lay stop is changed over.

To arrange the work and turn layout take the sheet-work imposition and place the gripper edges together to form one scheme (Fig. 48).

WORK AND TUMBLE

This method of printing is similar to work and turn. The one plate is used to perfect the sheet producing two copies. The sheet, however, is turned over on the axis of the long cross, necessitating a change of

Fig. 49.—Work and tumble imposition.

the gripper edge but retaining the same side lay. The method is used for imposition schemes such as the twelve-page which cannot be perfected by the work and turn method (Fig. 49).

IMPOSITION FOR WEB OFFSET

Web-offset press folders cut and fold from the running web of paper to produce one section. The number of webs entering the folder may be four or more. The correct imposition of pages on the plate and the position of the plates on the printing units of the press will vary according to the number of webs run. With the use of half webs and colour facilities ranging from two to four colours, an almost infinite variety of imposition schemes are possible. The following information is intended to give the lithographer an introduction to simple web imposition. If these principles are grasped, more involved impositions will present little difficulty.

Impositions for newspaper, magazine and book work must be planned from the folding sequence of the press folder. Figure 50 shows the standard folding sequence of most web-offset press folders. To simulate the folding sequence follow these directions:

1. Hold a sheet of paper in the oblong position and mark page 16 on the bottom left-hand corner of the sheet. Keep this page in front.

2. Fold the longest edge away from you (this corresponds to the former fold to make broadsheet).

3. Fold the longest edge away from you (this corresponds to the jaw fold to make tabloid).

4. Fold the longest edge away from you (this corresponds to the quarter fold for magazine).

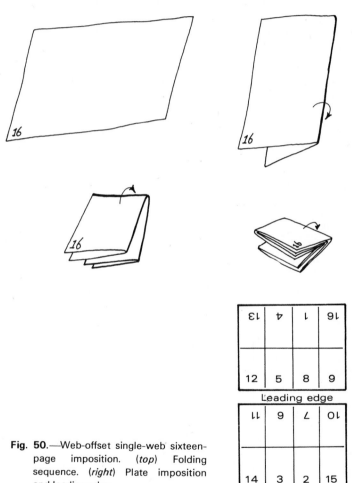

ƐL	⊅	L	9L
12	5	8	9

Leading edge

LL	9	∠	0L
14	3	2	15

Fig. 50.—Web-offset single-web sixteen-page imposition. (*top*) Folding sequence. (*right*) Plate imposition and leading edge.

5. With 16 as the back page, number through the section from 1 to 16.

6. Plan the plate imposition taking care to indicate the leading edge.

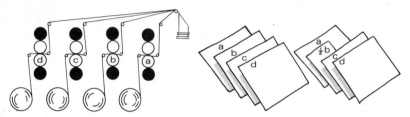

Fig. 51.—Form in which the cut-off webs align in the folder for folding.

For multiple webs use the folding sequence as above, adding an extra sheet for each web to be folded together. When planning the plate impositions, take care to indicate the leading edge, and mark each plate with a letter to denote which unit of the press it is to be mounted on (Fig. 51).

POSTER SIZES AND LAYOUTS

Small posters printed in this country vary in size, with a minimum dimension of 254 × 1016 mm. Large posters are made up of multiples of *poster sheet* (508 × 762 mm) which is equivalent to the old British double-crown paper size of 20 × 20 in.

The basic poster size is four poster sheets (called *four-sheet*)

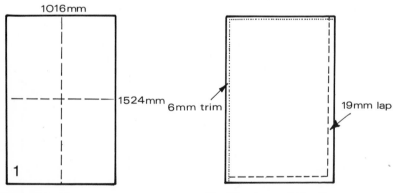

Fig. 52.—Four-sheet poster. **Fig. 53.**—Lap and trim allowance.

with an over-all dimension of 1524 × 1016 mm (Fig. 52). To make allowance for trimming and for overlapping edges when the poster is assembled the four-sheet size is 1549 × 1041 mm for printing.

The following list gives the common sizes:

Poster size	Number of poster sheet units	Finished size (mm)	Number of sheets
4 sheet	4	1524 × 1016	1
8 sheet	8	1524 × 2032	2
12 sheet	12	2032 × 2286 or 1524 × 3048	3
16 sheet	16	3048 × 2032	4
24 sheet	24	3048 × 3048	6
32 sheet	32	3048 × 4064	8
48 sheet	48	3048 × 6096	12
64 sheet	64	3048 × 8128	16

All these sizes are printed on large presses which take a sheet size of 1549 × 1041 mm (four-sheet). The number in the last column indicates the number of sheets which make up one poster.

Figure 53 shows the 6-mm trim and 19-mm lap which leave a

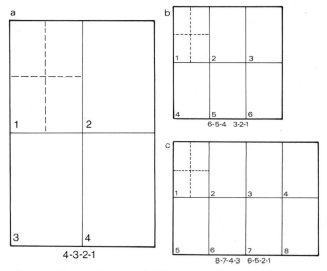

Fig. 54.—Poster diagrams. (*a*) Sixteen-sheet poster. (*b*) Twenty-four-sheet poster, a forty-eight sheet being twice the length but the same depth. (*c*) Thirty-two-sheet poster, a sixty-four-sheet being twice the length but the same depth.

visual area of 1524 × 1016 mm when a four-sheet poster is assembled on the poster-hoarding. All overlapping areas of the poster are marked "lap" and each section numbered to assist assembly. The sheets are pasted on to the poster-hoarding in a sequence which allows the laps to fall correctly. The sequence is indicated beneath the poster diagrams (Fig. 54).

Whenever possible, the 19-mm lap on the long edge of the sheet is used as the gripper edge when printed. When a number of poster sheets are used to complete a poster it is practice to lap from the

Fig. 55.—Poster lap for rain.

Fig. 56.—Example of altering the sheet layout to accommodate the poster image.

right over left and from the top over bottom. This last point is important as it allows rainwater to run off the poster without getting under the lower sheets (Fig. 55).

The layout of the poster image sometimes requires that the sheet joins do not fall across important details such as small lettering, which will spoil the appearance of the finished poster if sheet registration during pasting up is slightly out. In cases like this the poster may be made up of different-size sheets as shown in Fig. 56.

Special inks are used for poster printing which give protection against atmospheric pollution and usually have a lightfastness of not less than six weeks.

Paper for posters is usually the Machine Glazed (M.G.) Poster which has one side of rough texture to assist the pasting and hanging operation. Minimum substance recommended for posters is 106 g/m².

PHOTOLITHOGRAPHIC PLATEMAKING AND PROOFING

LITHOGRAPHY is distinguished from other printing processes because of the particular arrangement of the image and non-image areas of the printing plate. The establishment of an ink-receptive, water-repelling image on the surface of the lithographic stone; the treatment of the non-image areas with chemical solutions to produce a water-retaining, ink-resisting surface, was the foundation of Senefelder's invention. Enormous sums of money have been spent on lithographic research in recent years, but the basic principles of lithography are still the same after 170 years.

Modern technology, however, is making very important advances in platemaking techniques and materials. Only a few years ago the standard platemaking processes were limited to albumen and deep etch; today the albumen process is rarely used, and very soon we may see the retirement of the deep-etch process.

With these modern changes taking place, it was felt necessary to limit the platemaking techniques in this chapter to basic principles only. By this means the student will be able to adjust his techniques to the new technical improvements which develop in the industry.

SURFACE CHEMISTRY OF THE LITHOGRAPHIC PLATE

The lithographic plate functions on a *planographic* basis; the image areas are oleophilic (grease-loving), and the non-image areas are hydrophilic (water-loving). Both these areas are on the same plane and are of equal importance in the correct working of the process.

The original base on to which these image and non-image areas rested was the limestone slabs of *Kelheim stone* (hence the name "lithography"—the Greek word for "stone" is *lithos*). Senefelder was aware that the base material for the process could be any substance

so long as it was prepared correctly to support the oleophilic and hydrophilic surfaces. This is demonstrated clearly today in the considerable variety of lithographic plates, which have paper, plastic, stainless steel, aluminium, zinc, brass or mild steel as a base material.

The platemaker is not concerned with the material which forms the base of the plate so much as the establishment of suitable substances on that base material which will perform lithographically on the press.

OLEOPHILIC IMAGE AREAS

Those materials and substances most suitable for forming an ink-attracting image must conform to the following essential requirements:

1. They must have good adhesion with the plate and remain intact on the surface while subject to the powerful tack conditions encountered on the press.

2. They must have good resistance to abrasion and wear.

3. They must be relatively unaffected by chemicals and solvents which may be used during the printing operation.

4. They must have good oleophilic qualities, and be relatively resistant to water.

5. They must of course offer qualities which make them suitable for rapid and economical platemaking techniques.

The surface characteristics of the lithographic plate are very simply divided into two classes: the *surface plate*, in which the image is formed on the plate surface, and the *sub-surface plate*, in which the image is formed slightly recessed in the plate surface.

Surface plates

Current plates which fall into this classification are those in which the image material is formed on the the plate surface:

1. Dichromated colloids including egg albumen, soybean protein, casein and horse blood plasma.

2. A considerable number of synthetic materials such as photopolymer resins and diazo compounds which are used in the production of presensitised plates.

3. Electrostatically produced plates in which the image is formed by a thermo-setting resin binder.

4. A number of multi-metal plates in which the oleophilic metal (such as copper) is formed on the surface of aluminium, stainless steel or chromium plate.

Sub-surface plates

Under this classification the image material is slightly recessed (about 0·008 mm) below the hydrophilic surface:

1. The classical deep-etch plate in which the image areas are etched into the zinc or aluminium plate surface and rendered oleophilic with a lacquer film.

2. Certain presensitised plates are constructed in layer form with a hydrophilic compound coating which is removed to reveal the underlying oleophilic material.

3. Multi-metal plates which are constructed with the hydrophilic metal on the surface which is removed by etching to reveal the underlying oleophilic metal.

(a)

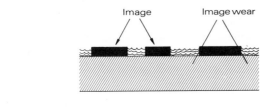

(b) (c)

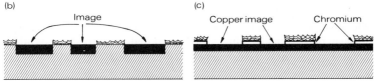

Fig. 57.—Surface and sub-surface plates. (a) Schematic of a surface plate showing area in which breakdown occurs. (b) Schematic of a sub-surface plate. (c) Schematic of the construction of a bi-metallic plate.

Sub-surface plates are considered to give longer press life with less fall-off in image quality than the surface plate. The explanation is found in the construction of the image which on the surface plate is exposed to more wear and may break down at the extreme edges during press runs, with the result that the image becomes progressively sharper (Fig. 57). The sub-surface image is protected from

this kind of press deterioration by the hydrophilic areas which are slightly higher than the image and consequently take most of the wear.

HYDROPHILIC NON-IMAGE AREAS

The treatment of the non-image areas of the plate has not been improved to the same extent as the improvements made in the image-forming materials. Senefelder early discovered that the organic substance, gum arabic, formed a hydrophilic layer on the stone surface when applied correctly. Despite modern research, no single substance has been discovered to take the place of gum arabic which has unusual properties. When a solution of gum is rubbed down to a thin film on to the surface of the plate, a chemical change takes place among the molecules of the gum which are in close contact with the metal surface. These gum molecules become tightly adsorbed on the surface and are insoluble in water. This means that when the plate surface is washed with water, the major part of the gum coating is removed, leaving behind a fine layer of insoluble gum. The chemical change which takes place is thought to be the re-orientation of the carboxyl molecular groups present in the gum. The molecule has a head which has an affinity for oleophilic substances and a tail which has an affinity for water. As the gum dries down the molecules become attached to the plate surface by the head, leaving the water-attracting tail sticking out into the air (Fig. 58).

The promotion of the insoluble gum layer is also believed to be encouraged when a phosphate salt is present, in the gum or on the surface of the plate. This is well attested by experienced lithographers, who have been using phosphoric acid and sodium hexametaphosphate in plate etches and fountain solutions for many years.

The formation of the insoluble gum layer on to the plate surface has been called *desensitisation*, because by its action the natural sensitivity of the metal for oil-based inks is removed. As long as the desensitising layer of gum remains on the surface of the plate the non-image areas will work clean. When the non-image areas become dry and an ink film forms on them (catch-up), the molecules quickly reject the ink and take the water when the plate is washed.

The wearing qualities of the insoluble gum layer on the plate surface are poor. It can be removed or damaged during normal press

use, and may be completely destroyed by abrasives, strong acids or alkalis and strong spirit solvents.

A note about ink solvents such as white spirit: many ink solvents contain molecular groups which will replace the gum molecules to make the non-image areas sensitive to ink, and produce scum conditions. If a desensitised plate is washed with one of these solvents

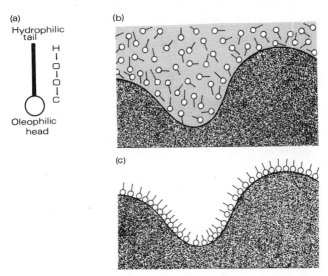

Fig. 58.—The behaviour of the carboxyl molecule in gum arabic. (a) The carboxyl molecule with its hydrophilic tail and oleophilic head. (b) Schematic of a grained plate with a thin coating of undried gum arabic on its surface. Note the random arrangement of carboxyl molecules. (c) The plate surface after the gum has dried and has been subsequently washed off with water. The carboxyl molecules at the plate interface have become adsorbed, with the hydrophilic tail sticking out into the air.

without there being an adequate film of dried gum on the surface (*i.e.* a normal gummed plate) there is every danger that the non-image areas will scum. The same effect can be produced when the printing ink has a high fatty acid content which will produce scum during the press run.

Because of these factors, the plate should be carefully desensitised with gum arabic after processing, and frequently gummed during its press life.

Gum arabic

This substance is a vegetable product obtained from the bark of the acacia tree which grows in the Middle East. The quality used by lithographers comes from the Sudan and exudes from the bark of the tree yielding two crops a year. The second crop is the most suitable, and when picked and graded is known as "Select Gum Arabic Sorts." The chemistry of the gum is not fully understood, although it is known to contain substances such as arabic acid, calcium, potassium and magnesium salts.

Normal gum solutions are made to 10 °Baumé and will retain their desensitising properties when freshly made for approximately twelve hours, after which time the gum deteriorates due to the influence of bacteria and moulds. In conditions of high humidity this deterioration accelerates. Preservatives added to the gum will reduce this deterioration and maintain the desensitising properties for a longer period.

Carboxymethyl Cellulose Gum (C.M.C.)

This is a modern alternative substance for gum arabic, being a sodium salt, or in other words a chemical substance derived from cellulose. It is an organic acid similar to gum arabic, and it reacts with acids in a similar manner. Its main advantage is that unlike gum arabic it can be produced in consistent quality. Its use, however, is limited to aluminium plates and because of this it has not found wide acceptance.

PLATE SURFACE TREATMENTS

Many materials offer themselves as suitable bases for the lithographic plate. On large offset presses metal plates are used because of their dimensional stability. Since the introduction of metal plates in the mid nineteenth century, various methods have been used to make the plate surface suitable for lithographic use.

GRAINING

The change from absorbent limestone to non-absorbent metal made it necessary to prepare the metal surface in such a way as to make it perform in a similar fashion to stone. By roughening the metal surface to produce an even grain the following features are obtained (Fig. 59):

1. The minute hills and valleys of the grained surface provide an anchorage for both oleophilic and hydrophilic materials.

2. The rough surface retains moisture, gives more even damping and slower moisture evaporation than smooth metal.

3. Press roller skid and slip are minimised due to the traction provided by the grain.

4. The surface area of the plate is increased by graining. This means that a grained plate will hold more moisture per unit area than a grainless plate and is thus capable of a higher degree of desensitisation.

Fig. 59.—Enlarged profile of the grained surface of the lithographic plate.

Graining methods are listed below. The tendency in plate-graining is towards methods which give consistent results in evenness of grain and similarity between one plate grain and another.

Graining with marbles

This is the traditional graining method which employs a machine which has a shallow tray into which the plate is clamped. Suitable marbles of steel, glass, wood or ceramic are placed over the plate surface and an abrasive such as sand, aluminium oxide, pumice, etc. is added in limited quantity. The tray is given a sideways shaking motion and a specified quantity of water is added to the abrasive to act as a lubricant during the graining period. The choice of marbles and of abrasive, the speed of the machine and the length of graining time are the variables which determine the type of grain produced.

Sandblasting

Sandblasting produces a fine even grain by forcing wet or dry abrasive against the plate surface under pressure. The choice of abrasive and the time factor determine the quality of the grain.

Wire-brush graining

By this method the plate surface is scoured by rotary stainless-steel wire brushes to produce fine indentations in the plate surface.

Chemical graining

The plate surface is etched to produce a fine grain by applying a strong acid or alkali solution.

Electrochemical graining

Commonly used by some manufacturers in the preparation of pre-sensitised plates, by this method a grained finish is obtained in an electrochemical bath by a process of reduction.

ANODISING

A major difficulty encountered in the use of zinc and aluminium plate has been the readiness with which these metals oxidise during processing and printing. Oxidation occurs when the oxygen in the air combines with the surface metal of the plate in a chemical reaction to produce an oxide of the metal. Whenever a plate is damped and allowed to dry slowly, or when the plate is left in a moist atmosphere oxidation of the plate surface will proceed rapidly. In the case of both metals, the oxide forms in spots and pits which is ruinous to half-tone work. At an early date it was appreciated that if the plate surface was coated in some way to prevent oxygen reacting with the metal the problem would be solved. For over fifty years various chemical plate treatments were marketed commercially. These treatments were applied by the platemaker during processing and by the pressman, often in the press fountain solution. Many of these treatments were relatively successful, but were superseded in the 1950s by the anodised aluminium plate, although the anodised process had been in use for some twenty years before it was applied to the lithographic plate. By this process the aluminium plate to be treated is made the anode conductor in an electrolytic bath. The electric current enters the electrolyte (sulphuric acid) by an insoluble conductor which is connected to the aluminium plate, and leaves by the cathode conductor which is usually made of lead. The oxygen liberated combines with the aluminium plate surface to form a dense film of oxide which is integral with the metal. The amount of aluminium converted to oxide is related to the quantity of electricity passed through the electrolyte, according to Faraday's law.

Anodic films have a microcellular structure, which is hexagonal in shape with a centre pore (Fig. 60). The cells are densely packed together on the plate surface and so prevent further oxidation of the surface. Aluminium oxide produced in this way is extremely tough

(in its natural state it is found as rubies and sapphires, and is used commercially as an abrasive in the form of emery), and it is also transparent. Usually aluminium plate is grained before being anodised, and after the oxide film is formed a further treatment to

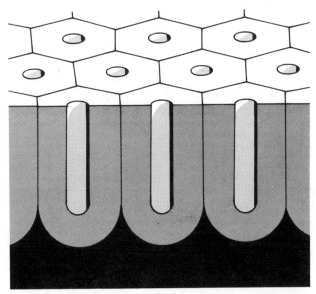

Fig. 60.—Schematic of the closely packed anodic oxide cells formed on the surface of the anodised aluminium plate.

seal up the cell pores is usually applied to give the surface added corrosion resistance. Patent sealing methods to promote a hydrophilic anodic surface have also been developed.

PLATE TREATMENTS FOR PRESENSITISED PLATES

A major difficulty which had to be surmounted in the preparation of the presensitised diazo-coated plate was the chemical reactivity of the diazo compounds with the plate metal. This reactivity seriously limited the shelf life of the coating on the plate. To overcome this the plate surface is normally treated prior to the application of the diazo coating with a compound such as sodium silicate, zirconium gluconate, modified resins or anodic oxide. Certain of these precoating treatments have been selected to give increased hydrophilic characteristics to the plate surface.

Chemical plate treatments applied by the lithographer

Prior to the introduction of the anodised and presensitised plate, a number of chemical treatments for zinc and aluminium plates have been successfully used to make the processing and use of these plates a commercial proposition. *Brunak, Cronak, Nital* and *Patrol* solutions are recommended chemical treatments for removing residual albumen, casein, etc. from surface plates and for establishing a hydrophilic film on the plate surface. These treatments are usually applied to the plate at the platemaking stage and are also renewed during the press run when necessary. With the commercial growth of anodised and presensitised plates, however, these chemical treatments cannot be used unless the manufacturer recommends them.

DICHROMATED COLLOIDS

Dichromated colloid coatings have been the most important photo-lithographic material for over a hundred years. Although these coatings present many problems in their use, and are now largely superseded by modern light-sensitive compounds, a survey of the traditional processes of albumen and deep etch will not be out of place here.

Ammonium dichromate. This is a water-soluble salt obtained by neutralising chromic acid with ammonium hydroxide to form orange-red crystals.

Colloid. This is a crystalline substance which has a large molecular size and which can form an even, continuous film. The molecules are not large enough to be detected with the naked eye, although they can be separated from the solution by a porous membrane filter. The colloids used in platemaking are: egg albumen, casein, horse blood plasma, soybean protein, gum arabic, polyvinyl alcohol and fish glue.

When a solution of ammonium dichromate and a colloid are coated on a plate and dried, exposure to actinic light initiates a chemical reaction in the coating causing it to tan and become insoluble in water to a degree. The photochemical reaction in the coating is complex and is thought to involve the oxidation of the colloid in combination with the chromate salt. In the case of surface plates, the insolubility of the coating is complete and is used to form the image areas of the plate. The partial insolubility of the dichromated gum

arabic, P.V.A. or fish glue, is utilised to form an acid-resisting stencil which is subsequently removed before printing.

Continuing reaction. This term is used to describe the chemical activity which continues to take place in the coating after exposure to light. A brief exposure to light will trigger off this reaction, which will then continue even if the coating is kept in complete darkness.

Dark reaction. This term is used to describe the chemical activity which takes place in dichromated colloid coatings as soon as they are dry. The reaction is spontaneous and the coating gradually hardens off even though it is kept in the dark and is not exposed to light at all. This factor has made it impossible to produce a precoated (or presensitised) plate, as the photographic qualities of the coating deteriorate after about twelve hours at 23 °C.

ALBUMEN PROCESS

The albumen process is over a hundred years old. In the nineteenth century the colloid was prepared by separating the white of egg from the yolk. Formulas in those days began, "Take three dozen fresh eggs ..."! Modern albumen colloids are prepared from egg albumen scales (not powder) which are light amber in colour and smell of dried egg. The colloid is prepared as follows:

1. Measure the correct amount of albumen scales into a cheese-cloth bag and suspend it in a measured quantity of cold water.

2. Leave to soak for at least twenty-four hours until the albumen has passed into solution, leaving the insoluble residue in the bag.

3. Adjust the density of the final solution to the required amount.

4. Add ammonium hydroxide as a preservative if the solution is to be kept for some time before use.

The ammonium dichromate solution should be added to the albumen solution just prior to use.

The following steps should be taken in the preparation of a lithographic plate for the albumen process:

1. Examine the lithographic plate for blemishes.

2. Apply a counter etch liberally over the surface and allow it to stand for one minute.

3. Wash off the counter etch with running water and lightly scrub the surface with a medium bristle brush.

4. Place the plate in the whirler, set the whirler speed and pour the filtered coating on to the centre of the plate until the coating is whirled over the entire plate surface.

5. Without using excessive heat, dry the plate while it is whirling.

6. Remove the plate from the whirler and dry the back of the plate.

7. The coating is now sensitive to light at the blue end of the spectrum, it should therefore be handled under orange safelights.

8. Expose the coating through a negative photographic film, covering all the non-image areas of the plate with masking paper.

9. Apply a thin film of liquid developing ink to the image areas of the coating and rub down until dry.

10. Wash off the unexposed coating under running water using a pad of cotton wool to clear the image areas.

11. Drain off the surplus water and apply a suitable plate etch.

12. Gum up the plate and dry rapidly.

13. Wash out the inked image with white spirit or turpentine and apply a thin film of asphaltum solution to the image prior to printing from the plate.

NOTES ON THE PROCESS

Counter etch

This solution is normally employed with zinc and aluminium plates for chemically cleaning the surface. Standard plates collect a small amount of dust and graining residue in the surface grain, and usually form an uneven oxide layer on the surface metal. The counter etch contains a dilute acid which attacks the metal, removing the oxide and surface residue by forming a salt which is easily washed away with water. The plate should not be scrubbed while under counter etch as this may cause damage to the grain. Modern anodised aluminium plates do not require a counter etch, a vigorous scrubbing with the brush is sufficient.

Whirler coating

Take care to avoid bubbles in the coating while applying the solution to the plate. The speed of the whirling will determine the thickness of the coating. A good coating will cover the peaks of the plate grain, but not be so thick as to make exposure times excessive. A coating

speed of about 80 rev/min will give an adequate coating on a fine-grain plate; coarser grains will require a lower whirler speed.

Exposure

The length of exposure given will depend on the following factors:

1. The density of the non-image areas of the negative. Longer exposures can be given to dense opaque negatives.

2. If the humidity is high the coating will absorb more moisture and so increase the chemical activity of the coating when exposed to light. The higher the humidity, the shorter will be the exposure.

3. The thickness of the coating will affect the length of exposure because the coating must be hardened right through to the plate surface. The thicker the coating, therefore, the longer the exposure.

4. The proportion of dichromate in the coating will determine the sensitivity of the coating to light. The more dichromate present in the coating the faster the coating is to light. If the proportion of dichromate to albumen exceeds the ratio 1 to 3 the dichromate may crystallise out to form fern-like patterns in the coating, making it useless.

5. The actinic value of the light used to expose the coating will determine length of exposure. Dichromated colloid coatings are sensitive to the violet wavelengths of the spectrum; wavelengths greater than 600 nm have a limited effect.

6. The more alkaline the coating the less sensitive it is to light. The addition of ammonium hydroxide as a preservative to the solution will change the colour from deep orange to pale yellow and also raise its pH.

Development

The water development of the coating should not be too easy. Rapid development may indicate an insufficient exposure, or a coating which is too thick. Warm water will help to clear stubborn coating, as will a 2 per cent solution of ammonium hydroxide.

Asphaltum

This natural pitch solution is selected because it has oleophilic non-drying properties. An inked image may dry over a long period with the result that it will lose its greasy nature, crack or peel off, leaving the image with little protection. Asphaltum solution does not deteriorate in this way.

D

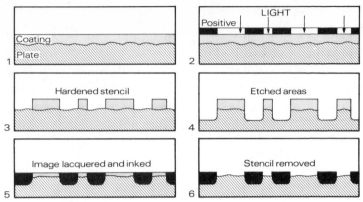

Fig. 61.—Steps in the making of a deep-etch plate.

DEEP-ETCH PROCESS

Gum arabic/dichromate coatings do not become completely insolubilised when exposed to light. This facility is utilised in the positive reversal process under the misnomer "deep etch," a misleading term because the depth of etch is not easily discernible with the naked eye. The dichromated gum coating is exposed through a photographic film positive and the unexposed coating developed away to leave an acid-resistant stencil on the plate. The image areas are etched to about 0.008 mm and an oleophilic lacquer film is formed as an ink base in the etched portions of the plate. The process is still regarded as the best method of making long-run aluminium plates, and in its modified form is used to process a number of multi-metal plates. The following steps should be taken when preparing a plate for the deep-etch process (Fig. 61):

 1. Prepare the plate in the same manner as for albumen coating.

 2. Filter the coating.

 3. Set the whirler speed and coat the plate. Wipe the back of the plate when removing from the whirler.

 4. Handle the plate under orange safelights after coating.

 5. Expose the coating through a film positive. Non-image areas must be completely hardened by light.

 6. Stop out unwanted areas with stop-out solution.

 7. Develop the image until it reproduces the form of the photographic positive exactly.

 8. Apply the deep-etch solution and etch for a specified time.

 9. Wash the plate surface clean with anhydrous alcohol.

10. Dry the plate quickly and thoroughly.

11. Apply the gum-based stop-out solution to unwanted areas and dry off.

12. Rub down a thin film of image-forming lacquer in the image areas and dry off.

13. Rub down a thin film of inking-in solution to image areas and dust with talc.

14. Remove the gum stencil under running water.

15. Apply the plate etch and gum up the plate.

NOTES ON THE PROCESS

Coating

If the coating is too thick, it may be difficult to harden through to the plate surface, with the result that the developer may undercut the stencil. Coating which is too thin may allow the peaks of the grain to develop out, resulting in over-all scumming of the non-image areas (this is known as "photo scum").

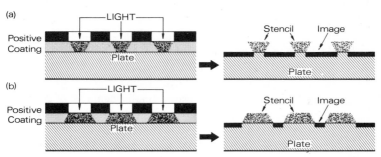

Fig. 62.—The half-tone dot. (*a*) An example of how an under-exposed coating produces an enlarged half-tone dot. (*b*) Over-exposure of the coating producing a reduced half-tone dot.

Exposure

Insufficient exposure will leave the base of the coating unhardened with the possibility of the developer undercutting the stencil. This will result in an enlarged half-tone dot. Over-exposure will have the effect of enlarging the stencil boundaries, thereby causing the half-tone dot to be reduced in size (Fig. 62).

Development

The active ingredient in the developing solution is water, which is held under control by a salt. The salt has the effect of holding the water

molecules, leaving only a limited proportion free to dissolve the unexposed gum coating. Many developer formulae contain a deliquescent salt such as calcium chloride which will extract moisture out of the atmosphere. For this reason the developer container should be kept closed, and developer pads and brushes kept in a dry atmosphere.

The activity or speed of the developer is governed by the proportion of water in the solution (the density of the solution indicates this), and this may be influenced by the prevailing humidity.

Etching

At the end of the development stage the plate may be washed with alcohol and dried. The stencil can then be exposed to light in order to harden the coating further and give it acid resistance. This is of particular value when using the strong etches required for multimetal plates.

Spirit wash

The thorough removal of the etching solution from the plate must be done with great care. A water-free (anhydrous) alcohol is applied to the plate, and disposable wipes used to clean the surface. Several applications are necessary, and the wipes should be used in a circular motion beginning at the plate centre and moving outwards to the edges of the plate. This is to ensure that the residual chemicals picked up by the wipes are progressively removed from the centre to the edges of the plate. The alcohol will absorb small quantities of moisture from the air and from the residual chemicals. If allowed to dry at room temperature the alcohol may evaporate, leaving tiny globules of moisture on the plate. At low temperatures and high relative humidity the evaporation of the alcohol may so lower the plate temperature as to cause moisture to condense on the plate. For these reasons rapid drying of the plate with a warm-air blast is recommended.

Stencil removal

This can be speeded up if warm water is used and a medium bristle brush employed. A mild acid solution such as 2 per cent sulphuric acid or citric acid will quickly clear the stencil away. A 2 per cent phosphoric acid solution is recommended for clearing the stencil on plates which require no further touching up, as this will promote the conditions which are favourable to good plate desensitisation.

Copperising the deep-etch plate

An extended image life is given to the plate by the chemical application of a fine copper film to the image areas. Copper is an ink-attracting metal and it has good abrasion resistance. The copperising solution is applied after the spirit-wash stage and worked over the image areas with a felt pad until the reddish copper deposit is formed. When complete, the plate is given a further wash with alcohol, the image inked, and the process completed in the usual manner. Copperising is not recommended for zinc plates and cannot be carried out on anodised plates.

P.V.A. AND POLYMER DEEP-ETCH COATINGS

A number of modern plastic materials are now being used as a substitute for gum arabic. The main advantage that they offer is the greater freedom from difficulties encountered with gum coatings during changes in relative humidity. These plastic-based coatings, such as polyvinyl alcohol (P.V.A.), are used in a similar fashion to gum deep-etch but are developed under running water, leaving a stencil which has greater acid resistance than gum has. This makes them very suitable for use in the processing of multi-metal plates. The P.V.A. process has not been very successful in this country despite the advantages that it offers to platemakers in the variable English climate. Very little latitude is allowed to the platemaker at the development stage in the control of half-tones, however, and the swelling of the stencil often results in a sharper image being formed.

Further development of the plastic-based coatings has resulted in a number of "water-wash" deep-etch processes being offered to the printer who is troubled with humidity variations.

PRESENSITISED PLATES

With the discovery of the light-sensitive silver salts in the mid nineteenth century, there arose a feverish activity to discover other light-sensitive materials which would serve photographic requirements. The important group of diazo compounds was discovered in 1858 by the chemist P. Griess, but it was not until Gustave Kogel of Munich applied these compounds to photocopying during the 1920s that any real advance in their use was made. The commercial presensitised plate was first introduced by an American company in 1950. This plate was made of paper with a light-sensitive coating of a diazo

compound mixed with a colloid. Since that time various diazo com-
pounds have been found to make satisfactory image materials
without mixing the compound with a colloid. Light-sensitive resins
(photopolymers) have also been employed successfully, and the
expansion of lithography in recent years can be traced directly to the
introduction of these new materials. Unhappily, from our point of
view, little can be said about the chemical structure and processing of
presensitised plates. The number of diazo compounds known can be
counted in thousands, of which a small number have been selected
for making lithographic plate coatings. All the commercial brands of
diazo and photopolymer sensitised plates are covered by patent
rights which prevent us from making more than a general assessment
of their particular qualities.

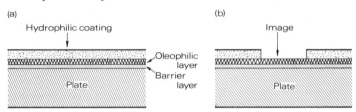

Fig. 63.—Schematic of a sub-surface presensitised plate. (*a*) The diazo
resin is mixed with a hydrophilic colloid such as polyacrylamide to
form the upper layer of the plate. (*b*) After exposure through a positive
the unexposed image areas are developed away to reveal the under-
lying oleophilic layer.

The presensitised plate is simply a precoated light-sensitive plate.
The plates are coated under factory conditions, packed in light-tight
wrappers and delivered to the platemaker ready for exposure. The
average shelf life of the plates extends beyond twelve months, and
because of mass production they are offered to the printer at eco-
nomical rates. The printer in turn is able to process the plates with-
out elaborate equipment.

Most of the presensitised plates fall into the category of surface
plates, although a sub-surface layer plate has also been developed
(Fig. 63). Certain characteristics of the light-sensitive materials used
for presensitised plates have been assessed and are as follows:

Diazo resins

These compounds (*a*) are water soluble; (*b*) form an insoluble image
when exposed to actinic light; (*c*) produce an image with oleophilic
characteristics; (*d*) are normally negative working.

Diazo oxides

These compounds (*a*) are water insoluble; (*b*) can be selected to give positive- or negative-working plates. Negative-working compounds permit the removal of unexposed coating with an acid-based developer. Positive-working compounds permit the removal of the exposed coating with an alkaline-based developer.

Photopolymer resins

The molecules of these specially developed resins crosslink (or polymerise) when exposed to actinic light. The crosslinking produces a rigid insoluble structure which is integral with the surface of the metal plate. These resins are selected for their hard-wearing qualities and oleophilic characteristics, and are negative working.

Positive-working photopolymer plates have also been developed. These function in much the same manner as the diazo oxides in that the exposed areas of the coating become sufficiently unstable to permit removal with a developer solution. The photopolymer resin plate is expected to permit greater development potential in the future than is possible with the diazo compounds. Photopolymer resins are harder wearing than diazo compounds and give a longer press life with less breakdown of the image quality in runs in excess of 100 000 copies.

With the considerable number of presensitised plates now manufactured, it is impossible to list the processing steps for these plates without considering the various commercial brands individually. However, the following points can be made:

1. The manufacturers' directions for processing, and his recommended chemicals must be used.

2. In general over-development is not a danger with negative-working plates.

3. Additions to the plates cannot be made photographically because the manufacturer does not supply the coating solution.

4. The plates cannot be re-used if a fault is made during processing.

5. Plates should be handled with care immediately after development because the image-forming material may be saturated with solvent and will not become hard until the solvent has evaporated.

LACQUER IMAGE PROTECTION

To increase the press life of the presensitised plate, a thin film of lacquer is often applied to the image areas of the plate. The lacquer serves to protect the plate and imparts added oleophilic qualities to the image. The lacquer may be applied in the following ways:

1. The lacquer is dispersed in an emulsion of gum arabic, phosphoric acid and the developing solvent. During the operation of development the non-image areas are desensitised and the film of lacquer built up on the image all in one step.

2. The lacquer is applied to the image subsequent to development by rubbing up the image with the lacquering solution until an adequate film is built up. This type of application enables the pressman to reinforce the image at intervals during the run. Care must be taken to avoid thickening half-tones which may ruin tonal values.

3. The presensitised coating is covered by a surface lacquer film during manufacture. When the plate is processed, the developer removes the non-image coating together with the lacquer film, leaving the lacquer only on the image areas. This type of image reinforcement is recommended because the lacquer is applied under controlled factory conditions.

PLATES SENSITISED BY THE PLATEMAKER

WIPE-ON-PLATES

These plates are sensitised with diazo compounds similar to those used for presensitised plates. The plate itself is usually metal (aluminium) and the surface carries an inert coating which acts as a barrier between the diazo compound and the metal. The sensitising compound is applied to the plate by smoothing the solution over the surface with a sponge or lint-free pad. Where a large number of plates are required the coating may be applied by whirler or by a simple roller-coating machine. When applying the coating with a pad care must be taken to avoid smoothing the plate when the coating becomes tacky—otherwise lint and fluff may be torn from the pad and become attached to the coating. A slightly streaky coating will not have a detrimental effect, but a poor coating may be washed off and the plate recoated. When preparing large plates the coating need only be applied to the areas where the images are required.

Courtesy: Coates Brothers & Co. Ltd.

Fig. 64.—Exposure of a Coates speedichrome plate while fixed to the press-plate cylinder.

The coating must be thoroughly dry before exposure, and this may be achieved either by allowing the plate to stand for a period, or by warming with a warm-air hand-fan. Coated plates may be kept for three or four days before exposure with no detrimental effects. Plates are exposed and processed in the normal manner. Wipe-on plates offer the advantages of being processed without the need for a whirler, and have the added benefit that the plate can be recoated if additional work is required on a finished plate. Special exposing units have been developed which permit additional work to be added to the press plate while it is still clamped to the press cylinder (Fig. 64).

Wipe-on plates are available in either negative- or positive-working form.

PRECOATED PLATES

This type of plate is a recent development, and it may be a major factor in the disuse of whirler coatings for deep-etch and bi-metal

plates in the future. The precoated plate is supplied by the manufac-
turer with a factory-applied coating which is not sensitive to light,
and has an indefinite shelf life. The plate can be handled safely in
daylight and it does not require light-tight wrappers. When required
for use the plate is sensitised by applying a liquid sensitising solution
to the plate surface with a sponge. The sensitising liquid is absorbed
into the plate coating, and when dry the plate is exposed through a
positive to produce a tough stencil; processing similar to the deep-
etch process completes the plate.

BI-METALLIC PLATES

The idea of using a metal which has oleophilic characteristics to form
an image on the lithographic plate is about fifty years old. Many
metals can be made hydrophilic and a few metals can be made
oleophilic with suitable treatment. All bi-metal plates produced today
are prepared by forming electroplated layers on a base metal which
may itself be chosen for its lithographic qualities.

Extensive research into the oleophilic and hydrophilic surface
qualities of various metals has resulted in the manufacture of multi-
metal plates in which two metals function lithographically (hence the
correct term for these plates: "bi-metal"). Often a third metal or
plastic acts as a support for the lithographic metals.

PLATE CONSTRUCTIONS
The following table shows metal combinations of plate construction:

Base metal	Non-image metal	Image metal	Type
Stainless steel	Stainless steel	Copper	Surface plate
Aluminium	Aluminium	Copper	Surface plate
Plastic	Aluminium	Copper	Surface plate
Mild steel	Lead	Copper	Sub-surface plate
Mild steel	Chromium	Copper	Sub-surface plate
Aluminium	Chromium	Copper	Sub-surface plate
Brass	Chromium	Brass	Sub-surface plate
Brass	Phosphorus nickel	Brass	Sub-surface plate

PROCESSING
Sub-surface plates require a light hardened acid-resistant stencil to be
formed in the non-image areas of the plate. The hydrophilic metal

(such as chromium) is etched away to reveal the underlying oleo-philic metal (brass or copper).

Surface plates require a light hardened acid-resistant stencil to be formed in the image areas. The oloephilic metal (copper) is etched away to reveal the underlying hydrophilic metal (stainless steel or aluminium).

The plate manufacturers have different processing methods for their plates, some of which are prepared in presensitised and pre-coated form.

Surface plates

In processing surface plates using deep-etch gum coating the follow-ing steps are taken:

1. The copper surface of the plate should be cleaned thoroughly with a 4 per cent sulphuric acid solution and the use of a fine abrasive such as Tripoli powder.

2. Coat the plate with gum coating in the manner used for deep etch. Thinner coatings are usually obtained with smooth-surfaced plates.

3. Expose the plate through a negative.

4. Develop the coating with deep-etch developer.

5. Clean wash the plate with alcohol and dry. Re-expose the plate to light to harden the stencil.

6. An etching solution containing ferric chloride or ferric nitrate is used to remove the copper until the underlying metal is revealed.

7. Remove the stencil by scrubbing under running water.

8. Sensitise the copper image by applying a 5 per cent sul-phuric acid solution and rub up the image with a suitable ink before gumming the plate.

Sub-surface plates

In processing sub-surface plates using deep-etch gum coating the following steps are taken:

1. Clean the plate thoroughly with brush and water.

2. Coat the plate with deep-etch gum coating.

3. Expose through a positive.

4. After normal development, clean the plate surface thoroughly with alcohol and re-expose the plate to light to harden the stencil.

5. Apply a suitable chromium etch until the chromium layer is removed from the image areas.

6. Remove the stencil by scrubbing under running water.

7. Sensitise the copper image with a 5 per cent sulphuric acid solution and rub up the image with a suitable ink before gumming the plate.

Due to the toxic fumes produced during the etching period the processing should take place in a trough which has fume-extraction facilities.

Processing the bi-metal plate requires the same care as is given to deep-etch plates. Special attention must be given to the etching stage to see that the stencil is not undercut by prolonged etching.

PLATE CORRECTIONS

At some time or another, it will be found necessary to make corrections to the finished plate. With the cheaper type of plate, the time spent on making corrections may be more costly than making a fresh plate. Larger plates, especially bi-metal plates, are certainly worth the time making the corrections so long as the work done will last for the life of the plate.

Corrections involve the addition of fresh work, or the deletion of unwanted work on the finished plate.

ADDITIONS

These can be made in the following two ways:

1. *By printing down.* The plate is recoated in the normal manner and the additional work printed down in the correct position.

2. *By hand techniques.* This method is limited to the repair of broken lines and solids, and the hand drawing on to the plate using lithographic crayon and drawing ink.

Broken lines and solids can be made good by scratching, scoring or burnishing the areas requiring attention while the plate is under a film of dried gum. After adding the work in this way, the corrected areas are covered with a thin film of asphaltum which will cause them to take ink on printing.

Drawn work can be applied to the plate after the surface has been counter etched and carefully dried. The clean metal readily accepts the drawing ink or crayon, and the plate must be thoroughly

desensitised and gummed before use. This method is not suitable on anodised plates or on plates required for high speed and long runs.

Bi-metal plates

Surface plates. The additional work can be made by using a copperising solution in conjunction with an electrolytic kit supplied by the manufacturer of the plate.

Sub-surface plates. Additions can be made by recoating the plate and printing down the correction and processing in the normal manner. Fine lines and solids can be made good by carefully removing the upper layer of the hydrophilic metal with a scriber or knife.

DELETIONS

These can be made in the following two ways:

1. *By physical treatment.* By using an abrasive such as pumice powder or pumice stick, correction rubber, glass brush, snake slip, etc., the image may be destroyed. When making a deletion of this nature the plate should be treated with a suitable desensitising plate etch followed by thorough gumming to ensure that the area will not take ink on the press. Avoid vigorous use of the abrasive which may damage the plate grain in the area of use. This will only cause additional problems of local scumming during the print run if the grain fails to hold moisture adequately.

2. *By chemical treatment.* A chemical solution can be applied which will destroy the ink receptivity of the area without damaging the grain, and is recommended for long-run plates. Before applying the chemical solution, remove the ink from the unwanted area and thoroughly degrease it with a strong solvent such as methyl ethyl ketone (M.E.K.). Special plates may require the plate manufacturer's deletion solution to prevent damage of the plate surface. A deletion solution for ordinary aluminium plates can be made by preparing a 50/50 solution of amyl acetate and hydrochloric acid (38 per cent).

After the deletion has been made the plate must be desensitised and gummed up.

Bi-metal plates

Surface plates. Deletions are simply made by applying the copperetching solution locally to the unwanted areas.

Sub-surface plates. Deletions are made by recoating the areas requiring attention with the hydrophilic metal using the electrolytic kit supplied by the plate manufacturer.

When making any chemical deletion, the plate should be under a film of dry gum arabic. The deletion area can be isolated from the rest of the work by placing adhesive tape round the area or by painting round with deep-etch stop-out lacquer.

QUALITY CONTROLS IN PLATEMAKING

A variety of platemaking aids are now available to assist the plate-maker in obtaining, and maintaining, good-quality plates. A few of these aids are listed below.

STEP WEDGE

The step wedge is a strip of photographic film which contains a number of density steps ranging from solid to clear. Both contin-uous-tone and half-tone wedges are used.

The continuous-tone step wedge

This wedge can be made by modifying the *Kodak Step Tablet No. 2.* The tablet is about 26 mm wide and contains twenty-one density steps; each step differs from the next by a density factor of 0·15. Cut the strip into two 13-mm strips and number each step on the strips from 1 to 21, beginning at the clear end of the wedge. Numbering may be done with Indian ink or by scribing the numbers on the film side of the wedge and filling in the marks with black crayon. Ready-made step wedges may be obtained commercially.

When making a plate the wedge should be placed outside the trim area of the work, and if possible as close to the centre of the plate as the work will allow. When a correct exposure has been obtained on the test plate, and the plate processed, the step wedge should be partially formed with the first solid step showing clearly. Let us say that the number of this solid step is 7. Correct exposures on all subsequent plates will yield a solid 7 on the step wedge. Any devia-tion from this norm will immediately inform the platemaker that there has been a change in the exposure time. The use of the wedge in this way is limited to those plates which form an image solely by exposure to light.

With plates which require a developing stage to form a stencil,

such as the deep-etch process, the wedge is used to evaluate correct development time. The correct exposure and development are ascertained by making a test plate. The nearest solid step on the wedge is then noted and this becomes the standard for all subsequent plates. Deviation from this norm, which may result in a change in tonal values on the plate, is readily seen by checking the solid step on the wedge.

Half-tone step wedge

This wedge is usually prepared by the works graphic reproduction department to conform with the type of work printed in the firm. The half-tone steps range from a highlight dot of about 5 per cent through a range of middle-tones to a shadow dot of about 95 per cent. The range chosen will depend on the type of work printed, for example on coarse surface paper such as newsprint the best highlight dot reproducible may be limited to 10 per cent and the best shadow dot to 85 per cent. A wedge within this range is, therefore, more suitable as a quality control.

When making a test plate the half-tone step wedge is placed alongside the continuous-tone wedge. Evaluation of the correct exposure or development time is made by viewing the reproduction of the half-tones as follows:

1. Broken highlight dots will indicate under-exposure with negative-working plates, and over-exposure with positive-working plates. On deep-etch-type plates the broken highlight indicates inadequate development.

2. If the shadow dot areas appear solid this indicates over-exposure with negative-working plates and under-exposure with positive-working plates. On deep-etch-type plates solid shadow tones indicate over-development.

The ideal reproduction of the half-tone step wedge will give half-tones in the exact proportions as are found on the wedge. This information is then correlated with the step formed on the continuous-tone wedge and a standard exposure and development time can be set.

STAR TARGET

This aid can be successfully employed to give a rapid and accurate visual evaluation of the quality of the lithographic plate. The target is

cleverly designed in the form of a wheel (Fig. 65 (a)). The thirty-six wedge-shaped spokes of the target become progressively finer as they near the centre of the target, but do not touch each other. An interesting feature of the target is that its design magnifies defects by approximately 23 times, for example, a half-tone dot increase or decrease in size of about 0·025 mm which may be undetected by the eye will show up as a defect of 0·58 mm in the centre of the target.

The target is placed in strategic positions outside the trim areas of the work and, as the diagrams show, will indicate dot gain or loss in the following ways:

(b) An increase in dot size will result in the centre of the target showing a solid area.

(c) A decrease in dot size will result in the centre of the target showing an open area.

(a) (b) (c)

Fig. 65.—The star target used for quality control. (a) The star target. (b) Increased dot size. (c) Decreased dot size.

This increase or decrease in half-tone dot size may be the result of incorrect exposure or development of the plate. It may also be caused by poor contact between the flat and the plate during exposure.

Other aids for checking plate reproduction and printing quality are available. In most cases these are designed in such a manner that when thickening or slurring of the image occurs the fine lines in the design close up to form a number or letter which is easily visible. A sharpening image has the reverse effect on the design, causing other figures or numbers to appear as the fine lines or dots in the aid become broken and separated.

USE OF PLATEMAKING EQUIPMENT

THE PLATE WHIRLER

This piece of equipment consists essentially of a motor-driven turn-table on which the plate is clamped and coated. The turn-table is enclosed in a housing with a hinged lid which also carries a hot-air drier unit.

Two types of whirler are in use: *horizontal whirlers* are used for coating plates, plastic sheet and glass, and *vertical whirlers* are used for coating plates and are valuable for their space-saving design.

The turn-table speed is controlled by a positive variable-drive motor and the revolutions per minute are indicated on a dial. The hot-air drier unit is usually screened to prevent dust particles from being blown on to the plate during the drying period.

Establishing correct whirler speed

Suitable plate coatings are obtained by making a few test plates. High whirler speeds produce thin coatings, low speeds produce thick coatings. The coating must be thick enough to cover the entire plate adequately, including the peaks of the grain. Thick coatings require long exposures. Aim at producing an adequate coating with low exposure times. Once a standard speed has been settled, the speed should be noted and all subsequent plates coated uniformly.

Coating

In the majority of cases light-sensitive coatings are applied by pouring the solution from a vessel held in the hand. The following hints will enable the platemaker to obtain good coatings:

1. Make sure the pouring vessel is free of dried coating before filling with fresh solution.

2. Fill the vessel to within 10 mm of the top. This will make it easy to remove bubbles and floating bits before pouring.

3. Make sure that the plate is wet all over before pouring on the coating, allowing the water to run on to the plate until coating commences.

4. At the moment of coating, raise the whirler speed to the correct level, remove the water flow and pour the coating on to the centre of the plate. Keep the vessel as close to the plate as possible when pouring. This will eliminate the possibility of splashing and bubbling. Pour a large quantity of coating on to the plate as

quickly as possible. This will ensure that the water lying on the plate surface is pushed off by the wave of coating spreading over the plate. If the coating is poured slowly the water on the plate will mix with it making it thinner.

5. When the coating solution has been poured out, stop the whirler and examine the coating for blemishes, bubbles and spots. Wash off poor coatings and start again.

6. Set the whirler speed for drying, and lower the lid of the whirler without bumping or jarring.

7. As soon as the plate is dry, switch off the heater. Do not cook the coating.

8. Clean the whirler regularly. Pieces of dry coating often detach themselves from the lid and sides of the whirler during coating and may ruin it.

VACUUM PRINTING-DOWN FRAME

This piece of equipment is used for exposing the flat to the sensitised plate. The base of the frame contains a flexible rubber sheet (called a "blanket") which has a raised rubber beading round its perimeter. The upper part of the frame consists of a sheet of flawless plate-glass which is mounted on hinges or a slide to allow it to open and close upon the rubber blanket. When in use the prepared flat is correctly positioned in the frame, the glass top closed down and locked to the base. A vacuum pump is connected by tube to the inner section of the blanket, and when switched on it removes the air from the frame compartment. As soon as a vacuum is created in the compartment the flexible rubber blanket collapses to the glass under atmospheric pressure, thereby forcing the flat into close contact with the plate coating. After exposure the vacuum pump is switched off and the vacuum in the frame broken by opening a valve. The glass lid is now raised carefully and the plate removed for processing. The following points should be noted:

1. The glass must be kept perfectly clean and free from scratches. When cleaning use a soft cloth and powder-free glass cleaner. Cleaning solutions containing powder may have an abrasive action on the glass, and when dry the powder may contaminate the frame during exposures.

2. Good contact in the frame is important if light undercutting of the flat is to be avoided. Sufficient contact is often indicated by

the formation of irregular coloured rings (Newton's rings) between the glass and the flat. Although the vacuum gauge may indicate sufficient vacuum this could be related only to the area round the vacuum outlet in the blanket.

3. Complete vacuum in the frame is never required. A pressure of 1 atm (101·325 kN/m²) over the frame surface will approximate to a thrust of 7 tonnes on the glass. Any irregular surface

Courtesy: Pictorial Machinery Ltd.

Fig. 66.—Xenon discharge lamp.

within the compartment at such a pressure will break the glass. Atmospheric pressure is often rated on vacuum gauges as 760 mm of mercury. Normal frames obtain good contact at half this pressure: 380 mm of mercury.

4. The rubber blanket often has an irregular stipple or corrugated surface to aid in the evacuation of air from the frame. This irregular surface may make slight indentations on thin aluminium

plates, and can be avoided by placing a thick sheet of manilla paper beneath thin plates before use.

EXPOSING LAMPS

A variety of lamps emitting radiation of short wavelength are used for exposing sensitised plates. These lamps include the carbon arc,

Fig. 67.—Spectral energy curves. Comparison between the spectral sensitivity of (a) a typical photopolymer coating, (b) dichromated gum, and between (c) spectral emission of the carbon arc-lamp, and (d) pulsed xenon discharge lamp.

and modern discharge lamps such as mercury vapour, xenon (Fig. 66), and metal halide. Spectral energy curves can be seen in Fig. 67.

Lamp distance

The distance of the lamp from the frame will depend upon the area to be exposed to light. As a general rule the lamp should be placed at a

distance from the frame not less than the diagonal of the area to be exposed. Even at this distance the centre of the exposed area may receive about 30 per cent more light than the corners. The further the lamp is placed away from the frame the more even the illumination, but as the light intensity drops with distance, so exposure times will necessarily rise.

Standard exposure times are calculated by making test plates (*see* page 93).

Inverse square law

Often it becomes necessary to alter the lamp distance to accommodate different plate sizes which are to be exposed. As the lamp distance is altered so also will the intensity of the light falling on the plate change. A new exposure time is required if a standard plate exposure is to be maintained. There is no need, however, to make a

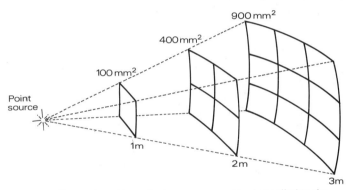

Fig. 68.—Illustration of how the inverse square law is applied to the illumination of an object from a point source of light.

fresh test plate when changing the lamp distance. The radiation of light from a point source follows a mathematical law called the "inverse square law" which is defined as follows:

The illumination of a surface by a point source of light is inversely proportional to the square of the distance from the source (Fig. 68).

In practical terms this means that when the lamp is moved to a new distance the new exposure time can be calculated by squaring

the new distance and dividing it by the square of the old distance, and multiplying the result by the old exposure time. As an equation it looks like this:

$$\frac{ND^2 \times OE}{OD^2} = NE$$

where ND = new distance;
$\quad\quad OD$ = old distance;
$\quad\quad OE$ = old exposure time;
$\quad\quad NE$ = new exposure time.

INTEGRATING LIGHT METER

It is not uncommon for discharge lamps to lose their intensity with age or during a drop in voltage. Carbon arcs often splutter and fail during an exposure. With variations in light intensity taking place during exposure it is obvious that plate quality may suffer if exposure time is calculated by minutes and not by light intensity. The integrating light meter consists of a photocell which monitors the intensity of light falling on the cell, and a meter which converts this evaluation into numerical terms. Units used in platemaking are coupled with the lamp circuit. The photocell is placed on the vacuum printing-down frame at a point where it is illuminated during plate exposure. A digital counter is often incorporated in the unit and this records the light intensity in suitable units. The counter can be pre-set to switch off the lamp after a certain level of illumination has fallen on the photocell. Should the lamp fail during the exposure the digital counter indicates the amount of exposure still required.

SAFELIGHTING

Safelighting in the form of orange or yellow lights is recommended for general illumination of the platemaking-room (Fig. 69). When using new light-sensitive materials such as presensitised plates it is always a good plan to test the plate sensitivity against the room illumination. The test plate should be placed on a working surface and strips exposed at intervals of three, four, five and six minutes, to the normal room lighting. When processed the plate will show clearly how long a plate may be exposed to room lighting without detrimental effect.

Courtesy: Hawthorn Baker Ltd.

Fig. 69.—A suitable platemaking-room layout for small presensitised plates.

PLATEMAKING BY PROJECTION

The production of large posters usually involves the making of a number of large machine plates, each of which will carry a portion of the image (*see* Chapter 2, page 64). To overcome the problem of registering one poster sheet to another on the poster-hoarding, the entire poster is planned as one unit and portions of this are made into separate plates and printed. The following procedure is used for making large plates by projection.

PLANNING

A proof of the original art work for the poster is prepared in full colour, approximately one-seventh the size of the finished poster. The planner divides this proof into suitable sections which will each represent a four-sheet area if possible. Adjustments are made to avoid cut lines falling through the centre of detail half-tone and fine lettering. The trim marks for each section are located on the proof sheet with provision made for weather overlapping edges of about 6 mm. A negative one-seventh the finished poster size is produced with a half-tone screen of 150. A glass negative is used because the heat of

the projector lamp may cause film to alter its dimensions during exposure. The negative is masked according to the planned sections and each section exposed on the large plates in turn.

PROJECTOR

The construction of the projector is similar to a gallery camera. It has a lamp-housing, condenser, negative-holder, lens and a vacuum

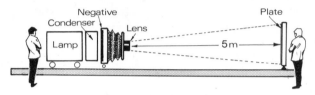

Fig. 70.—The typical construction of a projector used for poster platemaking.

back-plate platen (Fig. 70). The projection unit is adjustable to obtain variation of image size, and the plate platen can be moved horizontally or vertically to allow the projected image to fall in the correct position on the plate.

EXPOSURE OF THE PLATE

The sensitised plate is fitted to the platen and taped round its edges to effect a vacuum, thus pulling the large area of the plate into good contact with the platen. A mask is placed round the edge of the plate to allow for paper gripper edge and suitable side clearance. The platen is moved by micrometer adjustment to allow the projected image to fall on the plate in the precise position required.

Exposure time varies with the type of plate used, but is generally in the region of fifteen minutes or more.

Poster production usually consists of short press runs of approximately 8000 to 10 000 copies, with the larger 48- and 64-sheet posters of lower quantity than this. Because of this it is not uncommon to find the use of albumen coatings and coarse-grained zinc plates, which permit further hand drawing on to the plate by a lithographic artist.

Poster production by projection is a specialised craft and few printing establishments using these techniques are to be found in the United Kingdom.

PROOFING

In the preparation of a job for printing it is common for the customer to supply the lithographer with many pieces of art copy, transparencies, line-work, etc., which have to be photographed, enlarged or reduced in size, colour pictures which have to be separated and screened, and the whole planned to the customer's satisfaction before the actual production can commence. In order that mistakes and errors can be removed and the layout approved before printing, a set of proofs are prepared for the customer's examination, for all printing departments to consider and for the job of costing.

The following two common techniques of proofing are used:

1. Proofing with photomechanical aids.
2. Proofing with ink by a special printing operation.

PHOTOMECHANICAL PROOFING

Proofs prepared under this heading are usually made in the graphic reproduction or platemaking departments, and consist of preparing a copy in monochrome or full colour from the original by photographic means. Copy proofs in one colour are usually made on diazo sensitised paper which require that the film flats are exposed to the paper and processed in an ammonia-fume processor unit. Lithographic proofing, however, is normally confined to the production of full-colour proofs and it is this which will be considered.

Photomechanical colour proofing falls conveniently into the following two classes:

1. *Overlay systems*, which utilise transparent films, one for each process colour, magenta, cyan, yellow and black, which are placed one on top of the other in register to give a quantitative effect.

2. *Superimposure systems*, in which a common base material is used upon which the process colours are built up in the same manner as colour printing.

Overlay systems

These proofing systems require that a thin film of transparent plastic is processed to produce a positive image in each of the process colours. When separate films of magenta, cyan, yellow and black are produced, they are laid one on top of the other in good register, and

the whole taped to a sheet of white paper for viewing. The following two methods are used:

1. Thin film of approximately 0·05 mm is supplied which has a presensitised coloured coating on its surface. The colours approximate the process colours. After exposure to a negative or positive the non-image coating is developed away to leave the image in transparent colour.

2. Clear transparent film of about 0·05 mm thickness is coated with a light-sensitive material, dried and exposed through a positive. The unexposed image areas are developed away and a coloured dye applied to dye the image to the correct colour.

Superimposure systems

These systems utilise a single opaque-white base sheet on to which process coloured images are superimposed in register. The following four methods are used:

1. A rigid opaque-white sheet of plastic is coated with a light-sensitive material and exposed to a positive. The unexposed image areas are developed away and the process colour dye applied to form an image on the plastic surface. The exposed coating is removed and the plastic recoated and the process repeated for each colour until a full-colour proof on plastic is obtained.

2. A white sheet of gloss or opaque plastic is coated with a solution which approximates a process colour. The coating is exposed through a negative and the unexposed coating removed to leave the image in colour. The sheet is recoated with another process coloured solution and the procedure repeated until a full-colour proof is obtained.

3. Sheets of presensitised coloured emulsion paper are exposed to a negative and the emulsion transferred to a white plastic base sheet. This is done with each process colour until a full-colour proof is obtained on the plastic base sheet.

4. A special paper with a photoconductive coating on its surface is charged with static electricity. The paper is exposed to a positive and the light falling on the non-image areas causes the static charge to leak away, leaving a charge on the image only. The sheet is immersed in a bath of solution which is dyed to match a process colour. The dye takes to the charged areas and the sheet emerges with the image in one colour. The process is repeated for

each process colour using the same sheet until a full-colour proof is obtained.

Both the overlay and superimposure systems are made easier with the use of a punch-register system for obtaining good register between the individual colours.

PROOFING WITH INK

This aspect of proofing is more familiar to the lithographic pressman as is, of course, the traditional method of preparing proofs in colour. Modern proofing is often done on the production press when the customer requires that the proofs produced are an exact match to the final printed job. This is an expensive method of proofing and the customer is often charged for proofs made in this way. On many web-offset presses the job is proofed and run in one operation. When this happens the customer or his representative is present at the press makeready and the production proceeds only when he is satisfied that the job is correct. We shall here be considering in detail the traditional method of producing proofs with the use of the flatbed offset proofing-press.

Design of the flatbed proofing-press

The proofing-press may be constructed in one of three ways as follows:

1. The hand-operated press which is usually of small dimensions.

Fig. 71.—A modern automatic proofing-press. A—inking system, B—damping reservoir, C—motor carriage-drive, D—paper bed, E—plate bed, F—gripper foot-pedal.

2. The semi-automatic press which is similar to the hand press but usually larger and with power drive.

3. The fully automatic press which has power drive and an automatic system of plate damping and inking. These presses can be very large (Fig. 71).

In all these systems proofing is not considered a production operation and therefore high speeds are not found. The paper for proofing is laid to the lays and removed by hand.

Hand-operated proofing-press

The basic construction of the hand-operated proofing-press can be seen in Fig. 72.

The plate bed. This is furnished with a plate clamp on the leading edge, the back of the plate usually left to trail. The plate bed can be

Fig. 72.—Basic construction of a hand-operated proofing-press. A—blanket cylinder, B—plate clamp, C—gripper, D—plate bed, E—blanket reels, F—paper bed.

adjusted for height, and usually has adjusting bolts or screws at each corner of the bed for levelling. Plate-cocking facilities may be incorporated into the plate clamp or into the plate bed itself. This allows limited movement only.

The paper bed. This bed carries a set of grippers along its leading edge which are operated by a foot-pedal. Solid grippers are found on inexpensive presses, but sprung grippers are found on most modern presses. Lay stops are also situated on the leading edge of the bed and are usually adjustable for lateral position and have a micrometer control for paper register. This bed has height-adjusting facilities similar to the plate bed.

The blanket cylinder. This cylinder is constructed with a depression gap which houses one or two blanket reels. The most common mechanism for tensioning the blanket is a pawl and ratchet device situated at the end of one of the blanket reels.

Blankets suitable for proofing are generally soft with a Shore rating of 68° to 72°. Soft blankets and blanket packings are used to obtain good quality on all types of stock at low speed.

The press drive. Drive to the blanket-cylinder carriage is obtained by hand via a handle which usually rotates a pinion situated on the carriage. Running the length of both sides of the beds is a horizontal gear known as a "rack," and the pinion runs in the rack to move the carriage. Buffer stops at either end of the rack limit the travel of the carriage.

Semi-automatic proofing-press

This type of press is constructed on the same lines as the hand-operated press but has the carriage movement by power drive. On smaller presses the electric motor is situated in the base of the press and the drive to the carriage obtained via a chain and sprocket mechanism. When motivated the chain moves round the sprockets in one direction only with the link to the carriage obtained by a roller or pivot block which moves within a slide.

Fully automatic proofing-press

This type of press is a further extension of the semi-automatic proofing-press with the inclusion of a damping and inking system which functions on conventional lines. Because damping and inking are performed on a flat surface, the damper reservoir is constructed at one end of the press and the inking reservoir at the other. This arrangement allows the moving carriage to carry only the damping rollers and a rider and the inking-plate rollers. The inking-reservoir system usually consists of an ink-duct, feed roller and intermediate milling rollers which are operated by a separate motor from the carriage. Large presses of this kind may have the carriage drive motor which is located on the carriage and drives the carriage by worm gearing (Fig. 73). With this type of drive a braking mechanism is built into the electrical system.

Pressure controls

On hand-operated, semi-automatic and automatic presses, the method of applying blanket-cylinder pressure may be by hand via a lever, or automatic by the use of a rising cam and follower wheel, or friction clutch.

Figure 74 shows the simple method for obtaining printing

Fig. 73.—The Mailander carriage power drive.

pressure on many inexpensive proofing-presses. The forward move-
ment of the carriage leaves the blanket cylinder in a stationary
position with the depression gap at the bottom, allowing the blanket
to avoid contact with the beds. On its return motion, the blanket-
cylinder drive gear is engaged and the blanket turns, thus making
good impression contact with the plate and paper beds.

The most common mechanism for moving the blanket cylinder
into contact with the beds is the eccentric bearing bush situated on

Fig. 74.—Simple method of obtaining printing pressure. (*a*) Forward motion
of the carriage with the cylinder stationary. (*b*) Return motion engaging
the cylinder gear thereby turning the cylinder.

the cylinder. With this type of bush the cylinder is moved downwards by a slight rotation of the bush within the bearing-housing. This movement is obtained by a system of levers connected to a cam follower which is operated when the roller rises over a rising cam. Usually, this mechanism also allows for manual operation of the levers. Another device for rotating the eccentric bush is a slipping clutch located on the bearing housing. The clutch is arranged to turn the eccentric in the direction of carriage movement. This means that when the carriage is moving forward the eccentric follows the rotation of the cylinder in a clockwise direction to lift the cylinder out of contact with the beds. On the return movement the cylinder rotation reverses and the clutch also rotates the eccentric bush anti-clockwise, causing the cylinder to move into contact with the beds.

Setting pressures. Pressure setting of the beds to the blanket cylinder are usually made by moving a central control. This control is connected to the bed at its four corners and requires little disturbance on modern presses. Bed height is adjustable by a hand wheel and is used to accommodate varying thicknesses of printing plate and stock.

Setting pressures initially require that a correct sequence is followed:

1. The bed must first be levelled. This is done by relaxing the corner adjustments and placing a straight-edge across the bed. Many presses have a special straight-edge with a seating-piece on each end which is placed on the horizontal bearers running the length of the press. With the use of such a straight-edge a uniform gap between the edge and the bed is obtained all over the bed surface by adjusting the corner bolts. A feeler thickness gauge is placed between the straight-edge and the bed and the adjustments made until the gauge can be removed with slight resistance.

2. If the press has been installed quite level, the beds can be levelled by using a spirit-level. Press level can be checked by placing the spirit-level on the blanket cylinder.

3. When the beds have been levelled, the central control is used to bring the bed to the correct working height. The working height has to be calculated by measuring the thickness of the plate to be used and the position of the cylinder when in the impression position. If this is unknown the cylinder position is found by removing the blanket and packing and measuring the gap between cylinder body and bed with a feeler thickness gauge. The total

measurement of blanket and packings, plus plate thickness, will be equal to the gap, *less* the amount required to give good impression which will not be more than 0·1 mm.

4. Final pressure settings can be checked by fitting a plate of standard thickness and rolling it up solid with a blue ink. Move the blanket cylinder into contact and note the transfer of ink. The same procedure is followed for checking the paper bed height: lay a sheet of regular stock on to the bed and note the transfer of blue ink from blanket to paper.

PROOFING WITH PROCESS COLOUR INKS

In the majority of cases the use of process colour inks for proofing follows a simple pattern:

1. Standard colours of a balanced set of inks are used.

2. A standard thickness of the printed ink film is followed with the use of the reflection densitometer. Ink film thickness should be standardised by establishing an ink film thickness for each process colour which can be obtained on the production press. This avoids the danger of producing a set of progressives which the production press cannot match.

3. A book of progressives is produced on the proofing-press which can be followed by the production department. A book of progressives is made up as follows:

One sheet of stock printed with yellow ink.
One sheet of stock printed with cyan ink.
One sheet of stock printed with magenta ink.
One sheet of stock printed with black ink.
One sheet of stock printed with yellow and cyan ink.
One sheet of stock printed with yellow, cyan and magenta ink.
One sheet of stock printed with all four colour inks.

The progressives book will also contain information about the reflection density readings for each colour ink, type, make and number of the inks used. The sequence of printing process colour inks will not necessarily follow the above order, and is discussed in Chapter 5.

PROOFING WITH COLOUR INKS OF VARIOUS SHADES

The proofer often has to match colours for proofing which are not obtained by using process inks. A suitable selection of coloured inks must be kept for this kind of work. The following list is given as a guide:

Yellow inks	Cold = Primrose	Pure inks	Emerald-green
	Mid = Lemon		Violet
	Warm = Golden chrome		Umber
Red inks	Cold = Crimson		Sienna
	Mid = Scarlet		Black and White
	Warm = Vermilion		Tinting medium
Blue inks	Cold = Turquoise		
	Mid = Bronze		
	Warm = Royal		

Many commercial colour-matching ranges of inks are obtainable which are selected to match specified colours.

The following important points must be considered when matching coloured copy with a mixed ink:

1. The viewing light will affect the proofer's estimation of a colour match. If daylighting is used it should be of northern exposure, preferably light from a skylight without outside or inside colour reflection. Artificial lighting should be of colour-matching standard.

2. Care must be taken to avoid error in colour matching when the copy colour is close to a contrasting colour. The colour to be matched should be isolated.

3. Colour metamerism arises when a matched colour looks the same as the copy under one type of lighting, but fails to match the copy under another. This can be avoided by viewing the matched colour and copy under a variety of differing light sources.

4. The thickness of the ink film will determine the density of colour. Before proofing the mixed colour it can be tested for shade by tapping out a thin film of the ink on to the stock with the finger. Another common test is to draw down a film of the mixed ink on to the stock with a wide-blade palette-knife, which by varying the pressure on the knife will give a range of ink thicknesses.

5. The proofer should keep a record of colours mixed and matched, with a sample tap-out and a print, and if possible a small tinned quantity of the ink. This record will assist him later in matching similar shades of colour.

6. Before proceeding to mix inks for proofing, the proofer should ascertain whether special inks are required for the job; for example, special inks are required for soap wrappings, in which an alkali soap may cause the colour to change.

E

CHAPTER 4

PRINTING-PRESS DESIGN AND SETTINGS

Single-colour lithographic press

SINCE the development of the rotary offset press at the turn of the century, lithographic printing-machines have not changed their simple basic design. Construction techniques have improved tremendously, however, with improvements in roller coverings, damping systems, blankets and plate; machine speeds have increased and the lithographic press has become a simpler, more efficient and economical printing-machine.

35 9255

Courtesy: Maschinenfabrik Augsburg-Nurnberg

Fig. 75.—The plate, blanket and impression cylinders of the modern sheet-fed press.

The basic design utilised by I. W. Rubel in his first offset press of 1904 remains virtually unchanged. The modern single-colour sheet-fed press has plate, blanket and impression cylinders (Fig. 75). The

Fig. 76.—The single-colour offset lithographic press. A—feeder pile, B—feedboard, C—sheet-insertion system, D—damping system, E—ink-duct, F—ink-feed roller, G—inking system, H—plate cylinder, I—blanket cylinder, J—impression cylinder, K—delivery pile.

size and layout of these cylinders may vary with different manufacturers' designs, although the principal features contained in the following pages apply to most modern presses (Fig. 76).

PLATE CYLINDER

This cylinder carries the lithographic plate and it has a depression gap which houses the plate clamps which position and tension the plate. The gap occupies approximately one-quarter to one-half of the cylinder circumference. During the short period in which the gap passes the front of the feed-table, the oncoming sheet is registered to the front and side lays. The wider the depression gap, therefore, the more time is allowed for sheet registration. This is, of course, important on high-speed presses. The plate cylinder is usually arranged

to allow the pressman maximum access for attaching, and attending to the plate. The three principal types of plate clamp are as follows:

1. The bolting clamp functions by pinching the plate edge when a number of bolts set in the clamp are tightened.

2. The cam clamp pinches the plate edge when a simple cam mechanism built into the clamp is turned.

3. Plate clamps which can be detached from the plate cylinder and fixed to the plate edges on a bench and the clamps then clipped on to locating pegs in the cylinder gap.

On modern presses plate fixing and adjustment is arranged to be done with a minimum number of tools. Clamps may be arranged in sections or single bars. Plate movement in the lateral direction (*see*

Fig. 77.—Plate-clamp adjusting mechanisms.

Fig. 77) is made by adjusting a bolt A with a micrometer scale to indicate the movement. Movement of the plate circumferentially is made by adjusting a bolt or screw B which also has a micrometer scale.

ACCURATE PLATE REGISTRATION

Devices for making rapid lateral and circumferential adjustment of the plate find special usefulness during press makeready. A well-established method for plate registration is the use of engraved register marks situated one each side of the cylinder, approximately 10 mm above the plate clamp, and a centre line engraved on the plate clamp and the cylinder body at the leading edge (Fig. 78).

With the co-operation of the platemaker, suitable register lines which fall coincidental with the engraved cylinder marks may be

Fig. 78.—The position of engraved marks A on the plate cylinder facilitating rapid plate registration.

printed down with the plate image, thus ensuring that plates can be positioned accurately. The engraved mark in the centre of the cylinder body enables the pressman to centralise the clamp prior to fitting the plate.

Punch register

The use of the punch-register system will reduce makeready times by assisting in speedy register of machine plates (*see* Chapter 5). The system involves the punching of holes in the leading edge of the plate for positioning platemaking flats and for locating the plate in the plate clamps on the press. A similar set of holes is accurately drilled in the plate clamp and the plate located in the clamp by inserting the hand register-pins through the clamp and the plate edge before pinching up. When changing to the second plate of a close-register job the leading plate clamp should not be moved, and with the use of the register-pins the accurate positioning of this plate will be obtained.

CIRCUMFERENTIAL ADJUSTMENT

Both the leading- and back-edge clamps can be adjusted to move the plate round the cylinder by a limited amount as already described (*see* Fig. 77). The following points should be observed when fitting a plate:

 1. Centre the clamp by lining up the engraved centre marks on clamp and cylinder body.

2. Adjust the bolts (Fig. 77) until the leading-edge clamp is moved to its highest position against the cylinder body.

3. Position the plate in the leading-edge clamp and tighten.

4. Bring the impression between plate and blanket to "On," and inch the machine until the rear clamps can be adjusted.

5. Locate the plate into the rear clamps and adjust to take the maximum grip of the plate edge. If the machine has three sectional clamps, the centre clamp only may be tightened at this stage.

6. Take up the slack in the plate by tightening the tensioning bolts and move the cylinder impression to "Off."

7. Turn the cylinder and adjust the register lines on the plate to those on the cylinder by loosening the back-edge clamp and pulling the front edge of the plate forward. Having previously set the plate clamp against the cylinder body the clamp can only be moved in one direction, thus pulling the bend on the leading edge of the plate into the depression gap. If the clamp had been set low, however, it may be found necessary to raise the plate and thus cause the bend to move on to the cylinder where it would invariably print up.

8. Tighten the rear clamps and apply sufficient tension to obtain a tight fit, but avoid pulling the plate out of the clamps.

LATERAL ADJUSTMENT

The bolts (Fig. 77) enable the pressman to move the plate in a lateral direction to centralise and also to cock the plate. Plate-cocking becomes necessary when the plate image is slightly out of parallel with the cylinder bearers (Fig. 79). By moving the leading edge of the plate to the left, and the back edge of the plate to the right, the

Fig. 79.—Plate-cocking, required when the image is not square with the cylinder.

misaligned image may be corrected. When making such adjustments the plate-tensioning bolts must be loosened to permit lateral plate movement.

CIRCUMFERENTIAL AND LATERAL CYLINDER ADJUSTMENT

Many modern machines are constructed to allow the plate cylinder a limited circumferential movement in relation to the drive gears. The drive gear is attached to the cylinder body by bolts which are located through slots in the side of the gear. When the bolts are loosened the cylinder body may be moved circumferentially. The gear should always be set in the central position at the pre-makeready stage.

Courtesy: Maschinenfabrik Augsburg-Nurnberg

Fig. 80.—Lateral and circumferential controls on a M.A.N. press.

More sophisticated locating mechanisms are incorporated in multi-colour and web-offset presses, permitting circumferential cylinder movement while the press is in motion.

Lateral adjustment of the plate cylinder is found on multicolour and web-offset presses and features a mechanism which allows the plate cylinder to move sideways by a limited amount while the press is in motion (Fig. 80).

BLANKET CYLINDER

This cylinder has a depression gap which houses one or two reels to which the blanket is attached and tensioned. Blanket-fitting systems vary. Bolted clamps similar to plate clamps are used, the clamps

Fig. 81.—Schematic of how the blanket cylinder A moves out of contact with both B plate and C impression cylinders in one movement when the tie-bar D is moved. The blanket swings on the eccentric bush E.

being fixed to the reels and tensioned by rotating the reels. Blanket-clamp bars are commonly detachable, which permits the pressman to keep a replacement blanket complete with bars at the ready. Other systems use bar bolts, rivets and hooks to attach the blanket to the bar.

The main press drive is in many cases direct to the blanket cylinder, which in turn drives both the plate and impression cylinders.

Layout design usually places the blanket cylinder in such a position that it is able to break contact with both plate and impression cylinders in one movement (Fig. 81).

IMPRESSION CYLINDER

This cylinder has a depression gap which houses a system of grippers. Presses with the feed-roll insertion system and metal decorating presses also have front guide stops situated close to the grippers.

It is common on most modern machines to have no dressing on the impression cylinder. The machines that do permit dressing have a metal tympan or rubber blanket which is attached by suitable clamps.

The impression between blanket and impression cylinder is adjustable to allow for printing on stocks of varying substances. This adjustment may be obtained by moving the impression cylinder, but where this interferes with transfer-gripper settings the movement is made by the blanket cylinder which is constructed with an eccentric in the bearing housing.

CYLINDER GEARS

Each press cylinder has a gear fixed to one end which meshes with its neighbouring cylinder. The main drive usually powers the blanket cylinder, which in turn drives the plate and blanket cylinders. Accurate register demands that the gears are cut with the utmost precision to prevent jarring and rocking of the cylinders during the printing operation. Gears suitable for cylinder drives must comply with certain requirements as follows:

1. They must be designed to allow only limited back-lash.
2. The gears must not "float" when the press runs at speed.
3. Transfer of fine printing images from plate to blanket demands that the gears do not cause slurring, doubling or distortion of the image.
4. The gears must function well on adjustable cylinders where gear meshing is often altered.

Three types of gear are of interest to the pressman:

SPUR GEAR

This gear has its teeth cut parallel to the axis of the shaft (Fig. 82). It can only be fitted to drives which have their shafts lying parallel to

each other. The true diameter of the gear is measured from the pitch line, which is situated at half the tooth depth (Fig. 83). Gears are said to "mesh correctly" when the pitch line of both gears make contact. On bearer contact cylinders the gear pitch line corresponds to the height of the bearer.

Fig. 82.—The spur gear.

Fig. 83.—The pitch line on a pair of meshing gears.

Printing cylinders fitted with spur gears usually reduce backlash associated with this type of gear by incorporating a special *anti-backlash* mechanism in the gear itself. This mechanism may vary in design, but the most common type used is the adjustable split gear. The gear is in effect two gears bolted together, the wide gear transmitting the drive and the narrow gear adjusted to prevent the wide gear from rocking backwards. The narrow gear is constructed to allow it a slight circumferential movement in relation to the wide gear, which can be set to eliminate back-lash when the gears wear.

To set the anti-back-lash gear the following method may be used:

1. Ensure that the plate and blanket cylinders are correctly packed and pressures set according to the manufacturer's recommendation.
2. With the pressures off, loosen the gear bolts.
3. Pry the gear forward, that is, in the direction of rotation.
4. Tighten the bolts lightly.
5. Apply the cylinder pressure but do not run the press.
6. Secure the bolts.

The main drive should always be taken up by the wide gear. By moving the narrow gear forward the backward movement of the wide

gear is controlled. Spur gears are relatively inexpensive to manufacture and they have greater meshing tolerances than helical gears, which make them most suitable for adjustable cylinders.

HELICAL GEAR

This gear has its teeth cut at an angle to the axis of the shaft (Fig. 84). The following important features make helical gears most suitable for printing-machinery:

 1. Shafts lying at angles between 0° and 90° can be used.

 2. They have a higher engagement factor than spur gears, giving smoother action.

 3. Power transmission from one gear to another is smooth and free from jarring.

Helical gears are more expensive to manufacture than spur gears, and are usually found on bearer contact cylinders where gear-meshing is fixed by the bearer setting.

Fig. 84.—The helical gear. Fig. 85.—The bevel gear.

BEVEL GEAR

This gear is not used as a cylinder-drive gear, but is used in many component parts of the machine providing drive for inkers, dampers, feeder mechanisms, etc. The gear has teeth cut into a cone shape or bevel (Fig. 85) and it is used to direct shaft drive at right angles.

CYLINDER DESIGN

Cylinder design, like gear design, is of considerable importance to the printer. As the cylinders roll together at high speed during the

printing operation, plate wear, good image transfer, bearing stability and long press life will depend on well-designed cylinder units.

In theory, the satisfactory rolling together of cylinders and the transfer of the image correct to size will be obtained when the cylinders are all of equal diameter. This does not hold true in practice, however, because it is necessary to have contact pressure of at least $30 \cdot 0$ N/cm^2 between the cylinders to effect good transfer of the image ink film. The rubber blanket unfortunately alters its shape under pressure because it will not compress but is forced into a bulge on both sides of the impression nip. This has the effect of increasing the surface speed of the blanket cylinder when the press is in motion, forcing the bulge to the front of the nip. Because of this the image transferred to the blanket at the point of contact may be distorted by an uncontrolled amount, depending on the elasticity of the blanket surface, the amount of pressure between the cylinders, the size of the cylinders, *i.e.* if the plate cylinder is of smaller diameter than the blanket cylinder the bulge will occur behind the nip. Similar problems occur between the blanket and impression cylinders. A number of different approaches have been made to overcome this with the result that printing-machines are constructed with cylinders of varying diameters. A general rule is to expect the press to print to size when the cylinders have been dressed according to the manufacturer's specifications.

The design features of plate and blanket cylinders are of two principal forms as follows:

BEARER CONTACT CYLINDERS

Bearers are hardened steel rings which are located at either end of the cylinder body. On this type of cylinder the bearer diameter is the same as the pitch diameter of the cylinder-drive gear. The diameter of the cylinder body is smaller than the bearer diameter and the difference is known as the *undercut* (*see* A in Fig. 86).

When correctly set the bearers of the plate cylinder contact and roll together with the blanket-cylinder bearers. The following features are obtained with this design:

1. The bearers act as brakes which eliminate "float" in the gears while the press is running.
2. Gears are correctly meshed at pitch diameter.
3. Correct parallel alignment of the cylinders is assured.

4. The bearers compensate for the movement in the cylinder roller-bearings and so reduce the possibility of image doubling at speed (*see* B in Fig. 86).

Fig. 86.—Bearer contact cylinder. A—undercut, B—roller-bearing.

5. An important feature claimed for this type of cylinder is that the bearers prevent any tendency to move or give between the cylinders under pressure when the cylinder gaps coincide. Figure 87 shows that the contact pressure between the cylinders is eased when the gaps pass each other and is taken up again when the leading edges of the cylinders meet, at E. Any wear in the cylinder bearings will cause image distortion at point T in the form of "gear marking" across the printed sheet.

Pressure between the blanket and plate on bearer contact cylinders is obtained by packing the undercut differences to bring plate and blanket to bearer height, plus an additional 0·1 mm to effect transfer of the ink film. Pressure setting between the cylinders in excess of 0·1 mm must be avoided as this throws strain on the bearings and may force the cylinders to run out of bearer contact.

Fig. 87.—Contact pressure. A—plate cylinder, B—blanket cylinder, C—impression cylinder.

Setting bearer contact cylinders

When setting bearer contact cylinders the following method should be used:

 1. Release the cylinder contact adjustment until a 0·2 mm feeler gauge can be inserted with slight resistance between the plate- and blanket-cylinder bearers.

 2. Remove the cylinder dressings, plate and blanket.

 3. Note the position of the flats on the cylinder-adjusting bolts, and, placing a 0·1 mm feeler gauge between the bearers, count the number of flats turned to bring the cylinders into contact with this gauge. A simple computation will now show that if the adjusting bolts are turned a similar number of times the bearers will move into contact.

Having obtained bearer contact the adjusting bolts should be turned further to apply a pre-tension contact of approximately 0·08 mm. This will ensure that the cylinders do not part when correctly packed and under printing pressure. The checking procedure which follows will indicate whether the cylinders will part under an extra load of a 0·1 mm sheet. If parting does occur extra pre-tension must be applied.

Checking bearer contact

The following procedure should be adopted:

1. Clean the bearers, removing ink, dried gum, rust, etc.

2. Dress and pack the cylinders to standard specification.

3. Tape a full-size sheet of paper which is approximately 0·1 mm thick to the blanket.

4. Tap out a thin film of ink on to the plate bearers in one or two points.

5. Set the cylinder pressures to "On."

6. Run the press for a few revolutions.

7. If correctly set the ink should transfer positively from plate to blanket bearers.

BEARER GAP CYLINDERS

This type of cylinder has been more prominent in European machine design because the market caters for short-run work with a greater variation in stock substances than the American market whose presses are mainly of the bearer contact type.

Bearer gap cylinders are usually fitted with bearers whose main function is to act as gauge rings. The bearers run out of contact (*see* A in Fig. 88) with the cylinder dressings packed to a higher diameter than the bearers. On this type of press the pressure between plate and blanket is obtained by moving either cylinder into contact. On bearer contact presses the pressure between plate and blanket is adjusted by packing the plate or blanket. Alteration of the plate packing must always be compensated for by altering the blanket packing in bearer contact machines to maintain correct nip pressure between the cylinders. Change of blanket packing will also require further adjustment of the impression-cylinder pressure. All this lengthens makeready time, and it is for this reason that bearer gap presses are more suitable for short-run jobbing work, and bearer contact presses more suitable for high-speed long-run work.

The use of bearer gap cylinders creates problems, however, in the use of roller-bearings because the clearances in the bearing components allow movement of the cylinder. To overcome this difficulty it is usual for this type of cylinder to have solid bronze bearings (*see* B in Fig. 88), which because of their heavy construction limit cylinder movement to a minimum and provide non-vibrating transmission of power.

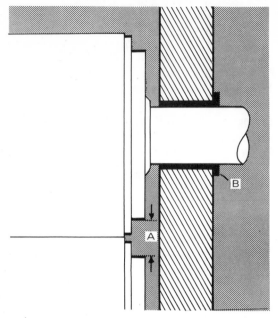

Fig. 88.—Bearer gap cylinder. A—bearer gap, B—solid bearing.

Setting bearer gap cylinders

Most modern machines incorporate a micrometer scale with a simple mechanism for adjusting the cylinders. For setting cylinders not equipped with a micrometer scale the following procedure will serve as a guide:

1. Remove plate, blanket and dressings from the cylinders.

2. Clean the bearer surfaces.

3. Ascertain the correct bearer gap required from the press handbook. This will take cylinder pre-tension into account.

4. Release the cylinder-adjusting lock-nut and move the cylinders out of contact.

5. Set the cylinder pressures to "On."

6. Insert the correct caliper feeler gauge between the bearers and adjust the cylinder until the gauge can be removed with slight resistance.

7. Tighten the lock-nuts and recheck the setting.

Once an initial setting has been made, the movement of the cylinder can be calculated in relation to the number of flats turned on the

adjustment bolts. Correct meshing of the gears is essential if cylinder vibration and gear marking are to be avoided.

Both the above systems are in current use and utilised on machines of reputable manufacture. As machine speeds are increasing, however, especially those of web presses, the bearer contact cylinder-type press is becoming more common in this country.

BLANKETS

The standard blanket is composed of a fabric backing material with a surface coating of synthetic rubber. The fabric layer is made of high-grade cotton plies, specially woven and pre-stretched with the lengthwise threads (the warp) usually of double thickness for added strength when the blanket is under tension. The cotton plies are bonded together with special adhesives which permit blanket stretching without distortion or separation of the plies. The surface coating of synthetic rubber such as Neoprene, Hycar and butyl, is applied to the ply carcass in a succession of passes through a spreader until sufficient thickness is obtained. After vulcanising, the finished blanket is tested for tensile strength, stretch, plies adhesion and uniform thickness before passing to the printer.

SELECTING GRADE OF BLANKET

The choice of a blanket depends upon the type of printing for which it will be used. Printing stock may vary between metal plate, board, coated paper or tissue. Printing inks contain a wide variety of oils, resins and solvents which require a special type of blanket. Press speed may also affect the choice. In every case the blanket-manufacturer should be consulted.

The following three basic grades of blanket are common:

1. Hard blanket, 76–82 °Shore. This blanket is recommended where difficulty with tack on heavy solids is experienced, especially on coated stock. The hard blanket gives long life and is used for printing on metal, board and high-speed paper printing. Also used as an under-blanket.

2. Medium blanket, 74–76 °Shore. A general-purpose blanket used for long runs, especially on coated paper, where good separation of the stock from the blanket is required.

3. Soft blanket, 70–74 °Shore. This blanket permits printing

without excessive pressure even on rough-surfaced paper. Suitable for proofing-presses, low-speed machines and where rapid make-ready is required.

TYPES OF BLANKET

Press blankets are continually being improved to match the increase in press speeds and ink-solvent requirements. Although plastic materials are being investigated, and a variety of novel blanket constructions have been suggested, the modern blanket remains basically the same as the simple description given above. One modern development, however, is the use of compressible layers within the blanket carcass. The solid synthetic rubber of the normal blanket does not compress when under pressure. This means that when the press cylinders come together under pressure the blanket surface distorts. This blanket distortion in turn produces a bulge in the blanket which lowers print quality and produces heat by friction on the high-speed press. The compressible blanket seeks to overcome these effects by incorporating a microcellular rubber layer in the carcass of the blanket. When pressure is applied, the minute gas bubbles in the layer compress, thus minimising blanket distortion.

Checking a new blanket and preparing for mounting

Before the blanket is punched for mounting it should be checked for squareness, noting that the warp threads run parallel with the cylinder bearers. Most machine-manufacturers specify the thickness of blanket and packing to be used. If an unsquare blanket is mounted on the blanket bars out of true, when it is tensioned round the cylinder, part of the blanket will be tight and other parts slack.

BLANKET SQUARING

The following method should be adopted:

1. Determine the direction of the warp. This is usually marked on the back of the blanket.

2. Ensure that the blanket edge has been cut parallel to the warp.

3. Find the centre of the blanket and draw a line throughout its length. Place a set square on the centre line and draw the blanket bar line on each end, at right angles to the centre line. This line will form the basis for lining up the blanket bar (Fig. 89).

PUNCHING

Most blankets have a tendency to pull thin in the middle because the centre is pulled from six directions (Fig. 90), whereas the sides release their tension by bowing inwards slightly. This condition can

Fig. 89.—Squaring the blanket Fig. 90.—Blanket pull.
for punching.

be remedied by mounting the blanket bars on to a series of punched holes which have been formed into a shallow arc. To form such an arc of punched holes the following procedure should be adopted:

1. Measure and mark a point 4 mm below the centre of the blanket bar line.
2. Place the blanket bar along the bar line and mark through the screw holes at the extreme ends of the bar only.
3. Holding the position of the right-hand hole, swing the bar down until the lower centre point is located.
4. Mark out the row of screw holes to the centre.
5. Replace the bar on the original end-hole positions.
6. Holding the position of the left-hand hole, swing the bar down to the centre.
7. Mark out the row of screw holes to the centre.

Note. The arc centre should be 4 mm for blankets up to 1 m wide, and proportionally increasing as the blanket becomes wider to ˙8 mm for blankets 2 m wide.

The best tool for punching the holes in the blanket is a sharp belt-punch which has the same diameter as the bar screws. When punching, a backing block of hardwood or preferably lead will produce a clean hole when the punch is struck smartly with a hammer.

UNDER-BLANKETS

These generally have the leading edge punched and fitted to a bar with the back edge left trailing. This will allow the blanket to settle down when the top blanket is tensioned. To reduce the amount of blanket wash which may find its way into the fibres of the under-blanket, causing the edges to swell, the under-blanket is usually cut a little narrower. When the top blanket is tensioned, the edges pull down tightly to the cylinder and prevent solvents from creeping underneath.

SHORE DUROMETER

This is an instrument called a "penetrometer," which is used for measuring the hardness of rollers and blankets. It consists of a frame which houses a spring-loaded ball point and a dial which registers the hardness of the material tested. The hardness ranges from 0 which corresponds to air, to 100 which corresponds to the hardness of glass.

FITTING THE BLANKET

When the blanket cylinder has been cleaned, the packing sheets are placed on to the cylinder first, the front edge being folded over the leading edge of the depression gap and fixed there with adhesive. The back edge of the packing is left to trail. The blanket is now fitted, the leading edge first, and smoothed down with the hand while inching the press until the back edge can be located in the back-edge clamp. Before the blanket is finally tightened, inch the press and examine the blanket with hand and eye to ensure that the packing has not slipped, and that no foreign matter is trapped under the blanket.

The tension of the blanket plays an important role in the quality of reproduction. Too little tension will result in slurring and doubling; whereas over-tension may cause blanket distortion and result in an uneven surface. Final tension will not be gained until the blanket has "bedded down" after a few hundred impressions. Some manufacturers supply a torque wrench and specify tension to a specific load rating, but generally the pressman is left to adjust the tension by empirical judgment. A useful test is to tighten the blanket and to depress the end that spans the cylinder gap with the thumb. Correct tension will give a slight yield to the thumb; avoid slackness or sagging, and rigid hardness.

The blanket should be rested periodically, for example at weekends and holidays, by releasing the tension. A better procedure is to remove the blanket, soak the back with water and hang in a dark

spot. This will allow the backing fibres to swell and regain their former resiliency.

PACKING

Packing sheets must be chosen carefully, be of uniform caliper and cut squarely. Packings may be soft (felt, baize) or hard (manilla paper, plastic sheet). Better half-tone dot reproduction is obtained with hard packings, faster makeready is possible with soft packings.

Packings of paper may become wet at the edges of the blanket causing local swelling which may show on full-out printing images. Plastic sheet is commonly used because it is unaffected by spirit and water, does not lose its bulk under pressure and, because of its stiffness, is easy to handle.

PRESS INKING SYSTEM

The function of the ink-roller system is to supply a fresh adequate film of ink to the plate image during each revolution of the cylinders. To do this, the individual features of roller layout, their number, diameter and coverings have to be considered:

1. The roller system must be so arranged that the ink is milled to the required consistency without the need to thin the ink with varnish.

2. The storage capacity of the roller system must be adequate to effect good recovery of the plate-roller ink film during each cylinder revolution.

3. Ink should be evenly and quickly distributed over the rollers.

4. Roller arrangement should permit rapid alteration of the ink-film thickness when necessary.

5. Roller layout should minimise any tendency for the plate-damping solution to mix and waterlog with the ink on the rollers.

THEORY OF INK-FILM FLOW

When a roller which is covered with an even film of ink is brought into contact with an uninked roller of the same diameter, the ink film splits and approximately 50 per cent of the ink passes on to the roller in one revolution. If there are a train of rollers in contact (Fig. 91) the ink flow path can be traced as the ink splits from one roller to another. An examination of the ink-roller diagram of any press will enable one to trace the flow path of the fresh ink from the ink-duct to the plate.

The following two ink-roller systems are current on modern machines:

Multi-roller inking system

From the diagram (Fig. 92) it will be apparent that all the rollers in
this type of inking system have approximately the same diameter and
vary between each other in diameter by small amounts. Tracing the
flow path, it will be seen that the primary path of fresh ink flows to
the first two plate-inkers. Designers use this type of system on the
premise that the fresh ink on the front rollers counters the main front

Fig. 91.—The ink-flow on a train of rollers.

Fig. 92.—The multi-roller inking system, showing
primary ink-flow path as a solid line and
secondary path as a dotted line.

of moisture on the plate. With these rollers resisting emulsification with fresh ink, the remaining plate-inkers function by equalising the ink film on the image.

Drum-roller inking system

In this design a large-diameter drum is included in the roller pyramid. Figure 93 shows that the ink flow path can be traced to feed the last two plate-inkers with fresh ink. The first two plate-inkers take

Fig. 93.—The drum-roller inking system.

the secondary supply of ink. The function of the large drum is to increase the storage capacity of the pyramid, thus increasing the recovery of the ink film during each revolution. By directing the fresh ink to the last two plate-inkers the designers propose to apply fresh ink to the image as it leaves the rollers, thus giving added tone and density to the print. The first two inkers are so arranged to remove excess moisture from the plate and to convey it to a point in the roller train where it can be evaporated and effectively controlled. Both these inking systems are in current use and give satisfactory results.

INK-DUCT

The ink-duct is a reservoir from which ink is metered to the roller pyramid. It incorporates a large steel drum which rotates at a controlled speed in a trough of ink. As the drum turns a film of ink is carried on its surface, and the thickness of this film can be controlled by adjusting the spring steel blade which is fitted close to the drum surface (*see* Fig. 94). The finger screws D are turned to either open

Fig. 94.—The ink-duct. A—ink-duct drum, B—ink trough, C—duct blade, D—adjustable finger screws, E—blade gap.

or close the gap E between blade and drum. Care must be taken when adjusting the blade. Always begin by opening the blade gap fully and turning the finger screws from the centre, working outwards to the ends. When setting the blade initially, use a 0·075 mm feeler gauge between the blade and the drum. The final setting will, of course, depend on the amount required on the printed sheet. The ends of the blade should not be pinched so tight as to make it difficult to turn the drum, this will only cause the blade to wear, making future setting difficult.

The duct roller may be motorised electrically or mechanically, or, as is more common on small presses, the roller is rotated by pawl and ratchet which can be adjusted to give a variable stroke.

INK-FEED ROLLER

This roller is often incorrectly termed a "vibrator" (European) or "ductor" (U.S.A). During the cycle in which the duct roller turns, the

feed roller moves into contact with it and takes a strip of ink from the drum. The feed roller then moves into contact with the roller pyramid and transfers the ink to the roller train. The width of the ink strip taken from the duct roller may be determined, either by the length of time which the feed roller remains in contact with the rotating duct roller (this is known as the *dwell*), or by the stroke of rotation given to the duct roller while the feed roller makes intermittent contact.

RECIPROCATING ROLLERS

Reciprocating rollers are given this name because in addition to revolving they also make intermittent lateral movement. They are

Courtesy: Frank F. Pershke Ltd.

Fig. 95.—The roller gear drive on the Solna 125 offset press.

generally made of steel with a coating of copper or plastic material. Copper has been selected because it has a good affinity for ink. Older pressmen will remember the problems which plain steel rollers presented when moisture in the ink pyramid caused the ink on the steel rollers to "strip," making ink flow difficult.

DRIVE ROLLERS

The ink pyramid derives its drive from a number of fixed metal or plastic-covered rollers which are rotated by gears or chains connected to the main drive of the press. All the resilient ink rollers are driven by friction contact with the drive rollers and are usually designed to rotate the rollers in contact with the plate at the same surface speed as the plate cylinder (Fig. 95).

INTERMEDIATE AND PLATE-INKING ROLLERS

The size of the ink pyramid and the number and diameter of the rollers will determine the ink-rolling power of the system. Consider

Fig. 96.—Fall-off points.

an inked roller brought into contact with a large-diameter cylinder (Fig. 96). On completion of one cylinder revolution the ink film transferred to the cylinder will vary in thickness with distinct fall-off points which correspond directly with the diameter of the small ink

roller. With an increase in the number of ink rollers the same fall-off points will be in evidence. When this occurs on the press the fall-off point may be quite noticeable on solids and tints, in the form of streaks running parallel to the gripper edge of the sheet. To overcome this tendency the plate-inking rollers are made in varying diameters which results in the fall-off occurring in non-coincidental points on the plate, thus eliminating the streak. This has a drawback, however, in that rollers of varying diameters have different rotating surface speeds which unless maintained within close tolerances will cause early wear of the plate image and a generation of heat in the roller pyramid.

A number of small-diameter rollers are often added to the pyramid at strategic points to act as scavengers. Their placing is important as they function by accumulating the fluff, lint and waterlogged ink from the pyramid. Because of their small diameter the rollers rotate at high speed causing them to run warm, thus evaporating the moisture entrained in the ink.

ROLLER COVERINGS AND ROLLER MAINTENANCE

Most lithographic ink rollers are made of vulcanised oil or synthetic rubber. The most common vulcanised oil roller is the *Ideal* roller introduced in the U.S.A. in 1915. The roller stock is made of a resilient material obtained by reacting vegetable oils with sulphur chloride. The roller surface is covered by a resilient hard skin which has good affinity for ink and which only slightly absorbs the ink solvent. This type of material is water-resistant and has good dimensional stability in changes of temperature and humidity.

Recommended cleaners are paraffin and white spirit. Strong solvents should not be used.

Dry ink can be removed with paraffin or white spirit mixed with a little pumice powder.

Natural rubber is not used for ink rollers because it is adversely affected by ink solvents. *Synthetic rubber* such as Neoprene is now currently used, especially on high-speed machines where increased roller temperatures have to be considered.

Recommended cleaners are paraffin, white spirit, and secondary butyl alcohol mixed in equal parts with petroleum distillate containing an anti-oxidant.

Dry ink may be removed with caustic soda in 5 per cent solution, followed by a thorough washing with water.

Polyurethane is a man-made plastic which offers rollers with good tack and is unaffected by ink solvents. It finds particular application on rollers used for heat-set inks.

Recommended cleaners are paraffin and white spirit. Automatic wash-up has to be performed with care as these rollers are inclined to skid when covered with wash-up solvent.

Dried ink is particularly harmful to the polyurethane roller and should be avoided.

The printing-ink roller has undergone many changes since it was first introduced. New plastic materials are constantly being tested to improve on roller-ink transfer, reduction of heat and speedy cleaning from one colour to another. Properties required for lithographic ink rollers may be summarised as follows:

1. Dimensional stability during variations of temperature and humidity.
2. Permit good adhesion of the ink and good transfer qualities.
3. Unaffected by ink solvents, vehicles or ink constituents.
4. Have elasticity without deformation, resiliency yet hard enough to resist the tensions of ink tack.
5. Resistant to water and the chemicals normally used on the press.
6. Do not absorb ink, and permit easy cleaning.

ROLLER SETTING

The *metal distributing drive rollers* serve as starting-points for roller setting (Fig. 97). These rollers occupy fixed positions because they are geared. First check that all the metal rollers are correctly set in their respective bearing collars.

The *intermediate rubber roller* adjustments should now be released and a number of strips of plastic film, 30 mm wide and 0·1 mm thick, placed at intervals between the rubber roller and the metal distributor. Adjust the setting until the strips can be pulled with slight resistance. Use both hands to draw the strips out and adjust for even tension. Tighten the lock-nuts finally and check again before moving to the next roller.

Paper strips may be used in place of plastic film, although the use of film makes it possible to check the settings during the run without washing up as the plastic is unaffected by ink or water.

The *plate rollers* require careful setting. Usually the drive to the plate-inkers is directed through the metal distributor. If this is so, the inker must be set slightly harder to the metal distributor than to the plate in order to ensure that the plate-roller drive is not obtained from the plate cylinder. When setting the rollers to the plate cylinder

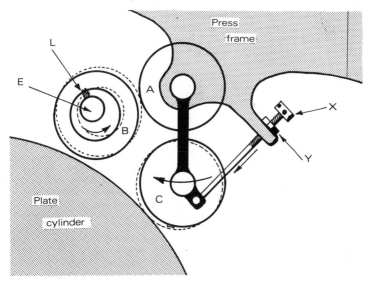

Fig. 97.—Diagram showing the principles of ink roller and damper adjustment. Roller A is a fixed metal roller. Rollers B and C are plate rollers. The locking screw L on roller B must be slackened off before moving the eccentric bush E to adjust contact between rollers A and B. The adjustment between plate and roller C is made by slackening off locknut Y and turning the adjusting screw X. Note that roller C makes an arc movement round roller A. Set rollers A to B first, and then roller C to plate.

the cylinder must be correctly dressed with plate and packing. To check the plate-roller setting, run a small amount of ink on to the rollers and drop the plate-inkers on to the plate while the cylinder is stationary. A strip of ink will transfer to the plate and this will indicate clearly the setting. The width of the strip of ink should approximate to 0·3 mm for a medium-size press and to 0·5 mm for a large press. A further check may be made while the press is running. Place a finger lightly on the plate-roller collar. As the roller passes over the cylinder gap slight movement will be felt. Should this movement be an appreciable bump the roller is set to the plate too hard.

DAMPING SYSTEM

The damping system is designed to apply an even film of moisture to the plate while the press is travelling at speed. The conventional system has two plate-damping rollers which are covered with fabric, driven by a metal reciprocating roller. Water is conveyed to the metal roller via a moving feed roller from the fountain roller which rotates in a trough of fountain solution.

FOUNTAIN ROLLER

This large roller rotates at a variable speed in a trough of water. The rotation may be obtained by a separate electrical motor, by gears linked to the machine drive, or by pawl and ratchet, the last being quite common (Fig. 98). Gear-driven rollers give a selection of roller

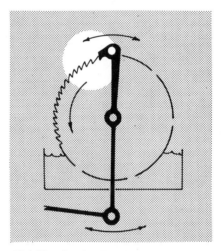

Fig. 98.—Pawl and ratchet mechanism.

speeds dependent on the construction of the gear-box. Electrical motor drives are normally found on high-speed presses and give a wide range of speeds. With the pawl and ratchet mechanism the stroke of the pawl can be adjusted to rotate the roller the required amount. The amount of water carried by the fountain roller as it rotates depends upon the following factors:

 1. The speed of rotation. This will determine the amount of water which is allowed to run back into the trough before the feed roller makes contact with the fountain roller.

2. The level of water in the trough will affect the amount of water carried by the fountain roller. A variation of water feed will occur if the trough is allowed to run low and is then filled up (Fig. 99). The constant-level trough is the remedy, and may be obtained by a gravity-feed bottle which maintains the level through a

Fig. 99.—High and low water-levels in the fountain trough affecting the amount of water fed into the damper system.

simple ball or air-flow valve, or the more sophisticated water-circulating unit. This type recirculates and filters the fountain solution which is kept in a reservoir. The level in the trough is maintained by the position of the return hose exit on the trough.

3. The surface of the fountain roller will determine the amount of water which is picked up from the trough. If the roller has a grained surface it will carry more than a smooth-surfaced roller. Again, if the fountain roller has a fabric cover a greater quantity of water can be carried on its surface. Most fountain rollers have a chrome-plated surface which has a good affinity for water and resistance to corrosion. With a sensible application of these variations the pressman can obtain the required amount of water transfer.

The layout of the image areas on the plate often require that the amount of water supplied to the plate has to be limited in certain areas. To do this adjustable *water-stops* are situated on the fountain roller, and may be in the form of squeegees or rollers which can be positioned anywhere along the fountain roller length and have adjustments to vary the pressure on the roller.

A number of variations of water-stop design are now found on modern presses. The most significant is the use of high-velocity air-nozzles which are used to force unwanted water off the fountain roller by directing the blast in the required position (Fig. 100).

Another design utilises a fountain roller which has a rubber spiral covering. The spiral is adjustable to vary the amount of moisture carried from the trough to the feed roller.

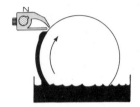

Fig. 100.—Air-blast water-stop.
N: adjustable nozzle.

DAMPING FEED ROLLER

This is a fabric-covered roller which travels between the fountain roller and the metal distributing roller. The movement is timed to complete its cycle on one or more revolutions of the press cylinders.

Uniform contact of the feed roller with the fountain and distributing rollers is essential.

To compensate for any variation in the diameter of the feed roller the return motion is usually spring-loaded.

On high-speed machines such as web-offset presses, the movement of the feed roller becomes so rapid that vibration, bouncing and an increase in noise results. To overcome this, the press-designers have dispensed with the moving roller and devised a number of systems which function better at high speed. The diagrams in Fig. 101 cover some of the suggested methods:

(*a*) This is a simple system where all the damping rollers are in constant contact with each other. The unit is currently used on web-offset presses.

(*b*) The conventional fountain roller is replaced by a flapper bar which makes intermittent contact with the distributing roller as it rotates.

(*c*) The brush-feed roller replaces the moving feed roller. As it rotates the bristles of the brush are bent backwards. As they move

Fig. 101.—Damping systems. (*a*) Rollers in constant contact. (*b*) Flapper bar causing intermittent contact. (*c*) Brush-feed roller. (*d*) Mullen system. (*e*) Air-mist damping. (*f*) Damping via the inking rollers.

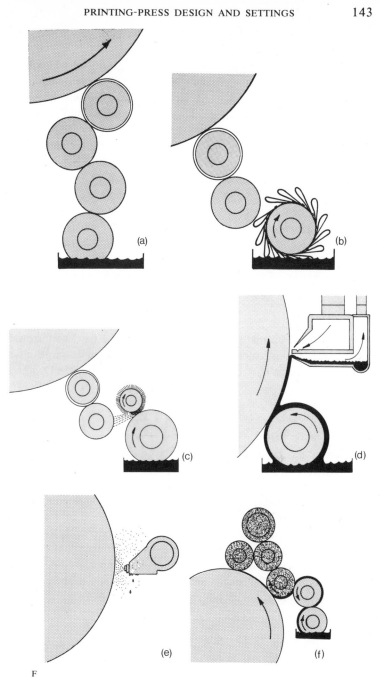

out of contact with the fountain roller the saturated bristles flick water on to the distributing roller.

(*d*) The Mullen system employs a fountain roller which is set so closely to the plate cylinder that the film of water on the roller surface contacts the plate. An air knife situated a little above the roller adjusts the thickness of the water film by applying high-velocity compressed air to the surface.

(*e*) The air-mist damping system applies water without the use of rollers. The theory of this system is plausible but has drawbacks in practice. The fine mist is not easily confined to a limited area, and tends to damp surrounding mechanisms, and the accumulation of water droplets round the plate clamps results in water being thrown out, thus marring the stock. The small globules of water which form on the image may also result in a spotty appearance on the final print.

(*f*) Damping via the inking rollers is a common method used in small offset printing. The system utilises the principle that the fountain solution remains as a separate damping agent while it is carried to the plate via the first inking roller. Special inks and fountain solutions are normally required to operate the system satisfactorily. A more sophisticated application of this system to large offset presses, especially web presses, is found in the form of the Dahlgren system.

DAMPER ROLLER COVERINGS

Molleton fabric cover

This cover has been used for a number of years in the trade, with very satisfactory results. Molleton fabric consists of a close-meshed cotton fabric which has short cotton loops forming a nap on its surface. It has good moisture-retaining qualities and presents an even texture for damping. The Molleton cover is supplied in a seamless tube form which only requires sewing at the damper ends to fix it to the roller. An underflannel fabric is often added to the roller covering to increase the water-storage capacity of the damper.

Most damper-roller stocks are made of synthetic rubber, the soft 20 °Shore rating giving flexibility to the damper surface.

Stockinette

This cover is made of closely woven cotton which has no nap surface and can be stretched to fit rollers of varying diameters. The absence

of nap on this cover results in less ink contamination of the surface and easier cleaning. Its moisture-retaining qualities can be improved by fitting it over an underflannel.

Paper damper covers

These covers are made of cellulose fibre and are similar in texture to paper. The fibres are specially selected for their hard-wearing and moisture-retaining qualities. The paper damper is usually supplied in roll form approximately 60 mm wide and 0·1 mm thick. The paper is wound in a spiral fashion on to a soft rubber roller stock. With an accurately ground roller very little variation in roller diameter occurs with use. Paper dampers are not cleaned as they are quickly changed when dirty, and the re-covered roller does not require re-setting. The cost of replacing the old paper cover is not likely to be more than the cost of cleaning a fabric cover, and this does not take into account the time spent on cleaning.

The recommended method for fitting the paper cover is as follows:

1. Place the paper strip in a bucket of water and allow it to soak thoroughly.

2. Begin the spiral by siting the correct angles to the roller, allow the paper cover to overlap the spiral by approximately 5 mm.

3. Apply tension to the strip, pulling slightly harder where the spiral overlaps. This will keep the spiral even.

4. Fix the end of the spiral by securing it with a tight rubber band.

Paper dampers may show signs of the spiral when printing solids. Another disadvantage is that the smooth damper surface does not remove hickies and fluff from the plate image in the same way in which fabric covers do. Pressmen often use a paper damper with a fabric damper to overcome these problems.

Synthetic damper covers

A further development of the paper damper is the cover made from synthetic fibres. The fibres chosen have good affinity for water but not for ink, are resistant to cracking and tearing and hold twice as much water as the paper cover. The cover is supplied in tube form and must be fitted to rubber stocks which are of suitable diameter. This is important because the sleeve is fitted to the stock when dry and shrinks initially when wetted to make a firm fit with the stock. It

does not require fixing at the ends. The synthetic cover is cleaned by wiping the surface once or twice a day with any non-oily solvent.

Both the paper and the synthetic fibre covering are unsuitable for use on the moving feed roller of the damping system.

Scavenger rollers

One of the problems which occurs with conventional damping systems is the accumulation of ink on the dampers. This occurs more frequently when printing large solids, or when the ink is of low viscosity.

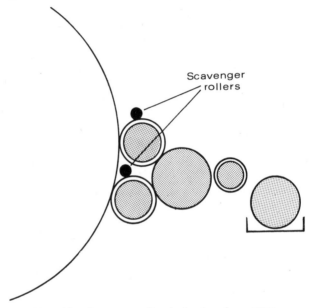

Scavenger rollers

Fig. 102.—Scavenger rollers in the damping system.

The metal reciprocating roller in the damper system applies drive to the dampers and transfers water from the feed roller. Pressmen generally desensitise this metal roller to prevent it picking up ink. It is not uncommon, however, to find a pressman who uses the metal roller as a scavenger by allowing it to pick up ink from the dampers, thereby keeping them clean. The metal roller is cleaned readily with a cloth. Designers have known this, but realise that if the reciprocating roller becomes covered with ink it does not transfer water so readily. A reciprocating brass roller with a spiral of chromium on its surface

has been designed to act as both a scavenger and water distributor. Because brass is an oleophilic metal it will attract the ink out of the dampers, leaving the chrome free to transfer moisture. A number of years ago P.A.T.R.A. proposed the fitting of small-diameter brass or copper rollers to the damping system to act as scavengers. These rollers were made with serrated surfaces and simply rested by their own weight on each of the dampers (Fig. 102).

DAMPER SETTING

The damper rollers are set in in the same manner as the ink rollers. A number of strips of plastic film 30 mm wide and 0·1 mm thick should be used. Dampers are usually set when wet because the moisture alters the diameter slightly. The following sequence may be followed:

1. Fit the plate and correct packing to the cylinder.
2. Rotate the cylinder until the plate is situated behind the dampers.
3. Slacken off the damper adjusting bolts and set to the metal distributor first.
4. Follow the sequence as for setting ink rollers. Take care to set the damper slightly harder to the distributor roller than to the plate.

The surface speed of the rotating damper should be the same as the surface speed of the plate if scrubbing and skidding are to be avoided. The recommended diameter for the dampers should, therefore, be closely followed.

FEEDER

The press feeder functions by separating and forwarding the stock a sheet at a time. The sheet passes down the feedboard where it is positioned correctly before passing through the impression nip.

Modern presses operate at high speeds and require the feeder to give accurate, trouble-free service with varying substances of stock. There are a number of current feeders which conform to two basic design types: the single-sheet feeder, and the stream feeder.

SINGLE-SHEET FEEDER

This type of feeder separates and forwards one sheet at a time to the feedboard. Figure 103 shows the main operations of this type of feeder.

The pile-height governor is adjusted to raise the pile automatically to the most suitable working height. If the pile is set too high the feeder mechanism may feed more than one sheet at a time. If it is not set high enough the suckers may miss the sheet or cause intermittent sheets to be forwarded.

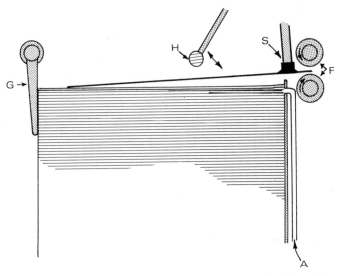

Fig. 103.—The single-sheet feeder. A—air blast, G—pile guide, H—pile-height governor, S—suckers, F—forwarding rollers.

Double sheets are avoided if the vacuum in the suckers is kept to a minimum. Suckers are often designed to tilt at a sharp angle once they have taken hold of the top sheet; this causes the adhering double sheet to drop off (Fig. 104). This angling facility is adjustable for varying substances of stock. The sucker should be set so that at its lowest point it does not force the separated sheets back into close contact with the pile. The sucker should contact the floating top sheet only (Fig. 105).

The working sequence of the single-sheet feeder (Fig. 103) is as follows:

1. The pile-height governor senses the height of the pile and automatically raises it to a predetermined position.

2. The air-nozzles situated at the front, sides and rear of the pile force air into the top sheets of the pile, partially separating them.

3. The front suckers descend and take hold of the sheet.

4. The forwarding rollers lift and the sheet is moved forward by the suckers until the leading edge of the sheet is between the rollers.

5. The forwarding rollers close on to the sheet and it is conveyed to the feedboard.

The single-sheet feeder has to operate at a speed comparable with the rotation of the press cylinders. This means that the whole operation of delivering a sheet from the pile to the front lays must take

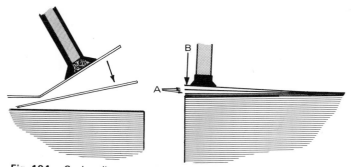

Fig. 104.—Sucker tilt to separate double sheets.

Fig. 105.—Sucker contact with the top sheet without forcing the sheet back to the pile. A—air blast, B—lowest point of sucker.

place in a short space of time. To prevent the sheet bouncing at the lay stops at high speed a number of slow-down devices in the form of suckers or grippers are often used to arrest the sheet near the lays and assist in the final registration without undue movement of the sheet.

The single-sheet feeder is generally found on smaller presses which run at speeds of about 6000 s.p.h. High-speed machines require the smoother action of the stream feeder.

STREAM FEEDER

With this type of feeder a continuous stream of sheets is conveyed to the feedboard, each sheet overlapping its fellow by approximately

one-third. On the single-sheet feeder there is a gap between the flow of sheets corresponding to the distance occupied by the depression gap of the cylinder. When one sheet is taken by the grippers the following sheet has to move rapidly to the front lays and be located in position in time for the grippers to grip the sheet after one revolution. The stream feeder functions by overlapping the sheets so that the distance to be covered by each sheet during a cylinder revolution is cut by two-thirds.

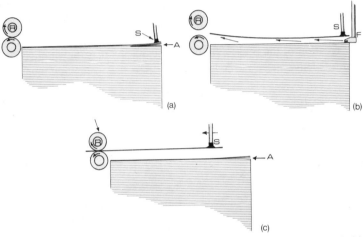

Fig. 106.—The stream feeder. A—air-blast separation, S—sucker, F—hold-down foot, R—forwarding rollers.

The sequence of operation of the stream feeder (Fig. 106) is as follows:

(a) Air is forced into the back edge of the pile separating the top sheets. The rear suckers descend and take hold of the top floating sheet.

(b) The suckers raise the back of the sheet and the hold-down foot descends to firmly hold the remaining sheets of the pile. This hold-down foot often acts as a pile-height governor. A stream of high-velocity air is now directed under the top sheet, lifting the front edge to a level with the forwarding rollers.

(c) The sheet is now moved forward on its cushion of air to pass between the forwarding roller and the drop wheels which

close on to the sheet and convey it forward. As the sheet is taken by the forwarding roller, the back separation unit begins its next cycle.

PILE HEIGHT

The height of the pile is important if the feeder is to operate without fault. The mechanism which controls the height relies on a sensing finger situated on the top of the pile. Correct sensing will take place so long as the top of the pile is flat and level. Paper piles which are waved or bowed will give trouble due to misreading by the pile-height sensor. In order to rectify this, wedges should be placed in the side of the pile to level the top and improve the feeding operation.

The height of the pile should be adjusted so that when the suckers reach their lowest point, the floating top sheet makes good contact. Should the sucker force the top sheet back to the pile the advantage of the air separation will be lost.

AIR SEPARATORS

On the stream feeder, air separators have a dual function. The first is to project a stream of air into the top sheets to break any vacuum or adhesion between the sheets, and to lift the top sheet clear of the pile. The second function is to send a stream of air beneath the lifted sheet to raise the leading edge of the sheet to the level of the forwarding roller. If the feeder is fitted with adjustable air-nozzles they should be set to blow a stream of air towards the corners of the leading edge of the sheet. The air velocity of the second-stage blowers should not be so strong as to make the sheet ripple violently.

COMBER SEPARATORS

This type of separator takes the form of a comber wheel which has bead-like segments set in its outer edge (Fig. 107). The wheel is positioned close to the back edge of the pile, and it functions by fanning the top sheets into a slight bulge by its rotary action.

SUCKERS

These cone-shaped discs are designed to make firm contact with the sheet and lift it by suction. The suckers may be made of metal for thin stock and rubber for heavier stocks. The general tendency,

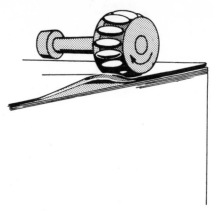

Fig. 107.—Comber separator mechanism.

however, is to use a flexible rubber sucker for all grades of stock. Separating suckers take hold of the top sheet and lift it clear of the pile. Many feeders have a different set of forwarding suckers which take over from the separating suckers allowing the next cycle to take place in a short space of time. Piston suckers are cleverly designed to extend on a telescopic principle until the sucker makes contact with the sheet. On contact, the vacuum is completed which causes the piston to snap back and lift the sheet clear of the pile. Piston suckers must have a free action and should be cleaned periodically with a non-oily solvent, or better, with a dry cloth.

FLIP ASSEMBLIES
These assemblies are positioned close to the edge of the sheet which is lifted by the suckers. They consist of short tongues of sprung metal or bristles of nylon. As the sheet is lifted, its edge is flipped by the assembly to discourage double sheets sticking together. The assembly should be positioned close to the separating sucker, but not so close as to pull the sheet off, or to damage it.

FORWARDING UNIT
As its name implies, the forwarding unit receives the sheet from the feeder and forwards it to the feedboard. It usually consists of a metal roller with a serrated surface which is driven in conjunction with a number of endless conveyor belts which span the feedboard. Above the forwarding roller are two or more drop-wheel assemblies. These make intermittent contact with the roller to nip the sheet which has

been presented by the sucker unit. The nip pressure is adjustable and must be set evenly, otherwise the sheet will not move forward squarely. If the rubber drop wheel is set with too much pressure the rubber will be forced into a bulge which will effectively increase its surface speed. Intelligent use of these wheels can, therefore, ensure that the sheet is forwarded in a manner suitable for the job.

FEEDBOARD EQUIPMENT

CONVEYOR TAPES

These endless belts are made of hard-wearing material, sufficiently coarse to friction drive the paper down the feedboard at constant speed. Sheet timing depends on the drive which the tapes control, and it is important that the tension is correct, and that the tensioning rollers beneath the feedboard are free to revolve. The tapes may be positioned anywhere across the feedboard. The general setting is to position two tapes in line with the front-lay stops, and the other tapes at equal distances apart to suit the sheet size.

CONVEYOR ASSEMBLIES

Two or more feedboard rails are situated over the feedboard. The running-in wheels, brushes and ball assemblies are attached to the rails by movable clamps. Figure 108 shows the recommended positions which each of the individual assemblies should occupy.

RUNNING-IN WHEELS

These wheels must be positioned over the conveyor tapes and tensioned to provide sufficient traction to the sheet. The first pair of wheels must be positioned so that they take over the forward drive of the sheet before the drop wheels on the forwarding unit are raised.

The number of wheels used will depend on the size of the sheet. They should not be positioned to contact the sheet at any point when the sheet has reached the front-lay stops. At this point the side-lay mechanism moves the sheet sideways, and if the sheet is pinched by the running-in wheels the sideways movement will not take place correctly.

ROTARY BRUSH WHEELS

These wheel assemblies should be positioned to contact the back edge of the sheet when it has reached the front-lay stops. Adjust them to

Fig. 108.—Feedboard controls. A—trailing brushes, B—rotary brush wheels, C—ball control assemblies, D—forwarding roller, E—drop wheels, F—side-lay movement, G—running-in wheels, H—front- and side-lay stops.

give a gentle stroking action to the sheet, but not to interfere with sideways movement.

TRAILING BRUSHES

Position these brushes just off the back edge of the sheet when it is at the front-lay stops. Like the rotary brushes, these brushes are used to discourage the sheet from bouncing back from the front-lay stops when the press is running at speed. The trailing brushes are the only assemblies which do not have to be positioned over the conveyor tapes.

BALL CONTROL ASSEMBLIES

These are the only sheet controls which may be used when the sheet is moved sideways to the side-lay stop. The ball comes in various sizes and weights to suit different substances of stock. When setting the ball assembly take care that the ball cage does not foul the sheet.

NO-SHEET DETECTOR

Sheets which arrive late at the front lays, or sheets which are missed altogether, must be detected and the cylinders tripped out of impression. The no-sheet detector is a sensitive device, usually situated at the front lays. Detector designs vary with electrical, photoelectric

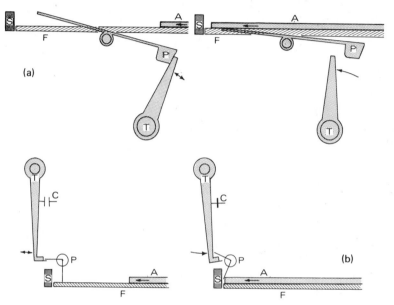

Fig. 109.—The no-sheet detector mechanism. (*a*) Mechanical sequence in operation. (*b*) Electrical contact.

and mechanical types being quite common. The basic principles of the mechanical detector (Fig. 109) are as follows:

1. The sensing mechanism consists of a delicately balanced pendulum P which is situated either above or below the feedboard F. The approaching sheet A moves forward to the lay stops S, tilting the pendulum and thereby allowing the trip latch T to complete its movement and either set a mechanical sequence in operation (Fig. 109 (*a*)), or make an electrical contact C (Fig. 109 (*b*)). Both result in the actuation of the cylinder pressures.

2. No-sheet detectors are also situated in the gripper pads and function by simple electrical contact if a sheet fails to enter the gripper.

3. Another type utilises a photoelectric cell which is situated close to the front lays. A beam of light is reflected into the eye of the photocell from the paper when it is positioned at the lays

Fig. 110.—The photoelectric cell no-sheet detector. (*a*) No-sheet detector cell unilluminated. (*b*) Beam reflected from the base of the sheet causing a current to flow through the cell.

correctly (Fig. 110). The minute signal is amplified and directed to operate a solenoid which actuates the cylinder pressure (*see* page 124).

TWO- OR DOUBLE-SHEET DETECTOR

This detector is usually situated above the forwarding roller. Mechanisms are electrical or mechanical, and function by either stopping the forward motion of the double sheet, or by tripping out the feeder and impression.

Cam-type detector

This incorporates a rotating cam which is adjusted to allow single sheets to pass but which will pinch on a double sheet. The following two methods are in use:

1. The cam may seize the double sheet and prevent it moving forward to the front lays thus actuating the no-sheet detector.
2. The cam may be designed to operate an electrical contact switch or a trip-latch mechanism which will trip the feeder, and cylinder pressures.

Caliper-type dectector

This has a caliper roller which is finely set to allow only one sheet to pass. When the double sheet passes, the roller lifts sufficiently to make the electrical contacts meet, thus actuating the cylinder tripping mechanism.

FRONT LAYS

The front lays are adjustable stops situated at the forward end of the feedboard. The position of the stop determines the amount of grip which the grippers take on the leading edge of the sheet. If the grippers take too large a grip on the sheet, the edge of the paper may be buckled or damaged. A small grip may result in the sheet being pulled out of the grippers during impression. The lays should be adjusted to give an equal grip across the sheet. Figure 111 shows a typical front-lay assembly.

Fig. 111.—The front lay.

The stop S can be positioned by adjusting the screw A which has a click-stop tumbler C permitting the pressman to gauge the amount of movement taken. The anti-buckle spring prevents the sheet buckling as it contacts the front-lay stop. The spring must be adjusted by the screw B to give a gap at G, which is equivalent to the thickness of two sheets of regular stock.

When positioning the stop on the keyed shaft K during make-ready, take care to give adequate control to the sheet. The front-lay adjuster should also be set in its central position to permit adequate plus or minus movement during makeready.

SIDE LAYS

The side-lay position of the sheet is controlled by a mechanism which moves the sheet sideways after it has settled at the front-lay stops. The mechanism functions by either pushing or pulling the sheet to

the required position, and it can be set to do this from both the near and the far sides of the press.

SIDE-LAY SETTING

The working sequence is as follows:

1. Adjust the side lay and the position of the paper pile so that when the sheet is moved to the stop the sheet movement does not exceed 5 mm. Excessive movement at this point will not improve the register and may cause the sheet to twist.

2. Check the pressure pinching the sheet and ensure that there is no buckle or damage to the sheet when it contacts the stop.

3. Centralise the side-lay adjustment at pre-makeready stage to allow plus or minus movement on the micrometer screw.

PUSH LAYS

This type of lay is usually found on presses taking a maximum sheet size of A2. It functions satisfactorily on rigid and heavy stock, but is not suitable for large sheets or flimsy stock.

The principle of the push lay is simple. An adjustable stop pushes the sheet to the required position and then moves out of the way as the sheet is taken by the grippers. To give more rigidity to the sheet while it is pushed, bars may be fitted to form a corrugation in the sheet at the line of contact.

PULL LAY

This type is more common on large presses. It functions by gripping the sheet and pulling it up to an adjustable stop. The following designs are in use:

Finger lay

This incorporates a finger which advances over the top of the sheet, closes to grip the sheet, and pulls it to the stop. The pressure of the finger on the sheet is adjustable and must be set to grip the sheet firmly, yet allow the finger to slip over the sheet when the lay stop is contacted.

Roller-finger lay

The principle of the finger lay is incorporated in this design. It has a spring-loaded roller above the sheet which descends to grip the sheet on to a sliding finger situated below the sheet.

Roller lay

This design (Fig. 112) has a continually rotating roller D situated below the feedboard. The edge of the advancing sheet passes over this roller and is pinched firmly by the upper roller F which descends within a fixed cycle. The pressure of the upper roller is adjustable by

Fig. 112.—The roller lay. A—upper roller adjuster, B—anti-buckle plate, C—eccentric roller adjuster, D—lower roller, E—side-lay stop, F—upper roller.

a screw A, and the anti-buckle plate B is adjusted by moving the eccentric bush C.

GRIPPERS

Grippers are metal fingers which take hold of the sheet at the leading edge after it has been positioned at the lays, and convey it, without movement, through the impression nip to the delivery pile. The grippers must hold the sheet firmly without marking or damaging the paper. In the case of the impression cylinder grippers, the sheet has to be held against considerable stress as it passes between the impression nip.

The construction of the gripper is simple. It has a metal finger located on a shaft, and it holds the sheet by closing on to a gripper pad. The following designs are in current use:

Solid gripper (Fig. 113)

This has a finger which is adjusted for grip and position by a clamp located on the gripper shaft. When closed it contacts the solid

gripper pad. This type of gripper requires very careful setting and is usually found on older presses.

Spring gripper

This gripper (Fig. 114) has an adjustable finger constructed in two parts. The body of the gripper is bolted to the shaft and the finger swings on a sprung pivot. Grippers of this type are easy to set and do

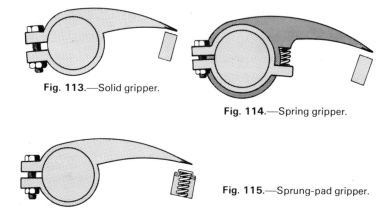

Fig. 113.—Solid gripper.

Fig. 114.—Spring gripper.

Fig. 115.—Sprung-pad gripper.

not require resetting for different thicknesses of stock. When setting the gripper, ensure that the spring is not completely compressed when it contacts the gripper pad.

Sprung-pad gripper

A further modification of the solid gripper (Fig. 115). The finger segment is fixed to the shaft, and the gripper pad is spring-loaded. Setting is the same as for the spring gripper.

 The grip taken on the sheet is dependent on the roughness of the surface of the finger and pad, and on the pressure applied. The face of the gripper finger and pad is usually serrated or roughened to give good grip to the paper. Old grippers can be revived by stroking the surfaces of the gripper and pad with a coarse file, or by sticking emery cloth to the worn faces.

 Most gripper assemblies open and close by a cam-roller mechanism situated at the end of the gripper shaft. The following two types are in current use:

1. *The spring-close gripper* (Fig. 116). This gripper assembly is opened by the rising cam C and closed by the tensioned spring S when the cam roller follows the low point of the cam.

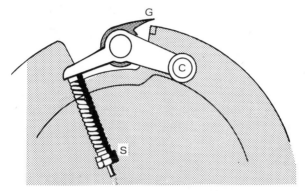

Fig. 116.—The spring close gripper. C—cam follower, G— gripper, S—spring.

2. *The forced-close gripper* (Fig. 117). This system has been designed to give more control over gripper pressure. The gripper assembly is opened by the spring S and closed by the cam roller C when it follows the high point of the cam.

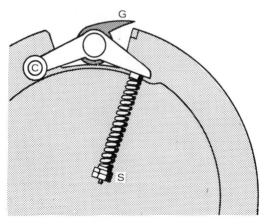

Fig. 117.—The forced close gripper. C—cam follower, G—gripper, S—spring.

PAPER-INSERTION SYSTEMS

After the sheet has been registered at the lays, it must be inserted through the impression nip without movement otherwise faulty registration will occur. Insertion systems have evolved over the years with a number of different current designs, each of which offers its own particular advantages.

TUMBLER GRIPPERS

This gripper assembly (Fig. 118) is located in the depression gap of the impression cylinder. It is operated by a tumbler mechanism which opens the grippers 180° to allow them to clear the feedboard, and then tumbles them closed to grip the sheet as they pass. This is

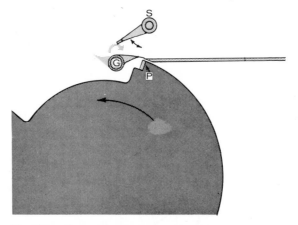

Fig. 118.—The tumbler gripper. G—gripper, P—gripper pad, S—front-lay stop.

the simplest type of insertion system and it is found on many presses. It has the disadvantage of leaving the sheet without positive control just before the grippers close, because the front-lay stops have to move out of the way. The layout design of the impression cylinder and feedboard is also limited to provide a correct angle for the sheet edge and the gripper closure to coincide.

On high-speed pressses a positive insertion system is used which allows the grippers to close on the sheet while it is being held in position at the lay stops.

SWING-ARM GRIPPERS

Figure 119 shows the basic construction of this type of insertion device. The swing arm A swings in a pendulum fashion to make contact with the sheet while it is still controlled by the lay stops S. The sheet is then conveyed forward in an arc coinciding with the depression gap in the impression cylinder. The impression-cylinder grippers close on the sheet while it is being held by the swing-arm grippers. Both grippers hold the sheet momentarily, and then the swing arm releases the sheet and moves to grip the next sheet.

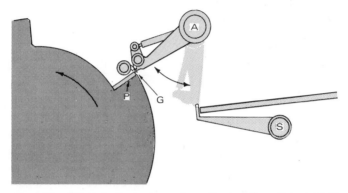

Fig. 119.—The swing-arm gripper. A—swing arm, G—gripper transfer point, S—front-lay stop, P—gripper pad.

Gripper systems which exchange a sheet in motion are called *transfer grippers*, and are found on insertion systems, transfer drums and delivery systems.

ROTARY GRIPPERS

This design (Fig. 120) is an extension of the swing-arm gripper; the gripper assembly is housed in a rotating shaft. The shaft rotates at low speed to grip the sheet when it is controlled at the lay stops; the shaft then rotates at an accelerated speed to match the speed of the impression cylinder where transfer takes place. The feedboard also alters its pitch during this sequence to allow the rotary grippers to clear the leading edge of the sheet.

Another design incorporates a swinging gripper assembly within a rotary shaft. The rotary movement advances the sheet into the impression cylinder grippers while the swinging action of the gripper

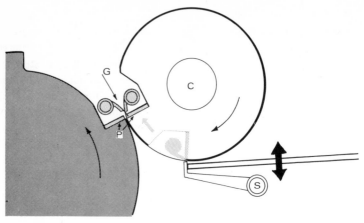

Fig. 120.—The rotary gripper. G—gripper transfer point, R—rotary shaft, S—front-lay stop, P—gripper pad.

assembly allows the grippers to make positive contact with the sheet on the feedboard. This system does not require a pitching feedboard.

FEED-ROLL INSERTION

In this system (Fig. 121) the sheet is pre-registered against a number of front-lay stops. Situated beneath the feedboard are four or more small-diameter wheels E which are aligned with an equal number of cam-shaped wheels located on a shaft above the feedboard C. When the sheet has been positioned at the lays the cam wheels rotate and

Fig. 121.—The feed-roll insertion system. A—paper hold-down, B—gripper stop, C—rotary cam wheels, D—front-lay stop, E—lower pinch rollers.

pinch the paper between the cam and the lower rollers. The lays move out of contact with the sheet and the cam rollers forward the sheet at a speed slightly faster than the speed of the impression cylinder. The sheet is forced into the impression cylinder grippers up against gripper stops B. The accelerated speed of the sheet causes the front edge to buckle slightly as it contacts the gripper stops prior to the grippers closing on the sheet. This buckle is known as "overfeed" and can be adjusted for sheet registration.

Three-point register system

Apart from the feed-roll system, most presses register the sheet by positioning it against three points on the feedboard: two front-lay stops and one side-lay stop. The system is both simple to use and accurate. The front-lay stops may be located to slide into the required position along a shaft, or a number of fixed stops may be situated at short distances from each other on a shaft; the stops not required are simply isolated by adjustment.

TRANSFER GRIPPERS

Transfer grippers have already been mentioned under "Swing-arm grippers." At the point of transfer both sets of grippers hold the sheet while the cylinders rotate through approximately 10 mm of circumferential movement. The transfer has to be timed to be clean and positive. On multicolour presses there may be upwards of a dozen sets of transfer grippers, and accurate sheet registration will depend on how these grippers are maintained. Pressmen should not neglect to oil, clean and check them regularly.

PAPER CONTROLS

When the paper passes through the impression nip considerable stress is applied to the paper. As the rubber blanket makes contact with the leading edge of the impression cylinder it is subject to tangential forces which tend to "iron out" by escaping to the sides of the blanket. These forces are transferred to the paper as it passes through the nip. Figure 122 shows how the force lines, if visible, would look. Because the paper is not dimensionally stable these stresses cause the back edge of the sheet to fan out.

Figure 123 shows an image printed on a sheet in an ideal manner (a). When the back edge of the sheet fans out during impression the

Fig. 122.—Force lines on paper
passing through impression.

image is correct to size (b), but when the sheet reverts to its former
shape the image also changes its dimension (c). When this occurs on
multicolour work the back edge of the image will not fit (d).

A remedy for this is proposed by bowing the front edge of the
sheet and thereby fanning out the back edge before the first pass
through the machine (e). The back-edge fan out due to the impression
stress also increases the fan out, with the result that when the sheet

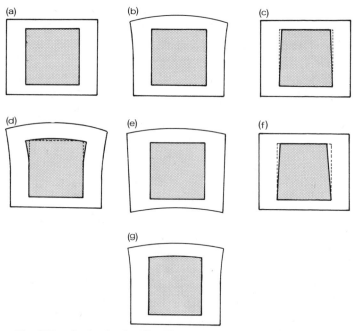

Fig. 123.—Back-edge fan distortion of the image and how this can be
controlled.

snaps back to its former size the image is slightly smaller than usual (f). The sheet is now printed with the second colour in the normal way. Because the sheet fans out on the second pass the altered image resumes its true shape and the second colour will fit (g).

Two different approaches have been made to deal with this problem. The first utilises the feed-roll system. Using this principle of forced feeding, the multiple gripper stops are set in a shallow arc. The sheet is forced into the shape of the arc, thus fanning out the back edge. Machines using the feed-roll system usually supply a variety of stops to allow for this adjustment.

Fig. 124.—The transfer gripper paper control which can be adjusted via the centre slide A to counter back-edge fan.

A second approach to overcome the problem employs a gripper shaft which can be adjusted to pull the leading edge of the sheet into an arc after it has been gripped. Figure 124 shows in an exaggerated form the movement possible on this type of mechanism. It has the advantage that the arc can be adjusted while the press is in motion, and it is suitable for use on transfer cylinders on multicolour machines.

THE DELIVERY

The delivery usually consists of a pair of endless chains which carry the transfer gripper assemblies. These grippers grip the sheet while it is passing through the impression nip. Any slackness in the chain or faulty grip will cause bad delivery.

SKELETON WHEELS

This unit usually consists of large-diameter wheels or cut-out discs which are located by adjustable collars on a shaft (Fig. 125). The shaft may also serve as a drive for the delivery chains.

The skeleton wheels serve to give support to the wet side of the sheet as it makes a sharp turn from the impression cylinder to the delivery point. The wheels or discs have their outer edges formed to a fine tooth to limit the area of contact with the wet sheet. The wheels may be positioned on the shaft to avoid making contact with the

Courtesy: Maschinenfabrik Augsburg-Nurnberg

Fig. 125.—The skeleton wheel unit.

sheet in the inked areas. Another modification consists of several outer segments to the wheel which can be adjusted to avoid inked areas.

TRANSFER DRUMS

These drums or cylinders are more common on multicolour presses. The drum is designed to do the same thing as the skeleton wheel, its construction is light, and it is normally equipped with gripper assemblies. The drum may be dressed with pads, wire coil, grater foil, rubber grommets or card cut-outs, all of which serve to support the sheet without contacting the wet areas of the print.

The skeleton wheel is limited to giving support to the sheet in the gutter areas of the print. The transfer drum (Fig. 126) has the advantage of giving support to the sheet even though it may not have gutters.

Air-cushion transfer drums

This design utilises high-velocity air which is directed against the sheet as it passes round the transfer cylinder. The air cushions the

Courtesy: Maschinenfabrik Augsburg-Nurnberg

Fig. 126.—The M.A.N. transfer drum showing adjustable wire-coil paper supports.

wet sheet to prevent marking, and also assists in surface drying of the ink film. The installation tends to be expensive, however, and rather noisy in operation.

FINAL DELIVERY MECHANISMS

The chain grippers, having passed round the skeleton wheel, convey the wet sheet with its face uppermost to the delivery pile. The gripper-release cam lifts the cam roller and the sheet drops on to the pile where it is jogged to form a neat pile.

Correct design and adjustment of the delivery will determine whether the sheets are marred or correctly stacked.

Figure 127 (*a*) shows a faulty delivery. The sheet is released by the grippers at an early point, which causes the leading edge of the sheet to fall across the top sheet of the pile A. This may result in sheet-marking, and a tendency for the falling sheet to prevent a buffer of air forming between itself and the top sheet, thus causing set-off.

Figure 127 (*b*) shows a correct delivery, where the sheet is released at B and falls vertically on to the pile, trapping air beneath it.

Large sheets are supported by additional delivery fingers, which hold the sheet until the back edge of the sheet is clear to drop

Fig. 127.—Delivery systems. (*a*) The faulty delivery system in which the sheet drops on to the pile too early at A. (*b*) The correct delivery system allows the sheet to fall vertically at B.

vertically on to the pile. On high-speed presses, a vacuum roller slow-down device is incorporated in the delivery, its function is to prevent the sheet bouncing against the back-sheet guides.

Certain delivery mechanisms have a special sheet-slitting device which cuts the printed sheet into two halves.

JOGGERS

These moving metal-sheet guides may be adjusted to jog the falling sheets into a neat pile. They operate on a mechanical or pneumatic principle and are timed to jog the sheet after it has been released by the delivery grippers. When setting the joggers, inch the machine until the joggers are in the fully closed position. At this point it should not effect a buckle in the sheet.

Paper delivered with a pronounced curl often presents jogging problems, which can be remedied by placing wedges in the pile. If correctly placed, the wedges will cause the sheets to flex into a shape which is sufficiently rigid to jog.

THE EXTENDED DEEP-PILE DELIVERY

With the increase in machine speeds and continuous-feeding facilities, the extended deep-pile delivery has been developed (Fig. 128). It has a double advantage in that it can take a deeper pile before

(a)

Courtesy: Color Metal Ltd.

(b)

Fig. 128.—Color Metal Champion 142 offset press. (*a*) The extended deep-pile delivery. (*b*) Outline of sheet path.

changing the pile-stand becomes necessary, and because it is set further away from the printing unit the ink film has additional time to gain an initial set.

DOUBLE DELIVERY

A further extension of the deep-pile delivery, this system utilises two delivery piles, the sheets being delivered to alternate piles during the run. This gives the ink more time to set, and enables one pile to be changed while the other is being used.

Multicolour lithographic machines

Multicolour printing-presses have been in use for over a century. As early as 1913 a four-colour satellite lithographic web press was designed for printing on fabrics. Modern multicolour machines are being continually developed to higher standards of performance utilising all the new materials and technical skills which are becoming available.

The multicolour press is designed on similar principles to the single-colour machine. The differences lie in the systems of transferring the printed sheet from one unit to another, and the registration devices necessary to make this an accurate operation.

UNITS AND TANDEMS

Two-colour machines are constructed on the tandem or modular-unit principle. The tandem press consists of two single-colour units placed in line. The printed sheet from the first unit is conveyed into the second unit before being delivered to the pile (Fig. 129).

The modular-unit press is a two-colour machine specifically designed as a two-colour press, and often incorporates a single-impression cylinder. The modular-unit press lends itself to manufacturing economies, and offers the facility of being coupled together with another modular unit in tandem to form a four- or six-colour press.

The single-colour modular-unit press is capable of being coupled in tandem fashion to print anything from two to six colours, and perfect as well. This allows the printer to begin with one modular unit and add to it as he requires to form a multicolour press.

TRANSFER SYSTEMS

The chief feature of the multicolour press is the method used to convey the sheet from one unit to another. The modular unit often incorporates a common impression cylinder serving one or more blanket cylinders. Transfer problems do not arise with this type of press. The tandem press, however, requires the sheet to be conveyed between the units, passing through as many as six impression nips and requiring a large number of transfer gripper points.

(a)

Courtesy: Color Metal Ltd.

(b)

Fig. 129.—Color Metal Champion 242 two-colour press. (*a*) Two-colour unit in tandem. (*b*) Outline of sheet path.

DRUM TRANSFER

In place of the delivery chain of the single-colour press, transfer drums complete with grippers convey the sheet to the next unit. The number of drums used is limited by the required flow path of the sheet. Figure 130 shows that the number of drums between the units will be (a) one, (b) three or (c) five. An even number of drums will result in the sheet travelling in the wrong direction at the next unit.

CHAIN TRANSFER

Some tandem presses use a chain-transfer system between the units (Fig. 131). One manufacturer has employed the chain-gripper system to convey the sheet from the feedboard to the delivery without transferring the sheet at any point.

Chain-transfer systems require correct chain tension and smoothness of operation to ensure accurate registration. Wear in the chain

Fig. 130.—Drum transfer. (*a*) One drum. (*b*) Three drums. (*c*) Five drums.

sprockets, looseness in the links or malfunction of the chain-link rollers due to accumulated dirt, grease and spray powder, may affect register.

The following points should be considered in the design of transfer systems:

1. If the number of transfer grippers used is high, the possibility of faulty registration is increased.

2. The angle at which the paper is conveyed round the drums must be taken into account to minimise sheet-marking, etc.

Fig. 131.—Chain-transfer system.

3. With the increase in the number of transfer drums, extra makeready time will be required to dress the drum surfaces to prevent sheet-marking.

PERFECTING PRESSES

The perfecting machine prints both sides of the sheet in one pass through the press. Design features vary, with some machines using an impression cylinder and others employing the blanket-to-blanket principle which is commonly used on web presses. An unusual design featured by an American manufacturer makes use of an impression cylinder perfecting unit which can also be arranged to print two colours on one side of the sheet in one pass through the press.

LUBRICATION

The lubrication of the moving parts of machinery is important to the correct working of those parts over long periods (Fig. 132). The

Courtesy: Harris-Intertype Ltd.

Fig. 132.—Lubrication system on the side frames of the Aurelia Multicolour offset press.

G

press manufacturer supplies an oiling and greasing schedule, indicating the points which need servicing and specifying the type of lubricant. The following information is intended to give the lithographer an understanding of why lubrication is necessary, and the reason for specifying different types of lubricant.

THEORY OF BOUNDARY FRICTION

Although a metal surface may appear flat and smooth, when examined on a molecular scale even a highly polished surface will appear rough and uneven (Fig. 133). When two surfaces like this are

Fig. 133.—Schematic of the molecular surface of a highly polished metal.

brought together in contact under load, movement between the surfaces will be limited by the friction of the irregularities, and this friction will increase in proportion to the load.

Some materials, such as split mica, have no molecular roughness on the surface. When two pieces of such smooth-surfaced material are brought together under load, the surface molecules make such close contact that the two pieces act as one solid piece and a sliding movement is not possible at all. This indicates that the reduction in surface roughness is not the total answer to the reduction of friction between sliding surfaces.

Boundary friction is determined by the following factors (Fig. 134):

1. The nature of the metal. Molecular surface structure varies with the material.
2. The load applied.
3. The application of tangential force to produce a sliding movement.

FRICTION

When friction occurs the heat energy at the boundary of the two surfaces may raise the temperature of the surface molecules, causing a change of state from solid to liquid. When this happens the frictional forces drop steeply, which immediately suggests that the fluid interposed between the surfaces reduces friction. Metal surfaces which flow due to frictional heat will deform and, when the surfaces cool, a weld between them will form.

LUBRICANTS

A lubricant interposed between two sliding surfaces must reduce the contact of the rough molecular surfaces, resist deformation and limit surface temperatures. Suitable lubricants may be solid, liquid or gas,

Fig. 134.—Boundary friction.

Fig. 135.—The lowering of friction by placing another substance between sliding objects.

having been bonded to the sliding surfaces permanently or requiring intermittent application. An interesting statement about lubrication was made by the fifteenth-century genius Leonardo da Vinci: "All things and everything whatsoever how thin it be which is interposed in the middle between objects that rub together lighten the difficulty of this friction."

In the approach to lubrication, da Vinci's point is fundamental. Substances which can be placed between the sliding surfaces prevent direct frictional contact (Fig. 135).

It is well known that rolling produces less friction than sliding. The roller- and ball-bearing are based on this principle, the roller taking the place of the two sliding surfaces (Fig. 136).

A true fluid lubricant simulates this rolling principle on a molecular basis.

Fig. 136.—Lubrication. (*a*) The solid bush, surfaces sliding. (*b*) The bearing bush, surfaces rolling.

OILS AND GREASES

In the majority of cases, lubricants used for metal surfaces are based on mineral oils which prevent oxidation of the metal surface and which do not degenerate under the influence of bacteria as do vegetable oils. Very few lubricating oils, however, are simple liquids. Many substances are added to the base oil to fulfil a special lubricating requirement. Factors which influence the formulation of lubricants are as follows:

1. The type of surfaces; the metal or materials involved.
2. The action of the surfaces; rolling or sliding.
3. The load on the surfaces; constant, intermittent or impact loading.
4. The speed of the surface movement.
5. The environment of the surfaces: intense cold, high temperatures, dusty or damp conditions, etc.
6. Usually the heavier the load the greater the viscosity of the oil lubricant.
7. High speeds and heat may require colloidal lubricants such as graphite oils, and oils containing anti-weld agents.
8. Additional characteristics are given to oils to prevent them being thrown off parts moving at speed. Clinging properties are improved by adding fibrous elements to the lubricant.

Methods of application

The application of oil to moving parts is divided into the following three categories:

1. *Continuous.* The oiling unit consists of a pumping unit plus a filter and sump or reservoir. Pumps are operated by a belt, chain or reciprocating ratchet. If the pump is separate from the machine an electric pump will be used.

Metering valves or regulators. These are compact assemblies fitted to each lubricating point and are made up as follows:

(*a*) A filter.

(*b*) A metering pin floating in an accurately machined bore which controls the rate of flow.

(*c*) A check valve (Fig. 137) which keeps the tubing full of oil and opens with an increase in the oil pressure. This type of valve is non-adjustable and is selected for its flow rating.

Gravity feed. Commonly used on parts with limited movement, the oil is applied by gravity through a hole placed above the point of

Ball valve

Needle valve

Oil

Fig. 137.—Return check valve on the head of a lubrication nipple.

Fig. 138.—See-through reservoir with a gravity drip feed controlled by needle valve.

lubrication. This method has the disadvantage that foreign matter also enters the lubricating hole, but this may be partly rectified by placing a spring cap over the hole.

Drip feed (Fig. 138). This consists of a see-through oil-container with an adjustable drip needle to regulate the flow of oil to tubes which service various points.

2. *Intermittent.* Capillary units operate on the principle that resistance to flow along a capillary tube of a constant bore is

proportional to its length. This means that the quantity of oil delivered through such a tube of a given length is twice as much as a tube double its length, or half as much as a tube half its length.

By careful placing of the tubing in a hand pumping system the correct amount of lubricant is supplied to each point in the system.

Hand pumping is obtained either by a fixed pumping unit on the machine or by a separate hand pressure gun.

3. *Continuous oil circulation.* An extension of the continuous method above, these systems apply lubricating oil by flooding or cascading over the gear and bearing surfaces, not only to lubricate but also to cool heated components.

The lubricant in each case is drained by gravity to a sump, recirculating via filters, and sometimes via cooling apparatus, to a storage-tank whence it is pumped back to the point of application.

Grease is usually applied to slow-moving parts under constant load at intermittent periods. The common form of application is by high-pressure grease-gun through a grease nipple situated above the point of lubrication, or a nipple connected by tube to a lubrication point.

The Metal Decorating Press

MACHINE DESIGN

The printing unit of the metal decorating press (Fig. 139) is similar in layout to the standard paper printing-machine. The plate, blanket and impression cylinders are arranged to permit the fairly rigid sheet

Courtesy: Crabtree-Vickers Lta.

Fig. 139.—The Crabtree Y-type two-colour metal decorating press.

of metal to pass through the impression nip with little flexing of the sheet.

FEEDER

This is constructed of heavy robust materials. The average pile of tin-plate will contain approximately 1000 sheets and weigh about 1 tonne. The pile-lifting mechanism is, therefore, constructed to support such heavy loads.

SHEET SEPARATION

Non-ferrous metals such as aluminium are separated and forwarded to the feedboard in much the same manner as carton board on the paper press. Because of the weight of these metals the air blast and suction are greatly increased and suckers are of heavy construction.

Ferrous metals are separated by magnets which are arranged with the north poles at the side of the pile and the south pole magnets at the rear. The upper sheets of the pile are magnetised. Since like poles repel each other the top sheet will be repelled by the lower sheet and float on the magnetic field.

FRONT FORWARDING SUCKERS

These are also of heavy construction and may be assisted by piston-type suckers at the back edge of the sheet. The printing of multi-colour work on single-colour presses requires careful handling of the printed sheet to avoid scratching the delicate dried print. Feeders, therefore, forward one sheet at a time and the feedboard sheet controls are designed to limit marking to a minimum.

As the sheet is passed over the forwarding roller there is a tendency for the back edge of the sheet to trail over the lower sheet on the pile. This may cause serious marking of the sheets on a multi-colour job. The overhead magnetic wheel guide is designed to lift the sheet clear of the pile during its forward motion to prevent back-edge trailing.

FEEDBOARD

Feedboard friction tapes as found on the paper press are not sufficient to propel the heavy sheet of metal to the front lays. A chain conveyor which has raised lugs (or dogs) is used to bring the sheet to the front lays and to insert the sheet into the impression cylinder grippers (Fig. 140).

Courtesy: Crabtree Mann Ltd.

Fig. 140.—Feedboard showing two-sheet detector and chain conveyors with raised lugs.

THE SIDE LAY

This is normally of the push type, and consists of an adjustable roller-bearing which pushes the sheet against a compensating spring-loaded stop.

THE FRONT LAYS

The impression cylinder grippers are normally cam-operated, and also embody the front-lays stops which are adjustable. The metal sheet is conveyed to the lays and forced positively up against the lay stops by the chain conveyor. The impression cylinder grippers close on the sheet at this point and the sheet is drawn into the impression nip. Once the sheet is held firmly in the nip the grippers release the sheet before it is flexed and the impression is completed with no positive control of the sheet.

Under normal printing conditions this has no deleterious effect on register of colours, although undue flexing of the sheet at the point of impression may cause bad register.

OVEN DRIER

A moving or travelling oven is used to effect the drying of the printed sheet. Drying of the ink film is by evaporation of ink solvents and oxidation of the vehicle.

Oven design is dictated by the following factors:

1. The temperature of the ink solvent must be raised quickly and evenly without scorching the sheet.
2. Volatile solvents must be removed.
3. The sheets must be heated to an even temperature.
4. Before stacking, the sheets must be cooled and the ink film set to prevent the piles from "blocking."

Gas-burners are normally used to provide hot-air zones within the oven which may be up to 54 m long. The moving portion of the oven consists of two or more endless chains which traverse its length and which carry individual sheet cages called "wickets." Air temperature depends upon oven length and press speed, with averages for printing of 176 °C and for coating 121 to 220 °C.

Delivery of the sheet from the oven may be either manual with hand stacking or automatic. Automatic stackers function better with finished work, while careful hand stacking is used in multicolour work to avoid sheet-scratching.

ROLLER COATING

The roller coating machine (Fig. 141) is used to apply lacquer, priming or opaque base coating, colour coatings and final surface varnish to metal sheets. The applicator roll may apply a solid coating which covers the entire sheet, or may be modified to apply strips or solids smaller than the sheet size.

The feeder and conveyor are similar to that used on the metal decorating press. The coating thickness is controlled by the contact between the feed rollers and the applicator and pressure roll. Coating thickness may be between 0·05 and 0·09 mm. Combinations of printing press and roller coater machine are common. This enables

Fig. 141.—The roller coating machine. If the coating material does not form a skin the drip-pan residue is conveyed back to the reservoir.

the printing and varnishing of the sheet to take place in one pass through the press followed by a single stoving. Operations like this are called "wet varnishing."

LACQUERS

Film-forming materials which are transparent and may be un-coloured or coloured are called "lacquers." Because the lacquers are transparent, the reflective surface of the metal sheet may be coloured to simulate gold, copper and various metallic shades of green and blue.

Sanitary lacquers are used for the lining of food-containers and have to provide the following specific characteristics:

1. Absence of taste.
2. Non-reaction with foods placed in the metal can.
3. Resistant to food-manufacturer's sterilisation process.
4. Non-contamination of food placed in the can.
5. Non-deterioration of its protective qualities.

LITHOGRAPHIC METAL DECORATING

In lithographic metal decoration the following factors must be taken into consideration:

1. The control of plate damping is more exacting than with paper printing because the water passed to the blanket is not blotted off by the passing sheet. Emulsification of the ink on the press rollers is, therefore, a greater danger.

2. Any change in the degree of tack between sheet and blanket at the point of printing may result in poor register of colour work.

3. Volatile solvents and increased ink-driers may cause premature drying of the ink on the roller train.

4. Buckled and damaged sheets, and sharp edges on the metal present problems of maintaining blanket quality.

5. The thickness of the printed ink film is usually heavier than that used in paper printing, with the resulting filling in of half-tones and fine line-work a greater possibility.

6. All printed work has to be varnished. This often changes the shade of pale colours and requires expertise on the part of the printer when he mixes the colour for printing to allow for the colour change.

METALS USED

Black-plate

Iron sheet with a colour varying between black and grey. It is a metal commonly used for non-food cans and containers for dry products. The metal must be protected on both sides by a lacquer coating.

Tin-plate

Full protection of iron plate is obtained by coating the metal both sides with tin. This prevents oxidation of the metal, and gives a smooth bright finish to the surface. Tin-plate consists of mild steel sheet approximately 0·25 mm with a film of tin 0·015 mm. Tinning is produced by the following two methods:

1. The hot-dip process, in which the sheets are dipped in molten tin.

2. Electrolytic deposition of tin, which is done while the metal is in coil form.

Aluminium

Non-ferrous metals such as aluminium and its alloys are used where the strength of iron plate is not required. These metals require special handling as they kink easily, and the print finish does not adhere to the surface as well as on tin-plate.

Web-offset lithographic machines

The web-offset press (Fig. 142) does not differ in its basic design very much from the sheet-fed machine. Each printing unit has dampers, inking rollers, plate and blanket cylinders, all of which function on the same principles that have been outlined in the section on sheet-fed presses. Printing from the web-fed press is in some respects a simpler operation: there are no feedboard, front or side lays, grippers or transfer cylinders to manage.

Courtesy: Crabtree Mann Ltd.

Fig. 142.—The Crabtree Crusader web-offset press installed at the *Bedfordshire Times*.

The web press prints on a continuous ribbon or web of paper which is fed into the press from a reel. The pressman has to learn the techniques of controlling the web of paper, of making ready while the press is printing on crawl, and moving with speed when rectifying troubles on the run. He may have to learn the operation of an oven drier, and condition himself to controlling print quality when the press is producing finished copies, possibly in four colours, at high speed.

Consider for a moment that a press is producing 30 000 copies an hour. If it takes the pressman one minute to rectify a print fault such as catch-up, 500 copies will have been spoiled in that time. Yet on many runs it may be more economical to run on and waste 500 copies, than to stop the press. This will serve to give the reader an insight into the manner in which these high-speed presses are designed.

Fig. 143.—Schematic of how a single modular unit can be added to make a multicolour press.

DESIGN FEATURES

The *modular-unit* design is used universally for web-offset machine construction. The units may either print on one side of the web or both sides (perfecting) at one pass through the press. Modular-unit construction lends itself here to versatility in press layout, enabling multiple webs to be run at once, and offers multicolour facilities (Fig. 143). Usually, the type of work undertaken by the printer will

determine the type of press he will require. For example, a sixty-four-page magazine in one colour may require more than one unit can deal with. Two units, running two webs into the folder may, on the other hand, be adequate. The machine is therefore built to suit.

Figures 144 and 145 illustrate the way in which units and webs can be arranged: single modular unit, one web (Fig. 144), and two modular units in tandem, two webs (Fig. 145).

Fig. **144**.—A single-colour modular-unit web press.

Fig. **145**.—Two modular units in tandem.

These designs are simple units printing one side of the web only. Machines which print both sides may consist of units such as these with a turner-bar layout between the first and second unit which turn the web over. Perfecting presses with the printing impression obtained by the blanket cylinders opposing each other are more common. The *blanket-to-blanket* press may be arranged in line with other units, or stacked one above another using the arch-type design, thus saving floor space.

UNIT ARRANGEMENT

An almost infinite number of printing-unit variations is possible on the web press. The advantage over the sheet-fed machine is seen here. Because the paper is in a ribbon, it can be turned and redirected very simply to travel forwards, backwards and at angles of 90°. By adding units, and directing the web path intelligently, a large permutation of

Fig. 146.—Web press layouts.

(*a*) Blanket-to-blanket; printing both sides.

(*b*) Common impression cylinder; printing two colours on one side.

(*c*) Common impression cylinder; web turned over on turner bars T, printed both sides.

(*d*) Two units in tandem; four colours printed on one side.

(*e*) The satellite modular unit is commonly used for multicolour printing. It has a large-diameter impression cylinder which may serve a number of blanket cylinders, in this case, four. The web is directed round the impression cylinder and receives four colours almost simultaneously while the web is held firmly. Two such units are required to perfect the web.

colour and pagination can be achieved. Figure 146 (*a*)–(*e*) shows a few possible layouts.

WEB-OFFSET MACHINE CHARACTERISTICS

Apart from the layout features of the web press which we have just considered, the machine has certain characteristics which are dictated by the following factors:

1. The paper travels through the press in web form. Large-diameter reels of specific width are used. Reel-stands, web-tensioning devices, path rollers and web-control mechanisms are therefore standard features of the machine.

2. Excessive and wasteful trim of the printed paper must be avoided. To do this the plate and blanket depression gaps are reduced to a minimum, and the printing area arranged to cover as much of the plate circumference as possible. The folder cuts the web into regular lengths, each length being known as the *cut-off*.

Press plate cylinders are constructed to take plates which occupy the area covered by the cut-off. Plate cylinders are, therefore, single-plated to conform to one cut-off length; or they may be double-plated; the total circumference of the cylinder then corresponds to two cut-off lengths.

3. Figure 147 shows the characteristic features of the web-press plate and blanket cylinders. Because the depression gaps are reduced the plate and blanket clamping mechanisms have to function within close confines.

4. The absence of lays for controlling the paper position is compensated by facilities for moving the plate cylinder both laterally and circumferentially to obtain register while the press is in motion.

5. The speed at which the web press runs requires that ink and damping mechanism operate without vibration. Moving feed rollers are modified, and in many cases dispensed with.

6. The printed ink film on the paper has less time to set before it is cut and folded. Special inks are formulated to speed stock penetration and drying, and the use of heat-set inks and oven driers is commonplace.

7. The peculiar stresses to which the paper is subject on the web press has made it necessary to produce special papers for web-offset printing.

Fig. 147.—Comparison of the design of sheet-fed plate and blanket cylinders with web-press cylinders.

8. Machine crashes can have a very damaging effect when the press is running at high speed. Various safety trips and detectors are used to minimise crash damage. Shear pins and slip-clutch mechanisms are used extensively to minimise serious damage to press components.

With these points in mind, we now turn to the more detailed description of the web-offset press. Basic machine items have already been covered in the section on sheet-fed machine construction. The following notes are related to those machine characteristics peculiar to the web press.

REEL-STAND (Fig. 148)

An average web width for a standard-size machine is approximately 900 mm, and the reel diameter 1000 mm. A vast variety of presses, however, take webs of differing widths and no international standard has yet been adopted. The "double-width" press which is now being

Courtesy: Maschinenfabrik Augsburg-Nurnberg

Fig. 148.—The M.A.N. reel-stand.

used in this country for newspaper work is printing double-width webs of 1800 mm.

The centre of the paper reel is supported by a heavy-duty straw-board tube with metal flanges at each end. The reel-stand has one of the following reel supports:

1. Side core chucks which locate firmly with the metal flanges on the end of the reel core.

2. A reel spindle which passes through the core of the reel and is secured by expansion flanges on the spindle.

When the reel is mounted on the stand it can be moved in a lateral direction to effect side-lay register of the paper by moving a hand wheel. Multiple-unit reel-stands are commonly used. This type of stand has two or three reel arms which enable the operator to load and position following reels while the press is running.

A further modification of this type of reel-stand is the *flying paster*. This mechanism automatically speeds up the following reel when the press reel is running low, and when the operator wishes to change reels the following reel is pasted to the press reel at speed and the old reel severed. This allows reel changes to take place without interfering with press production.

WEB TENSION

As the long ribbon of paper passes through the press at speed it is subject to many stresses which must be controlled to prevent it interfering with the print quality. The rate of paper flow into the machine must be the same as that which is entering the folder. On large presses difficulty is often met when the paper changes its dimensions because of the absorption of moisture and tension stresses. It is not uncommon for the machine to "make paper" within the press during the run owing to the paper stretching, and to allow for variations in the web speed, numerous devices are used, all of which contribute to even web tension on the run.

The main drive to the paper web is derived from the printing unit itself. As the paper passes through the impression nip the rubber blanket applies considerable traction to the paper; the infeed to the printing unit must, therefore, correspond to the printing unit speed. Look at the web path shown in Fig. 149. When the paper leaves the

Fig. **149**.—Web tension control on the wheel. B—brake, D—dancer roller, R—reel, S—slack web requiring more braking, T—taut web requiring less braking.

reel it passes over a roller which acts as a sensing device. This roller is called a *dancer* because it moves freely with the fluctuating tension of the web as it passes into the machine. The printing unit pulls the

paper off the reel. The reel has a tendency to overrun, thus making the web slack. The dancer roller functions by sensing the tension of the web and corrects it. When set correctly the dancer roller will send a signal (via an electrical, hydraulic, pneumatic or mechanical link) to the reel spindle brake. When the web becomes slack the brake is applied to slow the rotation of the reel, thus taking up the slack and gaining web tension again. When the web becomes over-tensioned the brake is released to allow the reel to run more freely. This correction of web tension takes place many hundreds of times a minute while the press is running.

Extended web paths through a large machine will often require additional drive to the web. The *P.I.V. drive* ("positively infinitely variable drive") consists of a mechanism which drives two rollers over which the web passes. One of the rollers is steel, the other covered with rubber. The web passes between these rollers, which are in contact with each other, and the traction obtained controls the web speed. Initially, the P.I.V. is set to the same speed as the printing unit by metering the surface speed of rollers and cylinders with a tacho-meter. During the run additional adjustments can be made to the P.I.V. roller speed by altering a hand wheel on the drive box.

Web tension is not affected by the many free-running path rollers on the press, nor by the chill rolls if a drier is incorporated in the machine. Most path rollers are made of polished metal which permit the web to slip when changes of tension occur. This may be altered, however, if the path rollers are covered with any non-slip material to prevent ink set-off.

At the folder end of the machine web tension is controlled by the R.T.F. and its trolley wheels and by the nip rollers situated below the former.

PATH ROLLERS

These rollers are usually of metal construction with a polished surface, and are free running on roller-bearings. The following modified rollers are also added to large presses to allow the pressman more control over the web:

SIDE-LAY ROLLERS

These rollers help to correct the sideways movement of the web as it passes through the machine. Side lay between reel and first printing

unit is obtained by the lateral position of the reel on the reel-stand. Beyond the first printing unit the web is positioned by side-lay rollers. These consist of a standard path roller mounted on each end with an eccentric bush which permits the roller to be tilted during the run to correct side-lay error. Fully automatic units are discussed at the end of the chapter.

Another type of specially constructed roller gives control over webs which have slack edges or baggy centres. The roller is cleverly designed with individual sections along its length which permit the roller to be shaped into an arc.

COMPENSATOR (REGISTER) ROLLERS

These units control the advance and retard movement of the web without affecting web tension. The compensator allows the pressman to position the page of one printed web with the page of another web

Fig. 150.—Compensator rollers. A—retarded position, B—advanced position, C—motorised worm drive to control compensator roller.

as the two webs pass into the folder. This ensures that when the webs are cut and folded the pages have their heads aligned. Compensators are also used to register the web between one printing unit and the next (Fig. 150).

TURNER BARS

These are not rollers because they do not rotate, but they serve to path the web through a right angle. The bars are usually made of metal with a high surface polish and perforated with air-holes. High-velocity air is forced through these holes to form an air cushion between the web and the bar as the paper is passing over it at speed. This effectively prevents friction and heat building up in the bar and reduces the possibility of wet ink smudging the paper. Turner bars

are used wherever the web is required to change direction, and are the basic feature of the ribbon folder.

FOLDER

As the paper passes from the last printing unit, each individual web is aligned by the compensator units and pathed over the *R.T.F.* ("roller-top-of-former") and controlled by the R.T.F. trolley wheels. The *former*—also known as the "kite" because it is V-shaped—makes the first fold in the web before it is cut to length. The *slitter* is situated over the R.T.F. and is used to cut the web into ribbons before it passes over the former when this is required (Fig. 151).

Courtesy: Frank F. Pershke Ltd.

Fig. 151.—Solna RP 36 Commercial heat-set web press and folder.

The former is adjustable for pitch, and is constructed of metal with a high surface polish and air-holes, similar to the turner bar.

Below the former are two rollers which direct the folded web into the *nip rollers*. These are adjusted to run closely together and consolidate the fold made by the former. The traction of the nip rollers

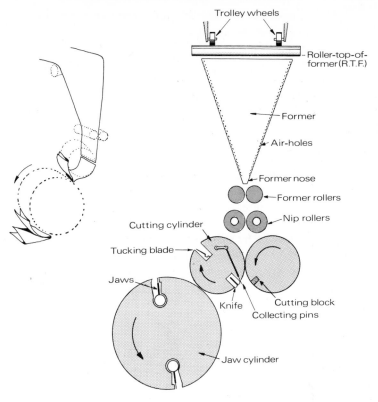

Fig. 152.—The web-press folder.

on the web controls the web speed as it passes to the cutting cylinder. Figure 152 shows one type of web-press folder.

The folding sequence is variable with different folders. A sample sequence may be as follows:

1. The web is directed over the R.T.F.

2. The first fold parallel with the web path is made on the former.

3. The web passes between the former rollers and nip rollers.

4. The pins in the cutting cylinder stab through the leading edge of the web and draw it round the cylinder.

5. The knife blade makes contact with the cutting block on the jaw cylinder, thereby cutting the web laterally (the cut-off).

6. The pins stab the leading edge of the next cut-off length at the same time that the web is cut.

7. The tucker blade on the cutting cylinder forms the second fold at right angles to the web path by forcing the web into the jaw on the jaw cylinder.

8. At this point the folded copy may be delivered via the conveyors as complete, or it may be passed to another folding unit to receive the "quarter-fold."

RIBBON FOLDER

This type of folder is used in bookwork production where a large number of pages are folded together. It is also favoured for folding multicolour work on coated paper where the stresses produced by the former folder may cause surface scuffing and marking. The ribbon folder functions by slitting the incoming web into ribbons and aligning the ribbons into the folder by passing them over short turner bars. The folding sequence is similar to that used with the former, and very often both ribbon and former folds are employed in one folder.

Kicker

This device is used to indicate on the conveyor delivery a specified number of copies. The kicker can be adjusted to "kick" a copy into a sideways position in the delivery line every dozen or so copies, so assisting in the packing of standard bundles.

PRINTING-UNIT CYLINDER CONSTRUCTION

The necessity for designing the plate, blanket and impression cylinders without a depression gap has already been referred to. Because of this the clamping assemblies for the plate and blanket are restricted to function in a cylinder gap of about 30 mm wide. This has resulted in the production of a number of interesting lock-up designs.

PLATE CYLINDER

Cylinders are designed to take one wrap-round plate (Fig. 153). The single wrap-round plate is usually found on units which are required to give accurate register, for example colour printing. Very little plate movement is possible once it has been mounted on the cylinder; movement is obtained for register purposes by the lateral and

Fig. 153.—Cylinder plates. (*a*) One wrap-round plate. (*b*) Two-plates (double plating). (*c*) Two plates side by side and two plates round. (*d*) Staggered plates.

circumferential controls on the plate cylinder itself. Multiple plates mounted on one cylinder make accurate register a more complex problem.

Plate lock-up systems are generally simple and efficient. Figure 154 shows a few sample designs.

Presses constructed for hair-line register work incorporate lateral and circumferential movement in the plate cylinder. Operation of

Untensioned Tensioned

Fig. 154.—Plate lock-up designs.

these movements is simply made by moving a hand wheel situated on the press side frame while the press is in motion. The amount of cylinder movement is usually limited to about 20 mm plus and minus a standard setting. During press pre-makeready this setting should always be returned to the standard position.

With such limited movement possible for the plate on the web press, it should be obvious that plate planning must be done with great accuracy, and plate bending and fitting performed with care, if speedy makeready is to be obtained.

BLANKET CYLINDER

These cylinders are usually constructed to take one wrap-round blanket. Most press designs make use of separate blanket bars which

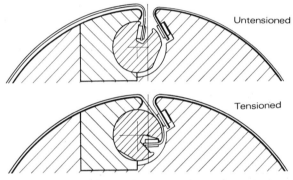

Fig. 155.—A blanket lock-up design.

are fitted to the blanket with bolts, screws or rivets. Figure 155 demonstrates a sample of blanket lock-up designs.

INKING SYSTEM

Web-offset press inking systems differ little from conventional designs. Compact construction of the press often dictates the number of plate inkers used, which may number as low as two. The roller pyramids are in many cases limited to low numbers because of lack of space, although with the high press speeds the performance is quite satisfactory.

High press speed and the use of rapid-drying inks may cause a rise in the temperature of the inking unit. To reduce this, water-cooled

metal distributing rollers are often incorporated into the inking pyramid.

In many press designs the moving feed roller has been modified to eliminate vibration and noise, and to give improved control over the metering of ink to the pyramid. The ink-duct roller is usually motorised to give a gradual variation of speed, and ink-duct agitators are used to prevent the ink from "hanging back."

DAMPING SYSTEM

This usually follows conventional lines with a modification to the moving feed roller as indicated in the section on damper design (page 143). The restricted area of the press damping system often results in only one plate damper being possible.

DRIER UNIT

The drier unit is installed on web presses when the type of work (multicolour, or non-absorbent stock) requires the printed ink film to be dry when it passes into the folder. A great deal of work can be printed on the web press without the use of a drier. The drier, however, will permit higher press speeds, the use of multicolour work, and will improve the finish of prints on absorbent stock by setting the ink before it has penetrated the stock.

Special inks called "heat-set" inks have been developed for use with a high-speed drier unit. However, the term "heat set" may be a little misleading. The printed ink film which is saturated with solvents is heated to a high temperature in the drier. The solvents are liberated from the ink, leaving it in a hot plastic condition. The ink does not actually "set" until its temperature has been lowered considerably by passing the web over the chill rolls.

The drier unit is usually constructed to the press requirements. The factors which influence drier design are as follows:

1. The speed of the web will dictate the length of the drier, the number of burners and air knives or volume of hot air, and the capacity of the exhaust and recirculating fans.

2. The number of webs to be run through the drier will dictate its size and layout.

3. The maximum weight of the ink film to be dried. This is

expressed as a percentage of four solids on one or both sides of the web. In four-colour printing with the use of undercolour removal the ink density may be as high as 300 per cent. This will dictate the layout of the drier, its heating capacity and the size and number of the chill rolls.

4. The paper must not be heated to such a temperature that it becomes scorched or discoloured. A lower temperature will demand a longer oven.

5. The loss of moisture from the paper must not fall too steeply. Paper will become brittle, will crack, shrink, blister, curl or lose its gloss if subject to too much heat. This will require a balance between oven length and heat.

6. The heat applied to the web must be quickly dispersed when there is a press halt. In most driers the heating unit is extinguished, a draught of cool air is forced over the web, and in some cases the hot unit moves out of close proximity with the web to prevent scorching.

TYPES OF DRIER UNIT

Flame-impingement drier

This type of drier is in common use despite its many disadvantages. The drier consists of a large chamber through which the web passes unsupported. Located at intervals above and below the web are a number of gas-jets which direct a naked flame on to the paper surface (Fig. 156). The drier also incorporates an exhaust system to remove

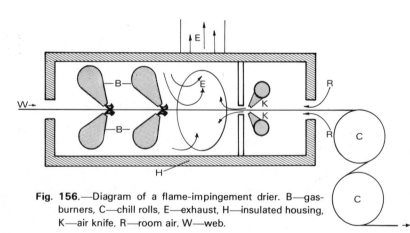

Fig. 156.—Diagram of a flame-impingement drier. B—gas-burners, C—chill rolls, E—exhaust, H—insulated housing, K—air knife, R—room air, W—web.

the solvent-laden atmosphere from the oven, and often air knives are used to force the solvent vapour away from the surface of the web.

1. *Lazy flame.* This type of drier utilises gas flame without pressurised combustion air. The flame is bent away from the web by the current of air carried along by the web as it passes through the drier (hence the term "lazy flame"). The removal of the solvent layer on the web is called "scavenging" and is performed by air knives situated just inside the drier exit. Ignition of the gas is usually controlled by a pre-set speed switch interlocked with the press drive.

This drier is used for medium ink coverage on cartridge and some coated stocks with substance about 80 g/m^2. Printing speeds are limited to 180 m/min.

2. *Forced combustion flame.* This type of drier is similar to the lazy-flame drier but utilises forced combustion air-burners. It employs pressure jets of gas-flame in direct contact with the paper, and often hot-air knives are arranged to produce "zones" in the oven to improve solvent evaporation. This is sometimes referred to as "multi-stage" drying, and is aimed at a gradual application of heat, coupled with an efficient scavenging of the solvent-laden air from the surface of the web.

This drier is used for heavy ink coverage, multicolour printing on both sides of the web, with stocks above 100 g/m^2, at printing speeds up to 300 m/min.

Hot-air driers

In this type of drier the drying chamber is flooded with hot air and the web passes between a corridor of high-velocity hot-air knives which force hot air on to the web at a speed of approximately 3600 m/min. The heat applied is easily measurable.

Combinations of gas-burner and hot-air drier are common, at printing speeds of 460 m/min with medium ink coverage on four-colour work. Its performance is better than the gas-flame drier, it gives improved colour and gloss with little discoloration of the paper, and it removes less moisture from the paper. It also has the advantage of using gas, oil or electricity to heat the air.

Microwave drying

Microwave drying is a recent development in the drying of printed ink films. Normally heat is applied to the surface of the ink film and

the interior of the film is heated by conduction of the heat from the surface molecules (Fig. 157). To achieve this in practice, the heat applied to the surface molecules must be higher than required in order to heat the interior of the ink film sufficiently.

The microwave drier functions by emitting radiation with a wavelength between 10^8 and 10^6 m into the ink film. Microwaves produce a volume heating effect because they pass through the ink film uniformly, with the result that all the molecules of the ink receive energy at the same time.

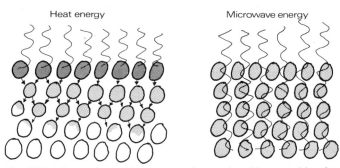

Fig. 157.—Comparison of heat conduction produced by normal heating of the ink film with microwave radiation.

The microwave drier unit consists of a drier chamber which houses the applicators, a system of magnetron radio-frequency generators, heat exchangers and a control unit. The magnetron generators convert the electrical power to the required high-speed concentration of radio-frequency energy which is emitted by the applicators on to the web as it passes through the chamber.

Microwave drying has the advantage over conventional systems because of the following factors:

1. Paper moisture loss is eliminated.

2. Surface scorching, blistering and discoloration are reduced due to the reduction in drier temperature.

3. Running costs are about one-third lower than conventional systems.

4. The construction of the drier unit is light and compact.

Electric infra-red drying

This type of drier is used on small web-offset presses, especially in-plant printing machinery. The infra-red heating elements are housed

in clam-shell reflector units which are located just above or below the web surface. When the press is halted the drier units can be swung away from the web manually or automatically. Temperature control is obtained by using proportional input controllers, or electric pyrometers for each individual heating unit.

Infra-red drying can also be employed as auxiliary driers on web presses to reduce set-off when the web is to pass over turner bars or path rollers.

CHILL ROLLS

After passing through the drier chamber the volatile solvents are removed leaving the ink in a gel-like plastic mass. Setting of the ink takes place when the temperature of the ink is lowered from about 148 °C to 32 °C. The chill rolls are large-diameter drums situated close to the drier exit. The temperature of the drums is low and maintained by cooling the interior with low-temperature water which flows at the rate of about 900 l/min in efficient systems. The number of chill rolls and their size is determined by the heat of the paper passing out of the drier, and the speed of the web.

PRESS TRIP AUXILIARY UNIT

Owing to the comparatively large size of many web-offset presses, and the number of printing units which may be incorporated into one

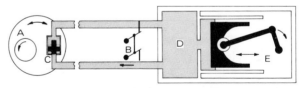

Fig. 158.—The basic principle of the auxiliary hydraulic-ram trip control. A—eccentric cam on printing-unit cylinder, B—slave valves, C—slave cylinder and piston, D—hydraulic fluid, E—master cylinder and piston.

machine, the power required to move the cylinders into and out of impression is not derived from the machine drive. Press trips are powered by an auxiliary unit which usually utilises the hydraulic-ram principle. This functions by employing a master pump which forces oil along supply pipes to the slave units situated on each printing

unit. Suitable valves are located in the system to control the flow of oil through the pipes. When the valve is opened the oil is forced into the slave unit, moving the ram piston and thereby actuating the press trip. When the valve is closed the oil is re-routed to move the ram piston in the reverse direction (Fig. 158).

AUTOMATIC CONTROL FOR REGISTER

The control of the side-lay and length register is obtained by the positioning of the register rollers and side-lay rollers on the press during the run. On smaller presses register adjustment is made by hand by the pressman. Fully automatic devices, however, are used on larger presses. These are pre-set by the pressman at the beginning of the run, and by special sensors they correct register error as it occurs without further attention by the pressman.

The optical scanning system outlined here is an example of how these automatic devices function.

The scanning system consists of a scanning head embodying a photocell which is positioned on the second and subsequent printing units. Each head produces electronic signals corresponding to the printed image being scanned. These signals are fed into a computer unit which assesses the register error and generates a correction signal which is proportional to the register error and the rate of change of the error. This correction signal actuates the correction motors of register or side-lay rollers and the required web movement is made.

As the printed web passes below the scanning head the photocell senses the mass of printing images plus register marks. Correct selection of the register marks out of this mass of printing is obtained in the following ways:

 1. By programming the computer to ignore all signals except those related to the register marks.

 2. By incorporating into the scanning head a number of miniature photocells coupled to electronic logic elements which recognise register marks among other printed matter in the same track.

Units of this type may also be used to effect reel side-lay control to ensure that the web enters the first printing unit in the correct lateral position.

VIEWING REGISTER AND PRINT QUALITY AT HIGH SPEED

In many situations, it is necessary to examine the printed web during the run, especially when re-reeling. The web pressman cannot take a sheet out for examination like the sheet-fed press-operator can. To give the web pressman good visual examination of a fast-moving web the following methods are used:

STROBOSCOPE

This consists of a lamp which illuminates the moving web in a series of flashes. When the lamp is set to flash over a particular area of the image that portion alone fixes its image on the eye and gives the impression that the web is not moving at all. The stroboscope functions on the principle of "persistence of vision." It is known that when we look at a moving object the image formed in the eye lasts for about one-tenth of a second. If the printed web is moving at speed

Courtesy: Crosfield Electronics Ltd.

Fig. 159.—Viewing the moving web with the aid of the Crosfield synchroscope.

H

and one small section of the image is illuminated, the pressman sees that portion, and before his eye has lost the sensation of the image the next lamp flash illuminates the following portion so that in fact he detects no movement.

SYNCHROSCOPE

This is an optical web viewer manufactured by Crosfield Electronics Limited (Fig. 159). The synchroscope consists of fifteen strip mirrors mounted round a drum driven by a selsyn motor which rotates at one-fifteenth of the speed of the printing cylinder. Its principle of working may be seen in Fig. 160. The synchroscope is electrically

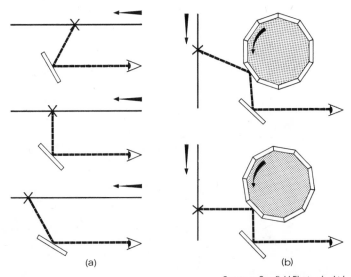

(a) (b)

Courtesy: Crosfield Electronics Ltd.

Fig. 160.—The basic principle used in the Crosfield synchroscope. Diagram (a) demonstrates simply how it is possible to stop motion visually. The eye has not moved but by slight rotation of the mirror it follows point X as point X progresses. In (b) this principle is applied in a practical manner. Successive mirrors mounted on a drum and rotated in synchronism with the speed of the web create a stationary picture of the printed material.

connected to the press and can give a stationary image at any press speed. A hand-wheel is provided to enable the operator to select the strip of web he wishes to view.

OPERATING THE LITHOGRAPHIC PRESS

LITHOGRAPHY has been with us long enough to be called an ancient craft. Its precipitation into the twentieth century on a world-wide scale, together with its recent expansion due to new technology and materials, will of necessity mean that the techniques discussed in this chapter are subject to change. Lithographic pressmen also develop personal techniques in press management which cannot be acquired other than by long experience. This chapter is designed to lay a technical foundation in machine operation, and should be taken as a guide to better press management.

PRE-MAKEREADY

Pre-makeready begins when the last job has been completed and sent home. At this point inkers and dampers have been cleaned, the plate and packings have been removed from the cylinder and the feeder and delivery bays emptied.

Most of the pre-makeready operations consist of ensuring that each section of the press is fully prepared for the next job, and is functioning correctly.

FEEDER

1. Check the rubber suckers for pin-holes and signs of wear. Any doubt about their condition should be sufficient reason to replace them.

2. Inspect the rotary valve for lint and fluff.

3. Examine the conveyor tapes, and see that the tension rollers are free to revolve.

4. Centralise the adjustment on the front lay, and the micrometer setting of the side lay.

5. Ensure that there are no small pieces of paper jammed under the anti-buckle plate on the side lay.

GRIPPERS

Make a routine check of the transfer point of the grippers, and see that the mechanism operates smoothly.

INKERS

1. A further wash-up of the ink rollers may be necessary. The usual procedure is to run up a light-coloured ink such as yellow and allow the press to run for a period before washing up again.

2. Do not neglect to clean the back of the ink-duct blade: the ink builds up at this point and may bleed into the next colour during the run.

DAMPERS

1. After cleaning, it is a good plan to check the settings as they are replaced in the press. This may be done after a plate has been fitted to the cylinder. This is very important when using Molleton covers.

2. Empty the fountain tray and clean it thoroughly. This is where bacteria and moulds can rapidly accumulate and reverse the desensitising effect of the fountain solution. If a recirculatory system is used, it is wise to empty the system regularly and circulate a germicide and detergent solution for a period. Unless this is done, the flow pipes will rapidly clog with mould and sludge.

3. Thoroughly desensitise the metal distributing roller by applying a 20 per cent phosphoric acid solution and leaving it under a dry film of gum arabic.

CYLINDERS

1. It is a good plan to check the blanket for indentations before washing up from the previous job. Ensure that the plate is gummed correctly and dry. Drop the inkers on to the plate and roll it up to a solid. Print a few sheets, or as an alternative apply the impression without passing sheets through the press. With the blanket covered with an even film of ink, surface imperfections will readily be seen.

2. Recondition the blanket surface regularly.

3. Centralise the lateral and circumferential adjustment on the plate clamps.

4. A fresh blanket should be kept in reserve in a dark place.

DELIVERY

1. Check the tension of the delivery chains.

2. Refill the anti-set-off spray bowl.

3. Examine the air-holes of the vacuum-roller slow-down to ensure that they are free from lint and spray powder.

4. Clean the projection points of the skeleton wheels.

LUBRICATION

1. Lubrication of moving parts of the press is an essential part of pre-makeready. The manufacturer's handbook will give the location of oil-holes, grease-nipples, etc., and advise on a routine oiling procedure.

2. When using an oil-can, carry a cloth to wipe excess oil from each hole serviced. Oil which runs away from moving parts can be a safety hazard as well as spoiling work if it drops on sheets passing through the press.

3. Check the oil-level bowls on compressors and empty the discharge bowls.

4. If oil-filters are fitted, change them at recommended intervals.

5. Top up oil-pumps.

MAKEREADY, RUNNING ON AND COMPLETING THE JOB

No firm rules can be made regarding the manner in which the makeready procedure is performed as this will depend to a degree on the type of work undertaken, the length of press run and the house practice (Fig. 161). The following steps are given as a guide for the single-colour sheet-fed press.

Courtesy: Harris-Intertype Ltd.

Fig. 161.—Making ready on an Aurelia multicolour press.

OUTLINE STEPS

1. Check the paper for the job.
2. Prepare the makeready book on the pile.
3. Set the feeder for the sheet size.
4. Inch the sheet through the press and set the sheet controls, lays, joggers and delivery-pile guides.
5. Run a few sheets through the press at speed to check the sheet path settings.
6. Examine and prepare the plate for the job.
7. Fit the plate to the cylinder, selecting the correct packing.
8. If necessary, adjust the blanket packing and select the correct pressure settings between plate and blanket, and blanket and impression cylinders.
9. Check the fountain solution and set the damper controls.
10. Prepare the ink and set the ink-duct; run up ink on to the ink pyramid.
11. Wash the gum off the plate, set the dampers on and run the press.
12. Set the inkers on to the plate, and ink up the image. Stop the press and examine the plate.
13. Commence printing by working through the makeready book.
14. Adjust impression pressure, position skeleton wheels and sheet-path supports.
15. Obtain an O.K. pass.
16. Recheck the makeready settings and commence the run.
17. Maintain quality during the run.
18. At the end of the run, remove the plate from the cylinder and prepare it for storage.
19. Wash up the inking system and clean soiled press mechanisms.
20. Clean the dampers.
21. Clean and revive the blanket.
22. Empty feeder and delivery bays.

The above steps are discussed in detail throughout this chapter.

PAPER

1. In a well-equipped machine-room the atmosphere will have both humidity and temperature control. Paper ordered from the mill can be obtained to conform to the machine-room conditions.
2. Paper should not be stacked on the floor.

3. Do not assume that the paper has been cut square. Bowed edges are often caused by the paper being cut when it was tight or wavy edged. If the paper is bowed, it must be seasoned before trimming, otherwise the same irregular cut will result.

4. To check for squareness, fold the sheet to bring the leading and back edges of the sheet together in the centre. A visual appraisal of the corresponding edges will reveal any unsquareness.

5. When printing register work or jobs which must conform closely to size, the paper must be cut with the grain running parallel with the leading edge (long grain).

PREPARING THE PILE

As each pack of paper is opened and stacked on the platform, the sheets should be fanned out to break any vacuum and to ventilate the pile with air. Care must be taken when knocking up the sheets to ensure that the edges are not damaged. This is most important when handling coated stocks, as they are, weight for weight, structurally weaker than uncoated papers.

THE MAKEREADY BOOK

When the press is ready for printing, the following three stages must be completed:

1. The sheet has to be positioned in its correct relationship to the printed image. This is called "sheet registration," and involves the positioning of the plate and the adjustment of the front and side lays.

2. The correct level and shade of ink consistent with the progressive proof has to be obtained. This involves the adjustment of the supply of ink from the ink-duct, both for uniformity and ink-film thickness.

3. A good clean reproduction of the image will be necessary to complete the makeready stage and to obtain a pass sheet before the run begins.

The makeready book is constructed with these three stages in mind. The following list will serve as a guide for the preparation of the book:

100 sheets of waste	Initial run to normalise the damping and inking systems.

5 sheets of stock One copy to the reader, one to the layout department, two to the finishing department.

6 sheets of waste ⎫
2 sheets of stock ⎪
6 sheets of waste ⎪
2 sheets of stock ⎬ Register adjustments.
6 sheets of waste ⎪
2 sheets of stock ⎭

50 sheets of waste ⎫
2 sheets of stock ⎪ Adjustment of colour shade and uniform-
50 sheets of waste ⎰ ity of ink.
2 sheets of stock ⎭

100 sheets of waste ⎱ Print quality assessment and pass sheet.
3 sheets of stock ⎰

SETTING THE SHEET PATH

1. Position the pile in the feeder bay by folding a sheet in half to find its centre, and setting the pile approximately 8 mm off-centre to allow the side lay to move the sheet into the feedboard centre.

2. To adjust the pile height, raise the pile to within 20 mm of its required position and allow the automatic pile-height mechanism to raise the pile. Adjust the pile-height governor until the correct operating height is obtained.

3. Adjust the double-sheet detector for the stock.

4. Switch on the air compressor, engage the feeder clutch and inch the press. Note carefully the feeder operating cycle and adjust the various components as they come into operation.

5. Advance the sheet and adjust the tension of the drop wheels.

6. Position the first pair of running-in wheels over the conveyor tapes so that the sheet is under positive control when the drop wheels lift.

7. Position feedboard sheet controls.

8. Position the side lay so that it moves the sheet to the centre of the feedboard. Sheet movement should be smooth and jerk-free, and not more than 10 mm.

9. Inch the press until the grippers have taken hold of the leading edge of the sheet. Using a fine-point pencil, mark the sheet at the tip of the grippers to ascertain the amount of grip taken on the sheet. By

folding the sheet after marking, a rapid assessment can be made of the level of the front-lay stops.

10. Inch the sheet through the delivery and adjust the pile guides and joggers.

11. Recheck the settings by running sheets through at speed.

PLATE MANAGEMENT

The success of the pressman's labours will depend a great deal on his management of the lithographic plate. Before the plate is fitted to the press cylinder the following procedure should be followed:

1. Examine the plate carefully and check it with the works order, dummy, etc.

2. Thoroughly clean the back of the plate.

3. Many pressmen prefer to re-gum the plate at this point to satisfy themselves that it has been done correctly.

4. Wash the ink away with white spirit or turpentine, and rub down a thin film of asphaltum solution over the image areas. If a clean colour is to be printed, a clear wash-out solution will prevent colour contamination. Many presensitised plates do not require the application of asphaltum solution.

MOUNTING THE PLATE

The correct packing for the plate cylinder should be selected and be thoroughly clean. If the plate is the first colour of a multicolour job, it may be necessary to overpack the plate cylinder in order to print the image short. The amount of overpacking can only be determined by experience, although the formula given on page 221 will enable the pressman to obtain an approximate figure.

An increase in the plate packing will require additional adjustments to be made to maintain a suitable pressure between plate and blanket cylinders, and ink rollers to plate settings will require adjustment. Before fitting the plate to the cylinder, adjust the leading plate clamp until it is at its highest point against the cylinder body. This is to ensure that when the plate is attached, the bend at the leading edge will be drawn off the cylinder body into the gap when final plate adjustments are made. If the clamp is left at a low position, and the plate fitted, the bend may be pulled on to the cylinder body where it may ink up and cause trouble during the run.

When the plate has been attached to both clamps, the circumferential adjustments will be made to align the register lines on the plate with those on the cylinder body. The value of situating register lines in this manner has already been examined (page 115).

Fig. 162.—Check marks on the printed sheet producing a pattern on the pile edge which enables the pressman to assess sheet register.

An additional set of marks to aid register checking during the run are now placed on the plate when the final position of the sheet has been settled. Figure 162 shows the position of the marks as follows:

The mark S is 5 mm long and is situated to print on the very edge of the sheet at the approximate point where the side-lay stop makes contact with the sheet edge. The marks F are situated approximately 40 mm from the front edge of the sheet and overlap the sheet by 3 mm. As the sheets are being printed, the marks will show a distinct pattern down the side of the pile and reveal any deviation in sheet register during the run.

To position the marks, first gum up the plate and dry. Then take an accurately printed sheet and tear a section away across the image area as shown in Fig. 163. Place the torn piece on to the plate and position its edges with the image exactly. Dab a thin film of ink from the finger on to the overlapping edges of the sheet at the point S. Remove the sheet. The extremity of the sheet is now clearly seen and should be scored through with a fine point and inked in. The marks F are measured accurately on both sides of the plate, scored and inked in.

When a pass has been obtained, spend a few moments checking that plate clamps and adjustment points are locked up, and lay stops are secure.

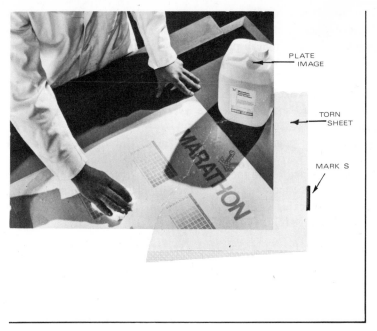

PLATE IMAGE

TORN SHEET

MARK S

Fig. 163.—Obtaining the position of the side lay. To find the side-lay mark S, a torn portion of an accurately printed sheet is registered with the plate image and the sheet edge is clearly indicated.

CYLINDER PACKINGS

Most modern machines have facilities for altering the packing thickness of the plate and blanket cylinders. This is allowed for the following reasons:

1. To compensate for different thicknesses of plates and blankets.

2. To permit adjustment of the contact pressure between plate and blanket cylinder on bearer contact machines.

3. To allow the pressman facilities for altering the circumferential measurement of the print image.

Variations in plate thickness do not occur as they did a few years ago when plates were regrained after use. With the use of regrained plates it is necessary to check the caliper of each plate and adjust the packing accordingly. The disposable aluminium plate is changing

this practice, although it is still necessary for the pressman to check that aluminium plates do conform to standard thickness. Errors plus or minus 0·025 mm in plate thickness can present difficulties if not detected and allowed for when fitting the plate.

An *engineer's micrometer* should be used to caliper a plate before fitting. Take a measurement from a number of different points of the plate, and estimate the average if the thickness varies a little.

The same points apply to the blanket. The thickness should be checked with a *blanket micrometer* if possible, but bear in mind that when tensioned round the cylinder the blanket may lose its bulk and thickness. The more accurate method for checking the blanket thickness and packing is to check the tensioned blanket with a *cylinder packing gauge* (Fig. 164).

PACKING SHEETS

The choice of material for packing sheets is important. It can be time-wasting and false economy to use regular paper stock as packing. Packing sheets should be of a non-compressible material such as manilla. It is better to use plastic sheet, such as I.C.I. Melinex, which will maintain its caliper indefinitely and is unaffected by oil, spirit or water.

An efficient method is to keep a stock of packings of varying thicknesses with the correct caliper clearly marked upon them.

CYLINDER CONTACT PRESSURE

When correctly dressed and set, the contact pressure between the plate and blanket should not exceed 0·1 mm. Over-pressure will only result in the early wear of cylinder bearings, and deterioration of image quality. The golden rule in setting cylinder contact pressure is to keep it as light as possible consistent with good image transfer. It is quite possible to have this pressure as light as 0·05 mm with grainless plates and a hard blanket. On high-speed machines the lighter the contact pressure the less surface heat will be generated between plate and blanket.

Pressure setting between the blanket and impression cylinders follow the same principles, although the final setting will depend upon the type and thickness of the stock to be printed. Some papers have an uneven surface which require additional pressure to

(a)

(b)

(c)

Courtesy: Printing Aids Ltd.

Fig. 164.—(*a*) The "pal" cylinder packing gauge with magnetic base. (*b*) Positioning the gauge into the slots and registering the micrometer indicator. (*c*) Micrometer sensor moved from the blanket surface to the bearer to record the related difference.

"bottom" the ink film. Coated papers on the other hand require less pressure to effect good transfer of ink. The most common method for setting the impression cylinder pressure is to move the cylinder out of printing contact with the blanket cylinder and to bring the cylinders together until maximum print quality is obtained. All modern machines have a simple adjustment mechanism for setting the impression cylinder contact pressure.

The recent introduction of compressible blankets which are claimed to function well at pressures twice that for the normal blanket without image distortion, should be treated in the same way. Set contact pressure as light as possible consistent with good image transfer.

PRINTED IMAGE SIZE

For many years it has been the practice of pressmen to alter the packing thickness of the plate to vary the circumferential measurement of the image. It is not possible to change the lateral measurement of the image by altering plate packings.

Alteration of the image size has been found necessary because of the dimensional instability of paper. The normal paper selected for lithographic use is known as "long grain" because the fibres of the paper run parallel to the gripper edge of the sheet. When the sheet passes through the press it takes up moisture from the blanket causing the sheet to expand. In long-grain paper this expansion is more pronounced from the gripper to the back edge of the sheet. The image printed on the sheet will obviously expand with the sheet in this main direction. A second colour printed on to the sheet will not fit the first print. If the plate packing is increased in thickness before the first image is printed, the increase of the plate diameter will cause the image to print short, thus making allowance for expansion of the paper.

The principles governing the change of image size will now be considered in detail. The following points are important:

1. When the cylinders are dressed to specification the printed image will be correct to size.

2. If the packing thickness under the plate is increased, the diameter of the cylinder is increased by double that amount.

3. An increase in cylinder diameter results in an increase in

circumferential measurement. The increase is equated by multiplying the increased diameter by π (pi) (3·142).

4. When the diameter of the cylinder is increased, the surface speed of the plate is increased.

With the above points in mind, let us examine the principles behind change of image size. In Fig. 165 the image on the plate cylinder covers 270°. When this cylinder is rotated in fixed contact

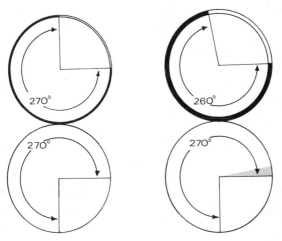

Fig. **165**.—Image size (270°). Fig. **166**.—Image size (260°).

with the blanket cylinder the transferred image is 270°, that is, the same size. In Fig. 166 the plate packing has been increased, thereby making the diameter greater. The plate image retains its size but, in proportion to the increased diameter of the cylinder, it now occupies 260°. The transferred image is therefore shorter.

CALCULATING CHANGE IN IMAGE SIZE

An increase in the plate packing of 0·1 mm results in an increased diameter of twice that amount, 0·2 mm. Multiply this figure by π and the increase in the circumference is 0·628. This increase will affect the image only in proportion to the amount which the image occupies of the circumference. If the image occupies 0·75 of the circumference, then the image size will be shorter by $0·628 \times 0·75 = 0·47$ mm. The formula for estimating change in image size is as follows:

$$P \times 2 \times 3·142 \times F = N$$

where P = packing thickness change;
\quad F = fraction of cylinder occupied by the image;
\quad N = new image size.

The effects of running the press with cylinder dressings at varying diameters, although solving the problems of paper stretch, may bring further difficulties. The change in diameter of the plate cylinder results in a certain amount of slippage occurring between the plate and blanket when printing. This slippage can result in a serious shortening of the plate life and the quality of the final print. Alterations in the thickness of plate packing ought, therefore, to be limited to the minimum consistent with good image reproduction.

Figure 167 shows the variations which can be obtained by changing packing thicknesses. You will observe that the alteration in the diameter of the blanket cylinder alone has no effect on image size. The ratios of plate and impression cylinder diameters alone determine the change in image size.

Fig. 167.—Variations obtained by changing packing thicknesses.
\quad (a) All cylinders dressed to correct size—same size image.
\quad (b) Plate cylinder overpacked, blanket underpacked, impression cylinder same size—short image.
\quad (c) Plate underpacked, blanket overpacked, impression cylinder same size—long image.
\quad (d) Plate and blanket packed to size, impression cylinder oversize—long image.
\quad (e) Plate and blanket packed to size, impression cylinder undersize—short image.

Few presses have facilities for altering the impression cylinder diameter. This is a notable point. If a machine prints to correct size using 0·1 mm stock, there will be an increase in image size if a card of about 0·3 mm is used, because this will in effect increase the diameter of the impression cylinder. Even if correct size is not

important, increasing the diameter of the printing surface will mean an increase in the surface speed of the stock as it passes through the impression nip. This may result in a loosening of the surface fibres of the stock yielding lint and fluff, higher blanket temperature and a lowering of print quality.

RUNNING IN A NEW BLANKET

Although the modern blanket is resistant to the variety of solvents used in inks, it may, however, absorb a proportion of the ink solvent, especially when new. The new blanket should be primed for use in the following manner:

1. Saturate a cloth with ink solvent or quick-setting distillate reducer (this can be obtained from the ink-maker).

2. Wipe the surface of the blanket, allowing the solvent to soak into the blanket over a period of two or three hours.

3. When the blanket has reached saturation equilibrium, the excess solvent is removed with a dry cloth prior to printing.

Inks with a volatile solvent, such as heat-set inks, often lose a proportion of solvent by absorption into the blanket during the run. When there is a press stop, the solvent evaporates from the blanket leaving the ink on the surface with a high degree of tack. When the press is started again the ink transferred to the blanket also loses its solvent into the blanket with the result that the tack of the ink pulls the paper to pieces during impression causing web breaks, etc. To remedy this condition the blanket should be primed immediately before the press begins to run. This may be performed either by wiping the blanket with solvent, or better, by spraying the solvent on to the blanket with a hand spray while the press is turning over.

LOCAL PATCHING

It is unusual for a blanket to be used for any length of time without it being damaged by creased sheets or foreign objects passing through the press during the run. In most cases the surface rubber is undamaged, but the carcass fibres have been depressed and do not return to their former thickness. Local patching of the battered area will consist of paper about 0·03 mm thick which is torn (not cut) to the shape of the indentation and fixed with adhesive to the underside of the blanket. It is always preferable to build up layers of paper to the correct thickness rather than using a single piece of thick paper.

Obviously, the time taken to do this will be the controlling factor, and random patching may be sufficient to finish the printing run. Correct patching will take longer but is necessary if light tints or solids are being printed. The adhesive used to fix the patch should be a suitable glue or gum for sticking paper, and not gum arabic, varnish or grease. The procedure is as follows:

1. Gum up the plate. Roll up the plate and blanket with a solid film of ink.

2. Release the back edge of the blanket, and reverse the press slowly while the blanket is lifted.

3. Using a soft pencil trace the outline of the damaged area on the back of the blanket by viewing the indentation of the pencil made on the front of the blanket.

4. Attach the patch by starting with the smallest layer and progressively enlarging each piece until the entire area of damage is covered.

5. The use of a lacquer spray to build up the area with a more uniform reduction in area thickness (called "feathering") may be used to give a more permanent repair.

Temporary cures for battering may often prove useful in finishing a run until a more permanent repair can be made. A strong solvent such as methyl ethyl ketone (M.E.K.) may be used to swell the surface rubber of the blanket. The use of a hypodermic syringe to inject water, turpentine, naphtha or benzene into the fibre plies beneath the damaged area is also a fairly common practice. The injected fluid causes the plies to swell, thus correcting the damaged area.

If the rubber surface of the blanket is cut or damaged, the area may be repaired temporarily by applying an india-rubber solution. The area to be repaired must be first cleaned thoroughly with benzene and dried.

Another method of overcoming surface damage is to move the blanket circumferentially forwards or backwards, thus moving the damaged area out of the line of printing.

REVIVING THE BLANKET

The gradual absorption of ink solvents and compounds into the blanket surface rubber, and the oxidation of the surface, will give rise to tackiness, glazing and embossing. When this occurs the blanket surface must be revived to its former condition if it is to transfer the printed image correctly.

Compounds which have built up on the blanket surface can be removed by using pumice powder and blanket wash solution. The blanket should be rubbed with a vigorous action using a cloth, applying the pumice in conjunction with blanket wash solution and a little water until the surface of the rubber becomes a dull velvety texture. A final wash with blanket reviver solution will leave the blanket almost as good as new.

WASHING THE BLANKET

The purpose of washing the blanket is to remove the ink from the surface and from the pores of the rubber, to loosen dirt and fluff deposited by the stock, and to revive its resilient qualities. Solvents used for this purpose are specially made and are to be preferred to the use of normal press wash-up solutions such as white spirit. The best washes are petroleum distillates which do not evaporate too rapidly during use. Turpentine and coal-tar solvents should not be used as they have a harmful effect on synthetic rubber and can cause tackiness.

Washing should not be performed too often as this tends to speed up the oxidation of the rubber. A wash with water will often be sufficient during the run to remove fluff and lint from the surface.

When washing the blanket the pressman should use two hands to complete the operation. A solvent-saturated cloth is used with one hand to thoroughly wet the blanket, and a dry cloth used in the other hand to remove the solvent before it has time to evaporate. Clean small areas of the blanket at a time. Remember that the finely dissolved particles of ink and driers will more readily penetrate the surface pores of the rubber when flooded with solvent, and must be removed before this occurs. The following factors are related to blanket deterioration:

1. Absorption of the ink vehicle and cleaning solvents with simultaneous oxidation of the rubber will produce a sticky plastic substance which makes the surface tacky.

2. When these plastic compounds harden, the rubber surface becomes shiny and unreceptive to ink, and leaves the blanket with poor transfer qualities. This condition is called "glazing" and is a common condition of blankets which have had prolonged use.

3. Heat and sunlight are two enemies of synthetic rubber, and their effect on the press blanket is made worse when the blanket is under tension. Every effort should be made to protect the blanket from direct sunlight.

4. The anti-oxidants originally included in the blanket rubber are removed from the surface by continual washing. The use of the blanket manufacturer's recommended washing solvents is necessary if this effect is to be countered.

DAMPING MANAGEMENT

Although dampers may be damp when fitted in the press, they often dry during the makeready stage. Ensure that they are damp before use, otherwise they will quickly become clogged with ink. Make the initial damping with the controls set at a minimum. If the amount of moisture in the dampers is unknown, the following procedure should be adopted:

1. Close down the moisture controls to a minimum.
2. While making ready avoid applying too much water to the plate with a sponge.
3. Keep the moisture controls at a minimum until the plate begins to catch up.
4. Open the moisture controls gradually, allowing the plate to catch up slightly before more moisture is applied. If this is done carefully a point will be reached when the plate will run clean. The pressman will now know that the press is running with a minimum of moisture, which is the ideal for good print reproduction.

Excess plate moisture will work into the ink rollers, bringing the problems of emulsification and the danger of non-drying prints.

FOUNTAIN SOLUTIONS

A few years ago the pressman added substances to his press fountain solution to maintain consistent printing quality and a trouble-free run. Often these additions were made on empirical judgments without the pressman actually knowing what they did to aid the job. Such practices are now dying out, due to the improvement in the working properties of modern plates and the supply of commercial fountain solution additives.

The fountain solution must be formulated according to the following requirements;

1. Plate damping must be uniform and moisture kept to a minimum. To obtain this, ordinary water may be used, but because water has a high surface tension it does not wet the plate surface effectively

unless a heavy film of water is applied to the plate. This leads to problems of ink/water emulsification, an increase in linting and piling with certain types of paper, and raises the moisture content of the stock.

Substances may be added to the fountain solution to reduce the surface tension and thereby permit good damping with less moisture on the plate. Gum arabic (14 °Bé) solution added in the proportions 2 : 100 (2 per cent) is used to reduce surface tension. Proportions higher than this may give emulsification problems.

Isopropanol alcohol (*I.P.A.*) when mixed in the proportions 20–30 : 100 (20–30 per cent) with water will lower the surface tension of water by one-half. This also reduces the tendency to emulsification because the alcohol evaporates from the ink at a greater rate than does water. Specially constructed damping systems are in use for the application of alcohol/water solutions.

2. The damping solution ought to maintain the desensitisation of the plate during the run.

Experience indicates that plate desensitisation is maintained during the run if a phosphate salt is mixed with gum arabic as a fountain solution additive. Stock solution in the proportions 1 : 100 (1 per cent) of phosphoric acid 85 per cent, to gum arabic (14 °Bé), is mixed with water in the proportions 2 : 100 (2 per cent) to make a fountain solution. The acid value of the fountain solution will depend on the pH of the water used, but the acidity should not be allowed to exceed pH 4·6. Aim at a norm of pH 5–5·6.

3. Additives to the fountain solution are necessary to prevent the accumulation of fungi and bacteria. Organic substances such as gum arabic quickly become the breeding-ground for micro-organisms; sunlight, plus the accumulation of fluff and dust in the fountain tray, accelerate this. Unpleasant smells and slime appear which will affect damping performance and clog circulatory systems.

The use of isopropanol alcohol will reduce this as the alcohol has a damaging effect on bacteria. A suitable additive recommended to prevent the souring of solutions which contain gum arabic is 8-hydroxyquinolin added to the fountain solution in the proportions 1 : 100 000 (0·001 per cent).

INKING MANAGEMENT

Having obtained the correct shade of ink, work it on the slab with a palette-knife for a few minutes. Because the ink is thixotropic it can

Fig. 168.—Setting the ink-duct by viewing the image layout.

be reduced from a fairly solid state to a fluid condition by working it like this. At this point the pressman will be able to assess whether the ink needs to be reduced further. Taking a small quantity of the ink, place it into the ink-duct and proceed to adjust the duct blade in accordance with the layout of the plate image. To obtain an approximate guide of the setting, move the feed roller into contact with the duct roller and rotate the duct roller by hand for a moment or two. An even film of ink will form on both rollers. A slight pause will allow the ink to flow into the roller nip, and when the roller is rotated

slowly the flow line will show the quantity of ink which is present on both rollers (Fig. 168).

Experience will of necessity determine how quickly the duct blade can be set with accuracy, but a few minutes spent making this initial setting will enable the pressman to give his undivided attention to the other aspects of making ready.

It is not a recommended practice to knife ink on to the rollers to obtain rapid ink volume, as this will give a false indication of the ink level and duct-blade setting. When the duct setting is satisfactory, run up a thin film of ink on to the rollers. Bear in mind that it is easier to add more ink than it is to remove an excess of ink. Increase the ink gradually during makeready until the required level is obtained. The stroke of the ink-duct roller should be adjusted to give a satisfactory level of ink when the control is set at two-thirds its maximum. Avoid running the job with the setting too close to maximum or minimum, as this will permit little adjustment if it should become necessary.

SEQUENCE OF PRINTING COLOUR

The order in which colours are printed in multicolour work is dependent on a large number of factors. The printing of colours other than process colours becomes even more complex due to the reasons which determine their use, for example, opaque colours may be used to cover coloured stock or mask surface reflection as with tin-plate. The following factors may find application to the printing of colours other than process colour inks, although their main application is in the use of four-colour process inks on white paper or board.

1. The progressive proof book may indicate the order in which the colours are to be printed.

2. Although process inks are relatively transparent, when two or more films of ink are printed on top of each other, the topmost film of ink will impart its own sheen to the final colour. In practice this means that a green produced with the yellow ink printed last will have a brighter appearance than a green in which the cyan ink falls last. Mixed shades such as brown will lean towards the colour of the last ink printed. With this in mind the job must be evaluated and colours arranged to give the best result.

3. Certain inks when dry may make the trapping of the subsequent colours difficult. The pressman may decide to print problem

colours like this at a later point in the sequence to overcome trapping difficulties.

4. The traditional method of printing the yellow first has the drawback that evaluation of its colour weight is difficult because it is a pale colour and is often difficult to see on some papers. Variations in the weight of ink printed during the run may only become apparent when printing the subsequent colours. It is common practice, therefore, to print a darker colour such as cyan first, because a variation in the printing of the yellow ink is more readily seen when superimposed than on its own.

5. On multicolour presses a heavy solid may not trap well on top of another wet solid. On two-colour presses the pressman will avoid printing two colours like this in one pass through the machine.

6. Where a job requires close register between two particular colours which may be affected by a change in paper dimensions after the first pass through the press, it is better to print these two colours in the first pass on a two-colour press.

7. It is often difficult to trap succeeding ink films to the first print when it is wet. This occurs because the paper has absorbed some of the ink solvent causing the ink tack to rise. The following print will not adhere to this tacky print unless it has a lower tack factor. When printing wet on wet, therefore, the inks are usually tack graded, *i.e.* the first ink has a higher tack factor than the second ink and so on. This in itself may dictate the order of printing the colours if there are one or two plates in the set containing work which will not print well with reduced inks, for example, fine line-work or shadow areas may fill in with reduced ink. In cases like this the problem colours will be printed first.

8. An important factor to be considered when printing wet on wet is the increase in half-tone dot size from the first printing unit to the last unit. The wet film of ink printed first on the sheet is partially transferred to the succeeding blankets on the multicolour press with a progressive increase in size, because of the spreading of the ink under pressure. Dot gain like this may show up more with certain colours than with others. A dot gain in a magenta print may make flesh tones appear flushed in the final print. Delicate tones in prints of food may turn a blue-purple shade if the dot gain occurs with the cyan printer. To overcome this problem it is often necessary to establish a standard colour sequence for the presses in a printing house, thus allowing the dot-gain problem to be tackled by the

graphic reproduction department. To do this those plates which are printed first are prepared with a half-tone dot size slightly smaller than normal to allow for dot gain on the press.

9. To avoid excessive contamination of the second and subsequent units on the multicolour press caused by partial transfer of the ink from the printed sheet, the printing sequence may be altered. This can be arranged so that heavier films of ink are printed by the last units of the press.

INK SET-OFF

The transfer of printing ink from one printed sheet to the back of another is known as "set-off." The problem occurs on sheet- and web-fed presses. From the pressman's point of view the setting of the printed ink on the stock involves three factors:

1. The printed ink film must key to the stock quickly enough to allow the second printing adequate trapping. This relies on satisfactory absorption of the ink vehicle into the stock as it passes from one printing unit to the next.

2. The ink film must gain an initial set from the time that it leaves the last printing unit to the moment that it is dropped on to the delivery pile. The modern pile delivery receives the sheet in under four seconds after it has left the impression cylinder, whereas on paper with poor surface absorbency, the ink may take as long as fifteen seconds to gain the initial setting required.

3. The printed ink must dry in the pile without further attention. Set-off can occur in the pile if the ink film dries too rapidly at the interface of ink and paper, thus preventing adequate penetration of the vehicle into the stock. When this happens the vehicle filters into the surface of the ink film and may result in set-off, and in heavy piles the sheets may stick firmly together (called "blocking").

The tendency for an ink to set off when printed may be influenced by the following factors:

1. Printing thick films of ink. On multicolour work the efficient use of undercolour removal in dense areas of the image will help to prevent this.

2. The use of non-absorbent paper and board.

Courtesy: N. V. Tools Ltd.

Fig. 169.—A portable static detector.

3. Smooth-surfaced papers permit closer interfacial contact between the sheets in the pile which will encourage set-off.

4. Inks which contain a high proportion of resin varnish (gloss inks) leave a relatively heavier film of ink on the paper surface than do standard inks.

5. Slow-drying inks. Caused possibly by high acid content of ink, paper or fountain solution; low concentration of driers in the ink.

6. High press speed will not give the ink time to gain an initial set before it is stacked.

7. Printing on cold paper may cause the ink film to increase its viscosity and prevent adequate penetration into the stock.

8. The build-up of static electricity in the printed sheets may cause them to cling together in the delivery (Fig. 169).

9. Careless handling of the printed sheets within a short period of printing.

REMEDIES TO SET-OFF

If the pressman has a reasonable idea of the cause of set-off such as those which are contained in the preceding list, his action to remedy the problem will lie in reversing the cause, for example, add more driers to the ink, check acidity levels, lower press speed, handle sheets carefully and so on. A number of specific aids for the prevention of set-off are as follows:

1. Stack the printed sheets in small piles and so reduce pile weight.

2. If the delivery pile is boxed in with cardboard, the air trapped between the sheets will act as a cushion and give more time for ink setting.

3. The racking of sheets and especially board will overcome set-off caused by pressure—or use delivery-pile spacers.

4. Extend the time between impression and delivery of the sheet. Presses with an extended pile delivery, and double-delivery systems, are favoured for regular work which has tendencies to set-off.

5. An increase in the pressure between blanket and impression cylinder may help to give the ink better penetration into the stock. The use of a compressible blanket will allow additional pressure without excessive distortion of the image.

6. *Static electricity* can be eliminated with the use of anti-static devices. Dry paper can acquire static charges during its passage through the press from its contact with the rubber and metal components. Because paper is an insulator, the charges build up on its surface, usually with unlike poles on each side of the sheet (*see* Fig. 13, p. 17), causing the sheets to cling together. Static build-up like this can be overcome in the following ways:

(*a*) Raising the moisture content of the paper. This may be done by placing an atomising water spray near the press, or by pre-running the paper through the press with the dampers on a plain plate and no ink.

(*b*) Raising the relative humidity of the press-room will prevent the build-up of static in the paper. Relative humidity of 65 per cent and above will keep paper free from static charges.

(*c*) The static charges in the paper can be earthed by placing a metal conductor (thin wire or metal tinsel strips) close to the paper. If the metal conductor is correctly earthed, the electrical field produced between the metal and the paper will discharge the electricity.

(*d*) Increasing the conductivity of the air near the paper will cause the static to be discharged. A number of commercial devices are available which ionise the air with the use of radioactive materials which emit alpha or beta particles, or use ultra-violet radiation. Strontium B particle neutralisers are claimed to be safe and efficient.

7. The most common aid to the prevention of set-off is the use of the *anti-set-off spray*. A spray device showers the printed sheet with very small particles before the following sheet settles on it in the delivery pile. The small particles serve to prevent close contact between the sheets and so allow time for the ink to set. The following two types of spray are common:

(*a*) The wet spray. This is based on dextrine or gum arabic particles which are suspended in a spirit. The spray is designed to form concave particles which break up as the spirit evaporates, leaving dry globules of dextrine or gum on the sheet.

(*b*) The dry spray. The spray particles are usually edible potato starch, calcite (calcium nitrate and ammonium carbonate) and powdered limestone. These materials must be chemically neutral, non-hygroscopic and have uniform particles of 15–40 μm (micrometres).

Water-soluble carbohydrates have been developed to give a "vanishing" anti-set-off powder which absorbs moisture from the air, allowing it to filter into the paper.

Excessive use of the anti-set-off spray may affect subsequent overprinting, especially in half-tone work; it may also cause troublesome slipping when fed into the press or folding machines. The contamination of machinery, delivery chains, vacuum rollers, etc., is another factor to be considered when using this type of spray.

Electrostatic powder distributors

Another method of applying the anti-set-off powder to the sheet is to convey the powder to the sheet by an electrostatic field. The dry powder is contained in a distributing tray which meters out a quantity of powder over the width of the sheet as it passes underneath. A discharge tube (10 000 V) creates a corona discharge over the passing sheet, thus forming an electrostatic field between the powder tray and the sheet surface. The falling powder follows the electrostatic field and becomes bonded to the surface of the paper.

High-voltage discharge units

These units are commonly used on sheet- or web-fed presses to remove static electricity from the paper by ionising the air above the sheet. The unit usually consists of a bar which has small projecting points situated along its length (Fig. 170). The bar is located above

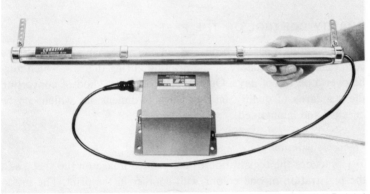

Courtesy: N. V. Tools Ltd.

Fig. 170.—A high-voltage discharge unit and transformer.

the paper and receives a high-voltage electrical charge (about 8000 V) which is emitted from the sharp ends of the projecting points on the bar. This ionises the surrounding air sufficiently to neutralise the static charges on the paper.

PRESS BRONZING

Special effects to printed work in the form of powdered metal are very common on Christmas cards and calendars. The usual metal is "gold

bronze," and consists of flakes of brass (zinc and copper alloy) which can be obtained in varying shades of colour depending on the proportions of the two metals in the alloy. The normal procedure for bronzing is to print a bronze adhesive on to the paper in the normal manner. The adhesive (called "size" or "gold size") consists of a tacky ink which may range in colour from yellow to green, depending on the final effect required. Before printing the adhesive, all other previously printed ink must be thoroughly dry.

After printing the adhesive, the sheet is passed into an enclosed unit which cascades the sheet with bronze powder and removes the excess by dusting and vacuum. Bronzed sheets are usually left for a period of about twenty-four hours to dry out and may be redusted to remove residual bronze powder from the sheet. Burnishing confers an extra lustre to the bronzed print. This is obtained by passing the sheets through a calendering machine which flattens and polishes the bronze particles.

QUALITY CONTROL ON THE PRESS

After obtaining a pass to begin the run, the pressman's main business is to maintain the quality of the printing during the run, which may be over a period of days. Quality control is a method of converting the standards of quality into measurable dimensions which can be checked and maintained.

Precise registration

This includes the registration of the printed image on the sheet, and the registration of one colour with another in the print. The pressman's attention will be focused on the squareness of sheets, the good separation and feeding of sheets into the press, control of moisture intake by the paper as it passes through the press and management of the change of image size on colour work.

The visual check of the position of the printed side-lay marks on the stock assists the registration of colours. Special rulers are available for the measuring of the dimensional change in paper.

Good reproduction

This involves the printing of the image to give good reproduction of fine line and highlight half-tone dots, and open shadow dots. The printing of the star target or a similar aid will permit rapid

assessment of these printing qualities during the run, including dot gain, slur and doubling.

Colour reproduction

The density of the printed ink film will affect the quality of colour reproduction. This is true of lithographic inks which are formulated with high tinctorial strength and which change their shade with very small changes in ink film thickness. The main aid for maintaining quality of colour is the densitometer, whose construction has already been shown in Chapter 1.

USING THE REFLECTION DENSITOMETER ON THE PRESS

A solid area of colour is selected for measurement under the photocell. When it can be permitted a solid bar 10 mm wide should be

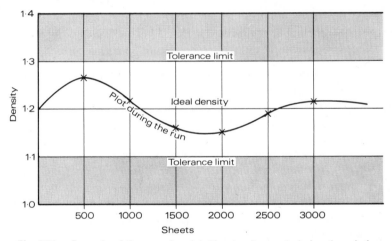

Fig. 171.—Example of the use of an ink-film density graph during the printing run. The tolerance limits indicate the point at which colour-density variation from the norm becomes visible to the eye.

placed on the plate to print in each colour on to the stock. An alternative is to use small squares placed at random outside trim areas on the sheet.

When a pass is obtained, the densitometer reading for that colour is taken from the solid areas on the sheet, and the reading noted on the pass sheet or, better, on a density graph. A note on the time which elapses between the actual printing and the reading should be

made, and further sample readings taken at the same time-interval. The graph should be arranged to allow readings to be taken over a period of time or according to the number of sheets printed. The density curve will also permit variations from the pass sheet density within a tolerable level, which should be noted on the graph (Fig. 171).

PREPARING THE PLATE FOR STORAGE

At the end of the printing run the pressman's first concern will be the preparation of the printing plate for storage. In many large printing departments press plates are prepared for storage by a craftsman who rolls the plate up with hand-press black ink, examines it for blemishes, makes the necessary corrections, applies desensitising plate etch, gums the plate and files it in a plate store.

Many smaller printing departments, however, expect the pressman to prepare the plate for storage at the end of the run. The following procedure may be followed to complete this operation correctly:

1. Before removing the plate from the press ensure that the image has an adequate film of ink.

2. Remove the plate from the cylinder and place it face up on a bench. Wash the surface with water and examine the image for defects, and the non-image areas for scumming, spots, etc. If small corrections can be made they should be done at this point.

3. The plate is subsequently desensitised with plate etch and gummed up and dried.

4. When the gum is dry, the press ink is washed off with white spirit, the plate bends cleaned, the plate turned over and the back washed thoroughly.

5. At this point the plate may be washed out with asphaltum solution, the film rubbed down to a smooth finish, and then stored. An alternative method is to wash the plate with water, and to rub up the image with a non-drying black ink. This operation is followed by gumming up the plate and storing.

ROLLER WASH-UP

Modern presses are equipped with an automatic wash-up device. This consists of a metal, fibre or rubber blade which is adjusted to contact

a metal intermediate roller high in the ink roller pyramid. The ink wash-up solvent is stripped from the rollers by the blade and the waste run into a tray situated beneath the blade. The following points are important for good wash-up:

1. *The wash-up solvent should be suitable for the job.* Commercial solutions usually contain anti-oxidants and deep-cleaning spirit which is better for roller maintenance than white spirit.

2. *Wash up one half of the rollers at a time.* This allows the dry side to drive the roller pyramid without roller skid.

3. *Increase the press speed for wash-up.* This ensures that the roller wash-up solvent carries the ink into the tray before it has time to evaporate into the air.

4. Care taken in cleaning the roller ends will mean longer roller life and freedom from hickies.

5. Make it a part of routine to inspect the rollers, revive the roller surfaces and check the settings regularly.

DAMPER CLEANING

Fabric covers tend to pick up ink from the plate during use, and this works into the nap and fibres of the fabric. Unless this ink is removed it will dry, making the cover hard and reducing its efficiency and reliability. The following cleaning sequence will maintain the efficiency of fabric-covered dampers:

THREE-WASH-UP SYSTEM

1. Thoroughly soak the damper fabric with white spirit or a non-oily ink solvent. Lightly scrub the fabric with a bristle brush until the impregnated ink is loosened.

2. Apply a liberal quantity of damper cleaning detergent, working this into the fabric until it is thoroughly mixed with the ink solvent.

3. Wash the damper under running water, scrubbing the surface to ensure that all traces of the detergent and ink solvent are completely removed. Finally, scrape the excess water out of the fabric with a dull-edged knife or a similar scraper.

The disadvantage of the fabric cover is its constant need of deep cleaning, and this may cause it to wear unevenly, making the cover lumpy and slack, thereby necessitating constant resetting.

I

Before replacing the damper in the press, check that the end stitching of the cover is secure, and dry the roller-bearing at the shaft ends and lubricate the bearings.

MAKEREADY ON THE MULTICOLOUR PRESS

Multicolour sheet-fed presses require a makeready procedure similar to that outlined for the single-colour press. The following points are additional factors which are peculiar to multicolour machines:

1. The first printing unit of a multicolour press has front and side lays like the single-colour press. Additional printing units obtain register by the facility of the plate-cylinder movement, which can be moved laterally and circumferentially to a limited degree.

2. When making ready on the first unit, the front lays must be set squarely. The side lay must move the sheet to the press centre. The plate must be fixed on to the cylinder squarely; if it is slightly cocked the plate positioning on subsequent units will be found difficult.

3. The circumferential movement of the first unit should be set at zero if possible. A movement which is plus or minus zero will need to be repeated on all following units.

4. It is common practice to make ready on the first printing unit with all the following units disengaged or out of impression. Makeready on the following units is made progressively, bringing each unit into line with the first.

5. With the extended period required for makeready on a press possessing a number of units, the ink on rollers and blankets may become tacky and give picking problems, especially on coated papers. To overcome this, the following procedures may be adopted:

(*a*) Use a small quantity of ink in each ink-duct which has a slow-drying compound added. Remove this when the run is about to begin.

(*b*) Use an absorbent uncoated paper of similar dimensions and substance to the job stock for making ready.

MAKEREADY ON THE WEB-OFFSET PRESS

Special procedures are required for lithographic presses which print on a web of paper. The normal sequence used for the sheet-fed press

will apply, with an additional emphasis placed on making ready on the run with a ribbon of paper. The following points should be noted:

1. Special attention must be given to the mounting of plates to ensure that they are perfectly square with the cylinder (Fig. 172). Little facility is given on most web presses for cocking the plate once it has been mounted; it is, therefore, important that the plate-

Courtesy: Crabtree-Mann Ltd.

Fig. 172.—Mounting a plate on a Crabtree Crusader.

bending operation be performed carefully. If a punch-register system can be used for positioning the plates on the plate bender, registration of plates will be simplified.

If the plate position on the plate bender is obtained by sighting-up marks, ensure that the plate marks are situated in relation to the image, and not to the plate edge which may be out of square.

2. It is important to limit the amount of moisture applied to the plate during makeready. Excess water will be squeegeed to the back of the plate where it will accumulate in the plate clamp until it is

thrown out by the cylinder motion to form a damp strip across the web causing it to break easily.

3. Makeready on coated papers or with the use of heat-set inks presents a problem when the ink tack rises, due to the solvents evaporating from the ink on rollers and blankets with the result that the web is broken. This may be overcome by making ready on an absorbent paper and changing to the coated stock when ready to run. Non-heat-set inks may also be used during the makeready period with a change to heat-set inks before normal production.

4. Evaporation of the ink solvent from the blanket during press stops will result in the increase of ink tack, which may break the web when the press is started. To remedy this the blanket should be saturated with the ink solvent (applied by hand spray) just before the run begins.

5. In place of waster sheets used on the sheet-fed press, the web press can utilise the end of reels from previous jobs for making ready.

6. Web breaks during the run are a serious production hazard and should not be treated lightly. Whenever a break occurs the severed ends of the paper should be examined to discover the cause. Web breaks are often produced by press faults which the pressman can put right if he knows how the paper was broken. In some cases, however, the fault lies with the reel itself and the condition in which it was delivered, and such faults should always be reported to the paper-supplier.

7. Ink set-off on to path rollers can be minimised by covering them with grater foil or a suitable coarse-textured material. This can, however, give rise to web breaks because the paper is unable to slip smoothly over the path rollers when changes in tension occur.

8. On large web-offset presses with multicolour facilities it is common for each member of the press crew to have a particular task which is his alone. One pressman will have the responsibility for colour, another for register of colours and another for register of pages and folding. Each member of the crew must do his own job without overlapping into another area of responsibility. Without this kind of arrangement the makeready period can become confused and time-wasting.

9. If continuous web feeding is provided by use of flying pasters, the leading pressman must be informed when a new web is to be joined so that the impression pressures can be tripped out as the join on the webs passes through.

PAPER AND INK FOR LITHOGRAPHY

Paper

THE principal material used in the making of paper is the cellulose fibre, which is a very small, narrow, flattened tube-shaped cell with tapering ends.

Cellulose is a white fibrous material with a high tensile strength. It is known as a "carbohydrate" because it is composed of the elements carbon, hydrogen and oxygen $(C_6H_{10}O_5)_n$. The fibre itself is made up of minute thread-like structures called *fibrils* which are packed together in the cell wall. Cellulose fibre constitutes the basic structure or skeleton of all vegetable plants from fine grasses to towering fir trees. The fibre has a natural affinity for water (hygroscopic) which causes it to increase its diameter when wetted, thus increasing the rigidity of the plant. An important characteristic of the fibre in this respect is its ability to absorb and desorb moisture according to the prevailing humidity until it reaches a level of compatibility known as *equilibrium*.

In addition to cellulose fibre, the living plant also contains other substances such as lignin, fats, waxes, gums, etc., which are of no use to the papermaker and must be removed from the raw material.

The paper manufacturer's task is to select a suitable vegetable plant, reduce it to a fibrous condition by mechanical and chemical means, remove the impurities, prepare the pulp for making paper, add substances which will improve the quality and finally to construct the paper on a suitable machine. The entire process is outlined below.

RAW MATERIALS

Esparto grass

Obtained from North Africa and Spain (Fig. 173). The fibre has an average length of 1.5 mm and a diameter of 0.013 mm. It is not a

Fig. 173.—Esparto grass fibres × 100.

strong fibre but produces paper with good bulk, opacity, flatness and elasticity. The plant contains about 50 per cent cellulose. It produces high-grade lithographic paper especially suitable for high-speed multicolour printing.

Cereal straw
Obtained from wheat, oats, barley and rye straw (Fig. 174). The fibre has an average length of 1·5 mm and a diameter of 0·023 mm. It produces a firm sheet (banks and bonds) with low opacity and tear strength. A non-fluff paper with a characteristic "tinny" rattle.

Rag
Obtained from cotton and linen rags (Fig. 175). Fibre length varies between 10 and 60 mm with a diameter of 0·020 mm. This is a strong papermaking fibre, the raw material yielding 92 per cent cellulose.

Fig. 174.—Straw fibres × 100.

Fig. 175.—Cotton fibres × 100.

Fig. 176.—Hardwood—birch fibres × 100.

It produces high-grade papers for stationery, legal documents, banknotes and similar papers requiring strong durable qualities.

Wood
This is the most common raw material for modern papers. Two classes of wood are used:

1. Hardwoods (Fig. 176) (deciduous); poplar, eucalyptus, beech, chestnut and birch. Raw material yields about 60 per cent cellulose with an average fibre length of 1·25 mm and a diameter of 0·025 mm.

2. Softwoods (Fig. 177) (coniferous, cone-bearing); pine and the commonly used spruce tree yield longer fibres than hardwoods, with an average length of 4·2 mm and a diameter of 0·025 mm. Trees contain about 60 per cent cellulose.

Fig. 177.—Softwood—pine fibres × 100.

Fig. 178.—Hemp fibres × 100.

Fig. 179.—Jute fibres × 100.

Mechanical wood-pulp is mainly made from spruce and is used for cheap paper such as newsprint, which is not a strong paper but has high opacity.

"Wood-free" or chemical wood fibres are used for strong papers, writings, wrappings and printings.

Other fibres

Hemp (Fig. 178), 77 per cent cellulose, fibre length 2 mm, diameter 0·03 mm. Obtained from rope.

Jute (Fig. 179), 60 per cent cellulose, fibre length 2 mm, diameter 0·02 mm. Obtained from sackings.

Manilla, 65 per cent cellulose, fibre length 6 mm, diameter 0·025 mm. Obtained from the plantain leaf it produces a very strong, almost untearable paper which is used for cylinder packings and dimensionally stable layout planning sheets in lithography.

MANUFACTURE OF PAPER

Initial preparation

This involves the breaking down of the raw material. Wood is cut into chips or ground. Rags are hand-sorted to remove buttons, pins and clips, and are then cut, and dust removed.

Breaking

The raw material is subject to mechanical treatment in the presence of water. The breaker rolls carry blades which reduce the material to small elements.

Digesting

This operation consists of cooking the material under pressure to isolate the non-cellulosic substances and yield a pulp of suitable quality. The liquor used in the digestor may be either an acid or alkaline solution, depending on the raw material processed.

Washing, bleaching and screening

The pulp is washed with clean water until all traces of the liquor are removed. A bleach solution (chlorine) is added to the pulp to remove colouring impurities. The pulp is finally screened to remove fibre lumps, knots and grit.

Pulping

This process reduces the agglomerated mass of pulp into its individual fibres. This is accomplished with Kollergangs or Hydrapulper machines.

Beating

Many characteristics of the final paper are determined by the process of beating.

The prepared fibres are mixed with water in the beater to about 7 per cent consistency. The fibres are bruised and crushed by the action of the beater, causing part of the cell wall to become solubilised in the water giving the pulp (or furnish) a greasy texture. The longer the pulp is processed in the beater the greater the increase of greasiness. This is known as *hydration*, and it is the greasy substance in the pulp which causes the fibres to bind together on the paper-making machine. During the beating stage the fibres begin to fray and

split revealing the minute fibril substructure. This is called *fibrillation* (Fig. 180) and the process enables the fibres to mat closely together to form a stronger paper than would otherwise occur.

(a) (b)

Fig. 180.—Paper fibres. (*a*) Before fibrillation. (*b*) After fibrillation.

Refining

In modern paper-mills the beating process is supplemented, and for some types of paper superseded entirely, by the refiner. This machine carries out the beating operation at very high speeds and requires less floor space than the traditional beater engine.

Internal sizing, colouring and loadings

A number of additives are included at the beater stage to improve the quality of the final paper.

1. *Sizing.* Rosin, wax, synthetic resin or starch may be added to the furnish to reduce the absorbency of the paper. Unsized paper resembles blotting-paper.

2. *Colouring.* Shades of colour are obtained in the paper by adding insoluble pigments, or dyes to the furnish. Optical bleaching agents function by absorbing ultra-violet radiation (which is invisible) and re-emitting the energy as visible bluish light. This fluorescent effect is used to increase the whiteness of paper.

3. *Loadings.* A large number of mineral fillers are available which, when added to the furnish, improve the finish of the paper, improve its printing quality, control absorption of printing ink and increase the opacity, softness, weight and dimensional stability of the paper.

China clay (kaolin) imparts smoothness and printability qualities. Titanium dioxide improves opacity and whiteness.

Barium sulphate gives opacity, increases bulk and yields a good
surface to the paper.

Calcium carbonate produces paper with low acidity and high
strength.

FOURDRINIER PAPERMAKING MACHINE (see Fig. 181)

The prepared pulp is flowed on to the moving wire via the *slice* from
the *breast box*. The *wire* is a continuous belt of phosphor-bronze
cloth, fashioned to allow the water to drain away from the pulp,
leaving the fibres and loadings to form a layer on the wire itself. A
sideways shake is applied to the breast-roll end of the wire to im-
prove the intermeshing of the fibres. The forward movement of the wire
causes a high proportion of the fibres to align parallel to the direction
of the wire; this imparts a noticeable "grain direction" to the final
paper. The table rolls and suction boxes assist in the removal of water.

The *dandy roll* is a metal roll with a surface of woven wire cloth.
The watermark motif is fixed to the wire surface and, passing lightly
over the wet pulp, presses the design into the surface, leaving the
paper slightly thinner at the points of contact.

The *wet press felt* and press rolls apply pressure to the web to
remove more water from the paper, which at this point may still
contain as much as 80 per cent water.

The *drying section* consists of hollow, steam-heated cylinders. The
paper is pressed against the cylinders by the drier felts. The number
of cylinders may number from six to sixty-five, and are arranged in
sections.

Tub sizing may be applied to the partially dried paper by passing
the web through a sizing bath, and drying it over a hot-air drying
cylinder.

Machine calenders are stacks of three to ten highly polished rolls
which buff and polish the paper surface by the friction of the web
passing over them. The paper rolls produced at the end of the
machine may be over 7 m wide and weigh upwards of 4 tonnes.
These are reduced to smaller reels by slitting and re-reeling.

PAPER CHARACTERISTICS

WIRE MARK

As the saturated pulp settles on the wire, the finer particles, short
fibres and loadings settle to the bottom of the layer, leaving the

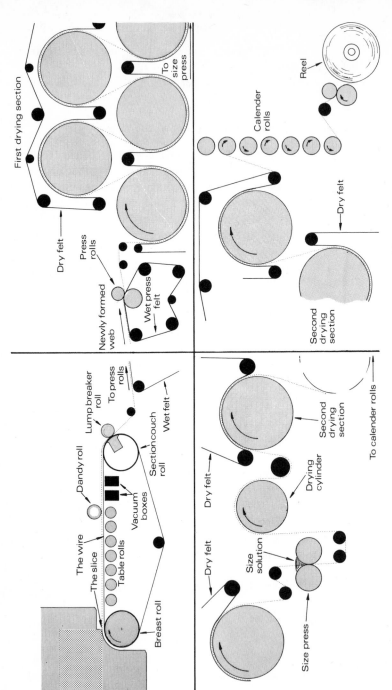

Fig. 181.—The Fourdrinier papermaking machine.

longer fibres to form the upper surface. This has the following double effect on the resulting paper:

1. The wire side of the paper carries an impression of the surface texture of the wire which may show up when printed upon.

2. The short fibres on the wire side of the paper tend to stick out, giving it a fluffy surface. This can cause serious fluffing problems to the printer, and also presents difficulties in matching coloured prints when each side of the paper has a different texture.

Twin-wire papers

These are constructed to overcome the problems of the wire mark. Fig. 182 shows how two separate papers produced on two separate

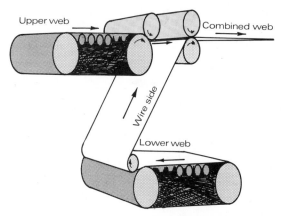

Fig. 182.—Schematic of a twin-wire machine.

wires are brought together to form one web with no wire side. Twin-wire papers are usually made to a substance of 85 g/m^2 and above.

GRAIN DIRECTION

With the majority of the paper fibres running in the machine direction, the tensile strength of the paper is formed with the grain, and tear resistance greater across the grain.

Because the paper is dried under tension in its passage through the papermaking machine it often has a built-in stress running in the machine direction of the cut sheet. This stress is often relieved when the paper becomes moist, with the result that the sheet shrinks slightly in the grain direction. In the case of the paper passing through the

lithographic press, the damping of the sheet is also accompanied by considerable impression stresses which may contribute to the deformation of the sheet.

MOISTURE CONTENT OF PAPER AND DIMENSIONAL INSTABILITY

Standard paper supplied for printing contains a proportion of moisture which is expressed as a percentage. An average paper will contain about 6 per cent moisture when delivered to the printer from the manufacturer. Because paper is hygroscopic, it will readily adjust its moisture content to that which is compatible with the prevailing room humidity. When the paper does this, it is said to reach "equilibrium" with the room humidity.

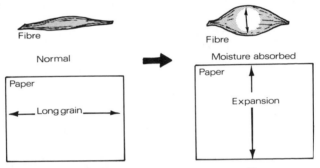

Fig. 183.—The effect of moisture on paper fibres.

The intake of moisture into the paper fibres causes them to expand, thus altering their dimensions. This expansion of the fibre usually results in a greater increase in size across the fibre than in the length (Fig. 183). Sheets of paper, therefore, increase their dimension more across the grain than with the grain.

The following factors are of importance to the pressman:

1. When paper passes through the lithographic press it takes up moisture from the damping system. It has been estimated that as much as 70 per cent of the moisture conveyed by the dampers to the plate may be absorbed by the paper.

2. If the moisture content of the paper is low, and the prevailing relative humidity high, the paper will absorb more moisture in the first pass through the press than in subsequent passes.

3. Dimensional change will take place when the paper absorbs moisture.

4. Dimensional change is greater across the grain than with the grain, due to absorbed moisture; but greater in the grain direction if there is a release of the built-in stress.

5. Paper with the fibre grain running parallel to the gripper edge of the sheet (known as *long-grain paper*) is recommended for close-register, multicolour printing. This type of paper changes its dimension from gripper to back edge of the sheet when damped, and the printed image will also change its dimension with the sheet. The pressman is able to compensate for this change in image size by altering the diameter of the plate cylinder (*see* page 220). Changes in paper dimension running with the grain are relatively small, but the pressman cannot compensate for these.

6. Where dimensional changes in the paper are expected to give problems to the printer (on large sheets the expansion across the grain may be as much as 8 mm), the paper may be conditioned by hanging the sheets in batches of ten in a conditioning-room where the temperature and humidity can be adjusted.

HYSTERESIS CURVE

The graph in Fig. 184 of a hysteresis curve highlights a feature of paper equilibrium. The very dry paper A (broken line), when brought

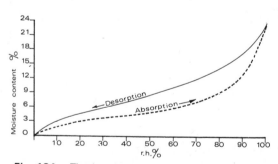

Fig. 184.—The hysteresis loop formed by absorption and desorption curves.

to equilibrium with the prevailing relative humidity has a different moisture content from the similar paper B (unbroken line), which started with a high moisture content. This indicates that separate papers will only reach a similar moisture content if they adjust to

equilibrium from the same direction. If paper with a history of high moisture content is mixed with paper which has a history of low moisture content, and the two types are brought to equilibrium, the printer may still experience difficulty with register printing because both papers will have a different moisture content.

DEFORMED SHEETS

Wavy- and curly-edged sheets are not uncommon in the pressroom, but they do present problems of accurate feeding and registration to the pressman. In most cases deformation is the result of uneven expansion or contraction of the sheets.

1. If paper is unwrapped in an atmosphere of high relative humidity the exposed edges of the pile will absorb moisture until it reaches equilibrium. This will cause the paper to expand at the edges only, resulting in wavy sheets and a warped pile (Fig. 185).

2. If the paper has a high moisture content and the prevailing relative humidity is low, the edges of the pile will desorb moisture and produce a tight-edged sheet and warped pile (Fig. 186).

Fig. 185.—Deformed pile due to expansion of the edges of the individual sheets.

Fig. 186.—Deformed pile due to contraction of the edges of the individual sheets.

3. If a pile of paper which has a low temperature is unwrapped in a room of high temperature and relative humidity, the pile may cool the air surrounding it. As the air temperature round the pile drops, its relative humidity will rise. The edges of the pile will as a result absorb moisture and cause the paper to curl and the pile to warp.

4. Paper which has passed through the press will have absorbed moisture from the damping system. If the piles are allowed to stand in the pressroom for long the pile edges will

desorb the moisture causing the sheets to become tight edged. This will give trouble if the sheets are to be printed with a second colour, or give feeding problems to folding machines.

The following precautions can be taken to avoid these problems:

1. Delay the unwrapping of piles until printing commences.

2. Test the unwrapped pile for temperature and relative humidity with a sword thermometer and sword hygrometer.

3. Allow the pile to reach temperature equilibrium before unwrapping.

4. Allow the sheets to reach equilibrium in small batches by hanging or racking. Wavy sheets may be improved by conditioning, but not by cutting to a smaller size.

5. Cover the printed piles with a suitable wrapping if they are to stand for any length of time.

6. The use of alcohol additive to the damping solution will reduce the amount of moisture taken up by the paper during its passage through the press.

PRINTING QUALITY OF PAPER

Good-quality paper for printing will have low-dimensional instability, give good contrast between ink and paper, take the ink film on to its surface uniformly and maintain the edge sharpness of the print.

To obtain these qualities the papermaker has to consider the particular use to which the paper is to be put. Paper for lithography must of necessity have different characteristics than paper for letterpress printing.

1. Chemicals and abrasives in the paper which may adversely affect litho plates and inks must be avoided.

2. The surface fibres must be well bonded to the paper to resist picking and plucking during its pass through the press.

3. The paper surface must be readily wetted by the ink, and have suitable flexibility for passing through the numerous transfer cylinders of the multicolour press.

PAPER pH

Generally speaking, the uncoated papers produced by the papermaker have an acid value of about pH 5. Coated papers, on the other

hand, usually have an alkaline value of about pH 8. Under normal circumstances the acidity or alkalinity of the paper will not affect the printing process. A paper with a low pH, however, will retard the drying of ink and may react with the chemicals used in the press fountain solution. Papers of high alkalinity may also cause scumming of litho plates during a long run.

The pH of paper is usually determined by making a hot- or cold-water extract of the paper and a test made of the extract with a pH indicator or electrode.

FLUFFING, LINTING, DUSTING

These are common terms which are used to denote loose fibres (linting and fluffing) and loose loadings (dusting), which are carried on the paper surface and which accumulate on the press blanket and spoil good print reproduction. Papers which are surface sized (tub sized) go a long way in overcoming this problem.

PICKING, PLUCKING, BLISTERING

Inks with high tack exert considerable stress on the paper surface as it passes through impression on the press. Loosely bonded fibres and coating are pulled off the surface and adhere to the press blanket. This is called "picking" or "plucking," and occurs generally in the image areas of the sheet. Blistering occurs when the stress causes the internal bonding of the sheet to break down, leaving the printed image with a rough finish. Blistering also occurs in paper used for web-offset printing. In this case the breakdown of the internal bonding is caused by the expansion of trapped moisture as the web passes through the drier oven.

PAPER SIZES

The International Organisation for Standardisation (I.S.O.) has established the following three series of paper sizes:

A series, which is used for general printing papers.
B series, which is used for large papers, posters, wall-charts, etc.
C series, which is used exclusively for envelopes.

The A and B series are based on a rectangle whose sides are in the ratio of 1 to the square root of 2 (thus B0, which has one side of

Fig. 187.—Paper sizes—the relationship between the A
and B series.

1000 mm has the adjacent side of 1414 mm, which is the square root
of 2000).

The sizes in the A and B series are also geometrically similar to
one another, so that when the shorter side is doubled or the longer
side halved, the new size is in the same proportions (Fig. 187).

A SERIES

This series is based upon the A0 size (841 × 1189 mm) which is
equivalent to 1 m² in area. When the sheet is halved the suffix 1 is
added: A1. As each half is made so the suffix denotes the number of
times this has been done, for example, A6 paper has been halved six
times from A0.

When the sheet is doubled in size a prefix is added to denote the increase, for example, 4A is four times the size of A0.

Certain long sizes can be cut from the A series for tickets, labels or cheques, etc., for example, $\frac{1}{4}$A4 is 74 × 210 mm.

B SERIES

The divisions of this series are made in the same way as the A series.

C SERIES

These sizes are arranged to form folders and envelopes which will enclose the A series.

UNTRIMMED SIZES

The stock sizes from which A and B series can be cut are slightly larger to allow for trimming.

The prefix R is used for normal trimming: RA0.

The prefix SR is used for extra trimming (bled work): SRA0.

Tolerances

A, B and C series papers are cut to size within the following tolerances:

Dimensions below 150 mm, a tolerance of ±1·5 mm.

Dimensions between 150 and 600 mm, a tolerance of ±2·0 mm.

Dimensions over 600 mm, a tolerance of ±3·0 mm.

STANDARD BOOKWORK SIZES

Paper sizes for bookwork remain substantially the same except that the dimensions are expressed in millimetres instead of inches. Due to the difficulty of dividing the metric inch (25·4 mm) by 8 or 4, the basic "inch" for bookwork is 24 mm, which is close to 25·4 mm. The Common English bookwork size crown 8vo ($7\frac{1}{2}$ × 5 in) gives a metric size of 190·5 × 127·0 mm. The new size is metric crown 8vo, 186 × 123 mm, which is a little smaller but divisible by 24, allowing trims of 3 mm.

Paper sizes may be found in Appendix 2.

PAPER SUBSTANCE

Quantities of paper are calculated and invoiced by metric weight. The term "paper substance" is used to indicate the weight of the paper in *grammes per square metre* (g/m^2) whether the paper consists of one sheet, one ream, one reel or even a fragment of a sheet. The A series of paper sizes have a direct relationship with the substance rating because the basic sheet size A0 measures 1 m² in area. For example: paper substance of 63·0 g/m² in any A series will yield a sheet of A0 of 63 g weight, an A1 sheet of 31·5 g, an A2 sheet of 15·7 g and so on.

PREFERRED NUMBERS

The R series of paper substances is a range of papers which progress from very light to heavy substances according to a geometrical progression giving a wider choice of paper substance at the lighter end of the range.

The prefix "R" is derived from the name of the French engineer Charles Renard who developed the scheme for use in the engineering industry. The number following the prefix "R" indicates the particular root of 10 on which the series is based.

The common series recommended for printing is the R20 series. This indicates that the twentieth root of 10 (written $\sqrt[20]{10}$) is the multiplying factor by which each term in the series increases progressively.

To obtain the twentieth root of 10 we must find a number which when multiplied by itself equals 10. This may be done with the use of logarithm tables, for example:

$$\log 10 = 1\cdot0000$$

Divide by 20,

$$\tfrac{1}{20} = 0\cdot05$$
$$\text{anti-log } 0\cdot05 = 1\cdot122 \text{ (which is rounded off to } 1\cdot12)$$
$$1\cdot12 = \text{twentieth root of 10.}$$

Beginning with the first term in the R20 series 20 g/m², the second term will be 20 × 1·12 which is 22·4 g/m². The next term is found in the same manner, 22·4 × 1·12 = 25·088. (For practical purposes the figure is rounded off to 25·0 g/m².)

R20 and R40 Tables can be found in Appendix 3.

Lithographic ink

Lithographic inks are formulated on three basic ingredients: *pigment* which gives colour, black and white; a *vehicle* which is semitransparent and serves to carry the pigment; and *driers*, which are substances added to promote drying of the printed ink film. This is, of course, a simplification. Modern printing inks are formulated on often complex recipes which require additional ingredients to these basic properties.

PIGMENTS

These are coloured substances which are finely divided and dispersed throughout the vehicle. Pigments are derived from a wide variety of sources and it is not unusual to find, therefore, that some inks perform better on the lithographic press than do others. Apart from giving colour to the ink, the pigment is combined in such proportions with the vehicle as to influence the performance of the ink. A pigment suitable for lithographic printing ink must possess the following characteristics:

1. Capable of reduction to a finely divided powder.

2. Possess colouring properties which are either transparent (for process inks) or opaque (for good covering of dull stock, etc.).

3. It must form a homogeneous (uniform) paste when mixed with the vehicle.

4. It must have good texture, grind easily and produce non-abrasive, smooth-working inks (Fig. 188).

Fig. 188.—Schematic of a three-roll ink-mill. This machine removes the small agglomerates of pigment.

5. When mixed with the vehicle the pigment particles must be capable of thorough "wetting," *i.e.* the particles must be completely enwrapped and coated by the vehicle.

6. The pigment should have adequate non-bleeding qualities in oil, wax and water solvents. Bleeding should not occur when one ink overprints another.

7. The colouring properties of the pigment in shade and strength must be higher for lithographic inks than for other printing processes.

8. The pigment must be relatively chemically inactive with those substances which it may encounter on the press or in the stock paper.

VEHICLES

The main function of the vehicle is to transport the dispersed pigment from the press ink-duct via the rollers, printing plate and blanket, to the paper where it must remain permanently. Suitable viscous liquids are chosen for this purpose and the ink-manufacturer has to consider the vehicle characteristics, its flow, tack, etc., covered by the science of *rheology*.

DRYING OILS

These are obtained from organic (animal and vegetable) sources and they are selected for their ability to flow and distribute well on the press, and form solid elastic films when exposed to the air. Drying oils such as linseed oil can be made more viscous by heating in the absence of air. The term "body" is used to indicate the viscosity of the ink. For example, butter has high body (low-flow characteristics), and low tack.

In the past an increase in ink body by heating has resulted in inks of high tack. Today many inks are produced with high body and relatively low tack.

Linseed oil

The most important of the drying oils and traditionally the basis of lithographic inks until the last few years. The oil is obtained by crushing the seeds of the flax plant *Linium* which is harvested in the U.S.A., Canada, South America and India.

Stand oils

These are linseed oils which have been heat polymerised in the absence of air (heat-bodied oils). These oils do not discolour pigments, are durable, have good rheological properties and flow and distribute well on the press. They are cheap and in regular and abundant supply.

The modern requirements in respect of high-speed drying, gloss, film toughness and freedom from odour (food packaging) have resulted in the use of additional substances for lithographic inks.

Synthetic resins

These are derived from complicated amorphous organic substances. The most common range used are the *alkyds* which are prepared by reacting acids and alcohols to produce viscous liquids. Alkyds are insoluble in water and when printed in thin films they dry by oxidation and polymerisation of the resin molecules in the same manner as stand oils. The main advantage of the alkyds is that they can be formulated to close specification, they are free from impurities, and are prepared from cheap starting materials such as phenol, formaldehyde, urea and glycerol.

Synthetic inks have the advantage over drying oils in that higher concentrations of pigment can be dispersed in inks of relatively low viscosity. Their inks have better flow and are less abrasive on the press plate. There is a tendency for alkyd inks to bleed in wet-on-wet printing, but they dry to a superior lively finish compared to the matt finish of most drying oil inks. Synthetic inks also dry to a harder, rub-resistant finish without an increase in drier concentration.

The selection of suitable vehicles for lithographic inks must be made with regard to the following factors (Fig. 189):

1. The vehicle must be capable of transporting the dispersed pigment from the press ink-duct to the stock, and there to trap the pigment in a dried film on the paper or metal surface.

2. Thorough wetting of the pigment particle must take place.

3. The vehicle must have oleophilic characteristics.

4. The vehicle must not react chemically with the pigment, plate substances, blanket material or chemicals used on the press.

5. The vehicle must not be strongly coloured, of strong odour, or produce odours when drying.

Courtesy: Coates Brothers & Co. Ltd.

Fig. 189.—Ink passes through the three-roll mill and is poured into containers.

INK-DRYING

The drying of the printed ink film takes place through the setting or rapid gelation of the vehicle until it becomes a firm, flexible film.

This drying action must not take place on the press ink rollers during the printing process. The drying of printing inks falls conveniently into two classifications, the purely physical, mechanical effects of ink on paper, and the chemical, which involves a molecular change in the ink film.

PHYSICAL FACTORS

Absorption

The paper surface is both porous and absorbent. The penetration of the ink into the interstices and capillaries of the paper surface depends upon the following points (Fig. 190):

1. The pressure applied during printing forces the ink initially into the surface of the paper.

2. The ink must be formulated to have a good affinity for the paper surface, *i.e.* good wetting properties.

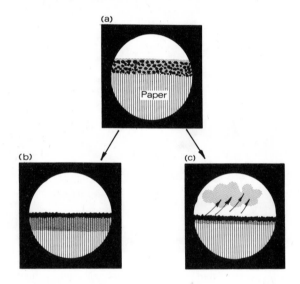

Fig. 190.—Ink-drying. (*a*) Ink layer immediately after printing. (*b*) Ink solvent absorbed leaving pigment packed on the surface. (*c*) Ink solvent evaporated leaving pigment packed on the surface.

3. Penetration of the ink into the surface is improved as the ink becomes more fluid, and is better at high temperatures.

4. The interstices in the paper surface exert capillary suction on the ink. The ink film contracts as it is drawn into the paper so that the pigment particles exert a contrary force; penetration ceases when both forces are equal.

Evaporation

In specially formulated inks the vehicle solvent evaporates from the printed stock, thus speeding up the setting period. Heat-set inks dry by the evaporation of the solvent at high temperatures with the setting of the remaining hot resin film taking place by rapid cooling of the paper. Heated rolls, warm air or flame-impingement drier systems are used to raise the temperature of the ink film, and cooling takes place by passing the paper over large chill rolls.

Gelation or filtration

Quick-set inks fall into this category. They are based on a two-phase medium consisting of a resin with a high viscosity, and the pigment dispersed in a low-viscosity medium. When printed on to absorbent stock the solvent drains away and the viscous resin gels on the surface, developing an initial set rapidly and gradually hardening over a longer period. Quick-set inks function well on coated papers and are particularly attractive for their high-gloss, rub-proof properties when dry. They require less driers than conventional inks and are less likely to give set-off problems in stacking, folding or perfecting.

CHEMICAL FACTORS

Oxidation and polymerisation

Immediately the printed film of ink is exposed to the air it begins to absorb oxygen which causes the ink to harden. This combination of oxygen with the vehicle causes the molecules of the vehicle (called "monomers") to link together to form a more complex molecular

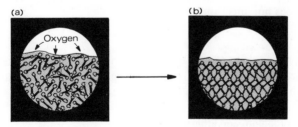

Fig. 191.—Drying by polymerisation. (a) Ink after printing contains random molecules which are reacting with oxygen. (b) Polymerisation causes ink molecules to cross-link forming a solid structure.

arrangement known as a "polymer." This change causes the vehicle to gel and when polymerisation becomes complete the gel solidifies (Fig. 191).

After the ink film has gelled the oxidation reaction continues for a considerable length of time during which an unpleasant odour may arise from the ink. This continuing change in the ink film often has the effect of altering the optical properties of the pigment and may result in a difference in appearance between a freshly printed sheet and one which is months old.

OXIDATION CATALYSTS—DRIERS

A drier is a compound which when mixed with the ink accelerates the drying time. The driers act as a catalyst by absorbing atmospheric oxygen and giving it up to the oxidising vehicle, thus speeding up the reaction of polymerisation. Apart from salicylic acid which promotes a mild drying action, the main driers used are metallic compounds.

Cobalt

A powerful drying catalyst, violet in colour. Because of its colour it may alter the shade of tints and whites. It has the disadvantage of being soluble in inorganic acids, which may lead to loss of cobalt from the ink when the pH value of the press fountain solution is too low.

Manganese

This drier is not as powerful as cobalt and usually requires lead to be present to act as an activator. The colour of the drier is red-brown and it does not affect the shade of tints.

Lead

A slow-acting drier of pale colour, now limited in use because of the many lead-free specifications for printing inks. It is not suitable for use with alkyd resins.

Cerium, zirconium and lithium

These are driers of medium efficiency, pale in colour, which are used to replace lead in alkyd resins. They are often used in conjunction with cobalt and manganese.

PASTE DRIERS

These consist of a mixture of certain inorganic salts of the above metals, such as acetates, borates or oxalates, which are finely ground in a drying oil. The fast-acting salt of cobalt is not normally used in paste driers because it yields prints with a hard surface which may be unreceptive to overprinting. The paste drier is formulated for its slow-drying characteristics which enable superimposed ink films to key satisfactorily.

LIQUID DRIERS

These are metals chemically reduced to soaps, such as linoleates, naphthenates, octates and resinates, which are soluble in turpentine and drying oils. A mixture of the drier compounds is often made to obtain the best characteristics of the various metals, the following points should be noted:

1. An excess of drier in the ink will not accelerate drying. The drier acts as a catalyst and therefore functions best when mixed in correct proportion.

2. An excess of drier compound in the ink may cause reaction with the fountain solution chemicals or the press plate and produce ink scum, bleeding, etc.

3. Acid fountain solutions may react with the ink drier to form a salt which may be leached out of the ink, thus retarding the drying of the ink film. Inks also dry more slowly on acid papers. Because of this fountain solution acid values should not fall lower than pH 4·6.

4. Inks dry more slowly in an atmosphere of high relative humidity.

EXTENDERS

These are inorganic substances which when added to ink vehicles become transparent or semi-transparent. Since they increase the area covered by the pigment, they are called "extenders." Extenders are useful for the following reasons:

1. Reducing the strength of colour without using white pigment.
2. Improving the working consistency of some pigments.
3. Improving the body of the ink without increasing the tack.
4. Reducing the cost of the ink by giving good covering power without loss of quality.

Whiting, china clay, barytes, aluminium hydrate, blanc fixe, gloss white, magnesium carbonate and precipitate chalk are examples of substances used as extenders.

PRINTING CHARACTERISTICS OF LITHOGRAPHIC INKS (Fig. 192)

THIXOTROPY

A familiar characteristic of lithographic ink is its solid body which can be broken down and made to flow by mechanical agitation. Unlike viscosity, thixotropy is not usually reduced by an increase in

Fig. 192.—The proportional thickness of ink film applied to smooth paper by the different printing processes.

temperature. The common press problem of ink "hanging back" in the ink-duct is the result of thixotropy which causes the non-flow characteristic of the ink to return if it is left for any length of time without stirring. This is overcome with the use of an automatic ink-agitator.

WATER VERSUS INK

During the operation of the press the amount of water entrained in the ink may vary between 7 and 20 per cent depending on the type of work being printed. As the proportion of water in the ink increases so does ink viscosity, with a proportional drop in ink tack. If the proportion of entrained water is allowed to rise too high, poor transfer of ink from rollers to plate results, giving a washed-out

appearance to the print. Waterlogged or emulsified ink may result in additional problems such as the following:

1. An increase in the proportion of water may retard ink-drying.

2. Reaction between fountain solution chemicals and ink ingredients may cause plate scum, tinting and possible damage to the plate image.

3. With press stops for pile changing, etc., the waterlogged ink may dry out and print a heavier film of ink when printing is resumed.

High-body inks are known to resist emulsification better than low-body inks. An increase in ink body, however, may mean an increase in ink tack which is not suitable for high-speed presses, where ink tack may cause a rise in roller temperature.

An increase in tack may also result in spoiled work if the pick resistance of the paper stock is not adequate.

WEB-OFFSET INKS

High-speed web-offset printing makes extra demands upon printing inks. The transfer and flow of the ink must be good at high speed without having to reduce the ink viscosity. With press speeds four times that of the sheet-fed machines, the heat of rollers causes the lowering of ink viscosity once the ink has entered the roller pyramid.

Additional problems of marking arise with web presses with a web which has to traverse path rollers, chill rolls, compensator rollers and folder, after printing. Various additives are included in these inks to give better slip and rub resistance.

Non-heat-set inks

These inks are used mainly for newspaper and magazine printing in which the paper permits rapid absorption of the vehicle. Penetration of the ink into the paper surface limits the choice of paper to those which have an open texture. Surface-sized papers have only a limited use because the surface film of size prevents ink penetration at high speed.

Heat-set inks

These inks are designed to dry primarily by evaporation of the solvent at high temperature, leaving a resin-bonded pigment on the

K

paper. Heat-set inks are intended to dry on the paper surface, giving increased density and gloss to the ink film. With a volatile solvent as part of the ink component, it is important that the ink dries quickly when passed through the drier oven, but not when it is on the press rollers. Certain drying accelerators may be used in the ink which remain inactive until heated to oven temperatures. The choice of ink solvent has to be made with consideration for the rollers, blanket and plate image-forming material. The removal of the solvent from the printed ink film takes place in the drier oven where the temperature is in the region of 150 °C. Simple heating of the ink results in a quilt of solvent vapour hanging over the web, which may be reabsorbed by the ink film. To prevent this taking place, it is common to find scavenging air-knives situated at the exit of the oven to remove the solvent vapour before the paper passes over the chill rolls.

PROCESS COLOUR INKS

The principle of modern full-colour reproduction is based upon the premise that the subtractive primary colours, cyan, yellow and magenta, may by selective combination produce the range of colours in the spectrum.

Colour prints are produced by using these three colours (trichromatic process) or with a black printer added to give density to darker tones (four-colour process). In theory the overprinting of cyan, yellow and magenta inks will produce a neutral black. In practice, however, it is difficult to maintain an even ink film thickness accurately during a printing run, with the result that the black is not neutral but indicates a cast in the colour which predominates.

The use of an additional printer in the form of a skeleton black overcomes the problem of producing darker tones by superimposition of the three primaries, and with the use of a photographic technique called *undercolour removal* the overprinting of three colours in darker tones is reduced, leaving the black printer to give that effect.

The setting of a standard for the production of process colour inks requires that the ink-manufacturer consider the following points:

1. The hue, in terms of wavelength reflection by the ink.
2. The saturation or strength of the colour. This will vary with ink film thickness, and pigment concentration.

3. Transparency. This will determine how much reflection from the paper will take place, and how much of the underlying colour will show through.

4. The method of printing, wet on wet, or wet on dry.

The European body responsible for setting colorimetric standards is the International Commission on Illumination (Commission Internationale de l'Eclairage; C.I.E.). It is the business of the ink-manufacturer to interpret the C.I.E. standards in the preparation of process colour inks which will be suited to various grades of paper and differing printing processes and methods.

COLOUR DEFICIENCIES

When the photographic separation of a full-colour original is made, the hue of the separation filters and the printing inks should be complementary, that is, the inks should reflect the light which the filters absorb. The spectral reflection curves in Fig. 193 show how an ideal ink will absorb one-third of the spectrum and reflect the other two-thirds when printed on perfectly white paper. The reproduction of colour by these ideals, however, is not possible for the following reasons:

1. The photographic separations made through the red, blue and green filters are not chromatically perfect. The filters absorb certain wavelengths which they ought to transmit, and transmit wavelengths which they should absorb. This is due to the difficulty of producing suitable dyes in the preparation of the filters.

2. The reflection of light from the surface of the printed paper cannot attain 100 per cent and is often adulterated by colour in the paper itself. Where there is a drop in the level of reflectance, the ink appears to have black mixed with it because it is not as bright as it should be.

3. The pigments used in the preparation of process inks do not come up to the ideal shown in Fig. 193. Figure 194 shows that the yellow is close to ideal, but both the cyan and the magenta reflect too little blue. All the colours reflect a low percentage of colour which they ought to absorb.

To accommodate the deficiencies in the process colours, *masking* and *retouching* techniques are used in the graphic reproduction department. Colour deficiencies are often shown diagrammatically in

Fig. 193.—Ideal ink curves.

the form of a circle or triangle (Fig. 195). This is convenient for studying colour in two dimensions, but a single diagram cannot express colour adequately in its three-dimensional qualities.

The triangle is formed within a circle on which are plotted the points relating to the subtractive primaries: yellow, cyan, magenta, and the secondary colours: green, red and blue. The triangle indicates the ideal process inks, the inner triangle shows the nearest that the process inks are to the ideal.

The combination of primary colours cannot produce secondary colours of equal brightness. In the colour circle the combined primaries are shown at an equal distance from the centre of the circle. The ideal ink primaries are also found on the circle perimeter, but their combinations to produce the secondary colours fall towards the centre, indicating a loss of brightness. The position of the inner triangle shows that process inks also have a lower brightness than the

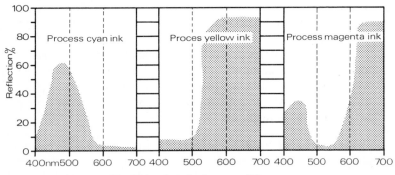

Fig. 194.—Standard process ink curves.

Fig. 195.—The colour circle. The outer perimeter represents maximum brightness, the centre of the circle, b, represents black. Colour plotted towards the centre becomes dull. Note that the combination of cyan and yellow produces a green which is considerably duller than pure green. The relative position of process ink is indicated by the inner triangle.

Fig. 196.—Screen angles. (*a*) For three-colour process printing. (*b*) For four-colour process printing.

ideal, and that a shift in colour must be accompanied by a corresponding shift in brightness.

HALF-TONE SCREEN IN COLOUR PRINTING

The representation of continuous tone by the half-tone dot in colour printing requires that the angle of the screen for each colour is set differently to avoid objectionable *moiré* patterns (Fig. 196). The angled screen dots produce a coloured mosaic when printed, in which some colours overlap to give additional colours (subtractive combination). Other dots in the colour mosaic lie side by side, each reflecting their individual colours, but because of their relatively small size appear as mixed colours (additive combination).

APPENDIXES

APPENDIX 1

FORMULARY

FOR PLATEMAKING

Counter etch
For zinc and aluminium
Acetic acid 99%	47 cm^3 (0·047 dm^3)
Add water to make	1000 cm^3 (1·000 dm^3)

For deep-etch aluminium
Phosphoric acid 85%	40 cm^3 (0·040 dm^3)
Add water to make	1000 cm^3 (1·000 dm^3)

Dichromated plate coatings
Albumen stock solution
Egg albumen scales	193 g
Ammonium hydroxide 28%	25·4 cm^3 (0·0254 dm^3)
Water	1000 cm^3 (1·000 dm^3)

Adjust the solution to 5·2 °Bé at 25 °C.

Gum arabic stock solution
Best gum arabic select sorts	400 g
Chlorocresol (5% spirit solution)	75 cm^3 (0·075 dm^3)
Water	1000 cm^3 (1·000 dm^3)

Adjust the solution to 14 °Bé at 25 °C.

Ammonium dichromate stock solution
Ammonium dichromate crystals	200 g
Water to make	1000 cm^3 (1·000 dm^3)

Adjust the solution to 14·2 °Bé at 25 °C.

Albumen coating solution
Stock egg albumen solution 5·2 ° Bé	1000 cm^3 (1·000 dm^3)
Stock ammonium dichromate solution 14·2 °Bé	203 cm^3 (0·203 dm^3)
Water	250 cm^3 (0·250 dm^3)

The final relative density of the solution should be 5·6 °Bé at 25 °C.

Deep-etch gum arabic coating solution
Stock gum Arabic solution 14 °Bé	1000 cm^3 (1·000 dm^3)
Stock ammonium dichromate solution 14·2 °Bé	340 cm^3 (0·340 dm^3)
Ammonium hydroxide 28%	50 cm^3 (0·050 dm^3)

The final relative density 14–14·2 °Bé at 25 °C.

Deep-etch stabilised developer

Calcium chloride	750 g
Zinc chloride	350 g
Lactic acid 85%	160 cm³ (0·160 dm³)
Water	1000 cm³ (1·000 dm³)

Adjust the final relative density to 41·5 °Bé at 25 °C by adding water to lower the density, and adding calcium chloride to raise it. The relative density must be exactly as specified.

Deep-etch solutions

1. *For zinc*

Calcium chloride (41 °Bé solution)	1000 cm³ (1·000 dm³)
Lump ferric chloride	25 g
Hydrochloric acid 38%	20 cm³ (0·020 dm³)

The final relative density should be 41 °Bé at 25 °C.

2. *For aluminium*

Calcium chloride (41 °Bé solution)	1000 cm³ (1·000 dm³)
Zinc chloride	380 g
Ferric chloride (51 °Bé solution)	285 cm³ (0·285 dm³)
Hydrochloric acid 38%	14 cm³ (0·014 dm³)
Cupric chloride	27 g

Copperising solution for deep-etch plates

1. *For zinc*

Isopropanol alcohol 99%	1000 cm³ (1·000 dm³)
Cuprous chloride	5 g
Hydrochloric acid 38%	10 cm³ (0·010 dm³)
Calcium sulphate (anhydrous)	112·5 g

2. *For non-anodised aluminium*

Isopropanol alcohol 99%	1000 cm³ (1·000 dm³)
Cuprous chloride	31 g
Hydrochloric acid 38%	32 cm³ (0·032 dm³)

Stop-out solutions

1. *First*

Orange shellac	250 g
Anhydrous alcohol	1000 cm³ (1·000 dm³)
Methyl violet dye	2 g

2. *Second*

Gum deep-etch coating may be painted on thinly, and when dry the plate exposed to light to harden off.

Plate surface treatments

G.A.T.F. Cronak for zinc plates

Ammonium dichromate	34 g
Sulphuric acid (r.d. 1·84)	6 cm³ (0·006 dm³)
Water to make	1900 cm³ (1·900 dm³)

G.A.T.F. Nital for zinc

Ammonium alum	30 g
Nitric acid (r.d. 1·42)	1 cm³ (0·001 dm³)
Water	1000 cm³ (1·000 dm³)

G.A.T.F. Brunak for aluminium

Ammonium dichromate	1350 g
Hydrofluoric acid 48%	160 cm³ (0·160 dm³)
Water	20 000 cm³ (20·000 dm³)

This solution can be contained in polythene bottles only.

Deletion fluids

No. 1

Caustic soda	15 g
Water	1000 cm³ (1·000 dm³)

No. 2

Hydrochloric acid 38%	100 cm³ (0·100 dm³)
Amyl acetate	100 cm³ (0·100 dm³)

Desensitising plate etch

For zinc

Ammonium nitrate	50 g
Ammonium biphosphate	50 g
Water	1000 cm³ (1·000 dm³)

For aluminium

Phosphoric acid 85%	40 cm³ (0·040 dm³)
Water	1000 cm³ (1·000 dm³)

Gum arabic etch for aluminium

Gum arabic solution 12 °Bé	1000 cm³ (1·000 dm³)
Phosphoric acid 85%	30 cm³ (0·030 dm³)

Plate gumming solutions

Gum arabic solution

Gum arabic select sorts	350 g
Chlorocresol (5% spirit solution)	70 cm³ (0·070 dm³)
Water	1000 cm³ (1·000 dm³)

Adjust the final solution to 10 °Bé at 25 °C.

Cellulose gum solution

Carboxymethyl cellulose powder	60 g
Phosphoric acid 85%	4 cm³ (0·004 dm³)
Water to make	1000 cm³ (1·000 dm³)

FOR PLANNING

Photo Blue for plates
Stock solution A

Iron of Ammonium citrate (Green Scales)	60 g
Water	250 cm³ (0·250 dm³)

Stock solution B

Potassium ferrocyanide	22 g
Water	250 cm³ (0·250 dm³)

Keep the stock solutions in opaque bottles.

Working solution
Add equal amounts of stock solutions A and B together prior to use.

Intensifying solution

Ferric chloride	50 g
Water	1000 cm³ (1·000 dm³)

Photo Blue for plastic planning flats
Stock solutions A and B as above.

Stock solution C

Pure gelatine	2 g
Cold water to soak gelatine	30 cm³ (0·030 dm³)
Boiling water to make	250 cm³ (0·250 dm³)

Working solution
Mix together equal amounts of stock solutions A, B and C. Shelf life twelve hours.

Intensifying solution

Hydrochloric acid 38%	10 cm³ (0·010 dm³)
Water	1000 cm³ (1·000 dm³)

PRESS FOUNTAIN SOLUTIONS

For zinc plates
Stock solution

Zinc nitrate	93 g
Phosphoric acid 85%	10 cm³ (0·010 dm³)
Water to make	1000 cm³ (1·000 dm³)

Working solution

Stock solution	10–16 cm³ (0·010–0·016 dm³)
Cellulose gum solution	4 cm³ (0·004 dm³)
Water	1000 cm³ (1·000 dm³)

For aluminium plates
Stock solution
 Zinc nitrate 90 g
 Phosphoric acid 85% 8 cm^3 (0·008 dm^3)
 Water to make 1000 cm^3 (1·000 dm^3)
Working solution
 Stock solution 10–16 cm^3 (0·010–
 0·016 dm^3)
 Gum arabic 14 °Bé solution 8 cm^3 (0·008 dm^3)
 Water 1000 cm^3 (1·000 dm^3)

INTERNATIONAL PAPER SIZES

A series

4A	1682 × 2378 mm	A4	210 × 297 mm
2A	1189 × 1682 mm	A5	148 × 210 mm
A0	841 × 1189 mm	A6	105 × 148 mm
A1	594 × 841 mm	A7	74 × 105 mm
A2	420 × 594 mm	A8	52 × 74 mm
A3	297 × 420 mm		

B series

4B	2000 × 2828 mm	B3	353 × 500 mm
2B	1414 × 2000 mm	B4	250 × 353 mm
BO	1000 × 1414 mm	B5	176 × 250 mm
B1	707 × 1000 mm	B6	125 × 176 mm
B2	500 × 707 mm		

C series

CO	917 × 1296 mm	C5	162 × 229 mm
C1	648 × 917 mm	C6	114 × 162 mm
C2	458 × 648 mm	C7	81 × 114 mm
C3	324 × 458 mm	C8	57 × 81 mm
C4	229 × 324 mm		

Standard bookwork series

Metric crown octavo	123 × 186 mm	Metric demy octavo	138 × 216 mm
Metric large crown octavo	129 × 198 mm	Metric royal octavo	156 × 234 mm

In addition to the above standard sizes the following are at present in use:

Metric foolscap octavo	105 × 168 mm
Metric medium octavo	144 × 222 mm
Metric royal standard octavo	156 × 246 mm

PAPER SUBSTANCES

R20 range (g/m^2)

20·0	56·0	160·0
22·4	63·0	180·0
25·0	71·0	200·0
28·0	80·0	224·0
31·5	90·0	250·0
35·5	100·0	280·0
40·0	112·0	315·0
45·0	125·0	355·0
50·0	140·0	400·0

R40 range (g/m^2)

21·2	60·0	170·0
23·6	67·0	190·0
26·5	75·0	212·0
30·0	85·0	236·0
33·5	95·0	265·0
37·5	106·0	300·0
42·5	118·0	335·0
47·5	132·0	375·0
53·0	150·0	

APPENDIX 4

CONVERSION TABLE— INCHES TO MILLIMETRES

(Basis: 1 in = 25·4 mm)

in	mm	mm
1/1000	0·001 000	0·025 400
2/1000	0·002 000	0·050 800
3/1000	0·003 000	0·076 200
4/1000	0·004 000	0·101 600
5/1000	0·005 000	0·127 000
6/1000	0·006 000	0·152 400
7/1000	0·007 000	0·177 800
8/1000	0·008 000	0·203 200
10/1000	0·010 000	0·254 000
12/1000	0·012 000	0·304 800
15/1000	0·015 000	0·381 000
20/1000	0·020 000	0·508 000
25/1000	0·025 000	0·635 000
30/1000	0·030 000	0·762 000
35/1000	0·035 000	0·889 000
40/1000	0·040 000	1·016 000
45/1000	0·045 000	1·143 000
50/1000	0·050 000	1·270 000
1/16	0·062 500	1·587 500
5/64	0·078 125	1·984 375
3/32	0·093 750	2·381 250
7/64	0·109 375	2·778 125
1/8	0·125 000	3·175 000
9/64	0·140 625	3·571 875
5/32	0·156 250	3·968 750
11/64	0·171 875	4·365 625
3/16	0·187 500	4·762 500
13/64	0·203 125	5·159 375
7/32	0·218 750	5·556 250
15/64	0·234 375	5·953 125
1/4	0·250 000	6·350 000
17/64	0·265 625	6·746 875
9/32	0·281 250	7·143 750
19/64	0·296 875	7·540 625
5/16	0·312 500	7·937 500
21/64	0·328 125	8·334 375
11/32	0·343 750	8·731 250
23/64	0·359 375	9·128 125
3/8	0·375 000	9·525 000
25/64	0·390 625	9·921 875
13/32	0·406 250	10·318 750
27/64	0·421 875	10·715 625
7/16	0·437 500	11·112 500

in	mm	mm
29/64	0·453 125	11·509 375
15/32	0·468 750	11·906 250
31/64	0·484 375	12·303 125
1/2	0·500 000	12·700 000
33/64	0·515 625	13·096 875
17/32	0·531 250	13·493 750
35/64	0·546 875	13·890 625
9/16	0·562 500	14·287 500
37/64	0·578 125	14·684 375
19/32	0·593 750	15·081 250
39/64	0·609 375	15·478 125
5/8	0·625 000	15·875 000
41/64	0·640 625	16·271 875
21/32	0·656 250	16·668 750
43/64	0·671 875	17·065 625
11/16	0·687 500	17·462 500
45/64	0·703 125	17·859 375
23/32	0·718 750	18·256 250
47/64	0·734 375	18·653 125
3/4	0·750 000	19·050 000
49/64	0·765 625	19·446 875
25/32	0·781 250	19·843 750
51/64	0·796 875	20·240 625
13/16	0·812 500	20·637 500
53/64	0·828 125	21·034 375
27/32	0·843 750	21·431 250
55/64	0·859 375	21·828 125
7/8	0·875 000	22·225 000
57/64	0·890 625	22·621 875
29/32	0·906 250	23·018 750
59/64	0·921 875	23·415 625
15/16	0·937 500	23·812 500
61/64	0·953 125	24·209 375
31/32	0·968 750	24·606 250
63/64	0·984 375	25·003 125
1	1·000 000	25·400 000

CONVERSION FACTORS FOR MEASUREMENTS USED IN LITHOGRAPHY

To convert	into	multiply by
Length		
inches	millimetres (mm)	25·4
feet	metres (m)	0·304 8
yards	metres (m)	0·914 4
miles	kilometres (km)	1·64
Area		
square inches	square millimetres (mm^2)	645·16
square feet	square metres (m^2)	0·092 9
square yards	square metres (m^2)	0·836
Volume		
cubic inches	cubic millimetres (mm^3)	16 400·0
cubic feet	cubic metres (m^3)	0·028 3
cubic yards	cubic metres (m^3)	0·765
Capacity		
pints	litres (l) or dm^3	0·568
gallons	litres (l) or dm^3	4·546
fluid ounces	cubic centimetres (cm^3)	28·413
Velocity		
miles per hour	kilometres per hour (km/h)	1·609 34
feet per second	metres per second (m/s)	0·304 8
feet per minute	metres per minute (m/min)	0·304 8
feet per minute	metres per second (m/s)	0·005 08
Mass		
pounds	kilogrammes (kg)	0·454
hundredweights	kilogrammes (kg)	50·8
tons	kilogrammes (kg)	1016
tons	tonnes (metric tons) (t)	1·016

To convert	*into*	*multiply by*

Volume flow rate

cubic feet per second	cubic metres per second (m^3/s)	0·028 3
gallons per minute	cubic metres per second (m^3/s)	0·000 075 8

Heat flow rate

Btu per hour	watts (W)	0·293
horsepower	watts (W)	746

Illumination

lumens per square foot	lux (lx)	10·763 9
foot-candles	lux (lx)	10·763 9

Luminance

candela per square foot	candela per square metre (cd/m^2)	10·763 9
candela per square inch	candela per square metre (cd/m^2)	1550·00
foot-lamberts	candela per square metre (cd/m^2)	3·426 26

continued from facing page]

°C), namely 40 °C. Similarly, to find the Fahrenheit equivalent of 40 °C, locate the figure 40 in the central columns and read off the temperature in degrees Fahrenheit in the left-hand column (headed °F), namely 104 °F.

Conversion of Fahrenheit to Centigrade
The conversion of Fahrenheit to Centigrade: subtract 32 from the F value, multiply by 5 and divide by 9. The equation looks like this:

$$°C = 5/9(°F - 32)$$

Conversion of Centigrade to Fahrenheit
The conversion of Centigrade to Fahrenheit: multiply by 9, divide by 5 and add 32 to the result. The equation looks like this:

$$°C = 5/9(°F - 32)$$

APPENDIX 6

TEMPERATURE CONVERSION CHART

(Fahrenheit to Centigrade or Centigrade to Fahrenheit)

°F		°C	°F		°C	°F		°C	°F		°C	°F		°C	°F		°C
−22	**−30**	−34.4	64.4	**18**	−7.8	150.8	**66**	18.9	237.2	**114**	45.6	323.6	**162**	72.2	410	**210**	98.9
−20.2	**−29**	−33.9	66.2	**19**	−7.2	152.6	**67**	19.4	239	**115**	46.1	325.4	**163**	72.8	411.8	**211**	99.4
−18.4	**−28**	−33.3	68	**20**	−6.7	154.4	**68**	20	240.8	**116**	46.7	327.2	**164**	73.3	413.6	**212**	100
−16.6	**−27**	−32.8	69.8	**21**	−6.1	156.2	**69**	20.6	242.6	**117**	47.2	329	**165**	73.9	415.4	**213**	100.6
−14.8	**−26**	−32.2	71.6	**22**	−5.6	158	**70**	21.1	244.4	**118**	47.8	330.8	**166**	74.4	417.2	**214**	101.1
−13	**−25**	−31.7	73.4	**23**	−5	159.8	**71**	21.7	246.2	**119**	48.3	332.6	**167**	75	419	**215**	101.7
−11.2	**−24**	−31.1	75.2	**24**	−4.4	161.6	**72**	22.2	248	**120**	48.9	334.4	**168**	75.6	420.8	**216**	102.2
−9.4	**−23**	−30.6	77	**25**	−3.9	163.4	**73**	22.8	249.8	**121**	49.4	336.2	**169**	76.1	422.6	**217**	102.8
−7.6	**−22**	−30	78.8	**26**	−3.3	165.2	**74**	23.3	251.6	**122**	50	338	**170**	76.7	424.4	**218**	103.3
−5.8	**−21**	−29.4	80.6	**27**	−2.8	167	**75**	23.9	253.4	**123**	50.6	339.8	**171**	77.2	426.2	**219**	103.9
−4	**−20**	−28.9	82.4	**28**	−2.2	168.8	**76**	24.4	255.2	**124**	51.1	341.6	**172**	77.8	428	**220**	104.4
−2.2	**−19**	−28.3	84.2	**29**	−1.7	170.6	**77**	25	257	**125**	51.7	343.4	**173**	78.3	437	**225**	107.2
−0.4	**−18**	−27.8	86	**30**	−1.1	172.4	**78**	25.6	258.8	**126**	52.2	345.2	**174**	78.9	446	**230**	110
1.4	**−17**	−27.2	87.8	**31**	−0.6	174.2	**79**	26.1	260.6	**127**	52.8	347	**175**	79.4	455	**235**	112.8
3.2	**−16**	−26.7	89.6	**32**	0	176	**80**	26.7	262.4	**128**	53.3	348.8	**176**	80	464	**240**	115.6
5	**−15**	−26.1	91.4	**33**	0.6	177.8	**81**	27.2	264.2	**129**	53.9	350.6	**177**	80.6	473	**245**	118.3
6.8	**−14**	−25.6	93.2	**34**	1.1	179.6	**82**	27.8	266	**130**	54.4	352.4	**178**	81.1	482	**250**	121.1
8.6	**−13**	−25	95	**35**	1.7	181.4	**83**	28.3	267.8	**131**	55	354.2	**179**	81.7	491	**255**	123.9
10.4	**−12**	−24.4	96.8	**36**	2.2	183.2	**84**	28.9	269.6	**132**	55.6	356	**180**	82.2	500	**260**	126.7
12.2	**−11**	−23.9	98.6	**37**	2.8	185	**85**	29.4	271.4	**133**	56.1	357.8	**181**	82.8	509	**265**	129.4
14	**−10**	−23.3	100.4	**38**	3.3	186.8	**86**	30	273.2	**134**	56.7	359.6	**182**	83.3	518	**270**	132.2
15.8	**−9**	−22.8	102.2	**39**	3.9	188.6	**87**	30.6	275	**135**	57.2	361.4	**183**	83.9	527	**275**	135
17.6	**−8**	−22.2	104	**40**	4.4	190.4	**88**	31.1	276.8	**136**	57.8	363.2	**184**	84.4	536	**280**	137.8
19.4	**−7**	−21.7	105.8	**41**	5	192.2	**89**	31.7	278.6	**137**	58.3	365	**185**	85	545	**285**	140.6
21.2	**−6**	−21.1	107.6	**42**	5.6	194	**90**	32.2	280.4	**138**	58.9	366.8	**186**	85.6	554	**290**	143.3
23	**−5**	−20.6	109.4	**43**	6.1	195.8	**91**	32.8	282.2	**139**	59.4	368.6	**187**	86.1	563	**295**	146.1
24.8	**−4**	−20	111.2	**44**	6.7	197.6	**92**	33.3	284	**140**	60	370.4	**188**	86.7	572	**300**	148.9
26.6	**−3**	−19.4	113	**45**	7.2	199.4	**93**	33.9	285.8	**141**	60.6	372.2	**189**	87.2	581	**305**	151.7
28.4	**−2**	−18.9	114.8	**46**	7.8	201.2	**94**	34.4	287.6	**142**	61.1	374	**190**	87.8	590	**310**	154.4
30.2	**−1**	−18.3	116.6	**47**	8.3	203	**95**	35	289.4	**143**	61.7	375.8	**191**	88.3	599	**315**	157.2
32	**0**	−17.8	118.4	**48**	8.9	204.8	**96**	35.6	291.2	**144**	62.2	377.6	**192**	88.9	608	**320**	160
33.8	**1**	−17.2	120.2	**49**	9.4	206.6	**97**	36.1	293	**145**	62.8	379.4	**193**	89.4	617	**325**	162.8
35.6	**2**	−16.7	122	**50**	10	208.4	**98**	36.7	294.8	**146**	63.3	381.2	**194**	90	626	**330**	165.6
37.4	**3**	−16.1	123.8	**51**	10.6	210.2	**99**	37.2	296.6	**147**	63.9	383	**195**	90.6	635	**335**	168.3
39.2	**4**	−15.6	125.6	**52**	11.1	212	**100**	37.8	298.4	**148**	64.4	384.8	**196**	91.1	644	**340**	171.1
41	**5**	−15	127.4	**53**	11.7	213.8	**101**	38.3	300.2	**149**	65	386.6	**197**	91.7	653	**345**	173.9
42.8	**6**	−14.4	129.2	**54**	12.2	215.6	**102**	38.9	302	**150**	65.6	388.4	**198**	92.2	662	**350**	176.7
44.6	**7**	−13.9	131	**55**	12.8	217.4	**103**	39.4	303.8	**151**	66.1	390.2	**199**	92.8	671	**355**	179.4
46.4	**8**	−13.3	132.8	**56**	13.3	219.2	**104**	40	305.6	**152**	66.7	392	**200**	93.3	680	**360**	182.2
48.2	**9**	−12.8	134.6	**57**	13.9	221	**105**	40.6	307.4	**153**	67.2	393.8	**201**	93.9	689	**365**	185
50	**10**	−12.2	136.4	**58**	14.4	222.8	**106**	41.1	309.2	**154**	67.8	395.6	**202**	94.4	698	**370**	187.8
51.8	**11**	−11.7	138.2	**59**	15	224.6	**107**	41.7	311	**155**	68.3	397.4	**203**	95	707	**375**	190.6
53.6	**12**	−11.1	140	**60**	15.6	226.4	**108**	42.2	312.8	**156**	68.9	399.2	**204**	95.6	716	**380**	193.3
55.4	**13**	−10.6	141.8	**61**	16.1	228.2	**109**	42.8	314.6	**157**	69.4	401	**205**	96.1	725	**385**	196.1
57.2	**14**	−10	143.6	**62**	16.7	230	**110**	43.3	316.4	**158**	70	402.8	**206**	96.7	734	**390**	198.9
59	**15**	−9.4	145.4	**63**	17.2	231.8	**111**	43.9	318.2	**159**	70.6	404.6	**207**	97.2	743	**395**	201.7
60.8	**16**	−8.9	147.2	**64**	17.8	233.6	**112**	44.4	320	**160**	71.1	406.4	**208**	97.8	752	**400**	204.4
62.6	**17**	−8.3	149	**65**	18.3	235.4	**113**	45	321.8	**161**	71.7	408.2	**209**	98.3	761	**405**	207.2

Instructions for use: The columns of figures printed in bold type indicate the temperature (Fahrenheit or Centigrade) which is to be converted. For example, to find the Centigrade equivalent of 104 °F, locate the figure 104 in the central columns of the table and read off the temperature in degrees Centigrade in the column immediately to the right (headed

[concluded on opposite page

THE MICROMETER
USING THE MICROMETER

The micrometer (Fig. 197) consists of a highly accurate ground screw which has a pitch of 0·5 mm, connected to a spindle. The spindle is set in a frame and when moved by turning the thimble opens or closes the space between the face of the spindle and the anvil. One complete revolution of the thimble moves the spindle 0·5 mm along its axis. An object is measured by placing it between the faces of the anvil and the spindle and rotating the thimble until both faces contact the object. The measurement is then read off the sleeve and thimble graduations.

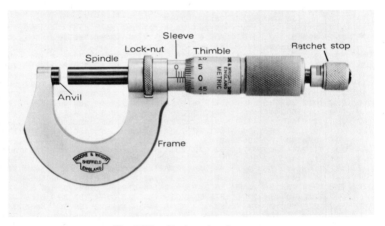

Fig. 197.—Engineer's micrometer.

The datum line on the sleeve is graduated in millimetres from 0 to 25 mm and each millimetre is subdivided in 0·5 mm. It requires two revolutions of the thimble, therefore, to advance the spindle a distance equal to 1 mm.

The bevelled edge of the thimble is graduated in fifty divisions, every fifth line being numbered from 0 to 50. Since a complete revolution of the thimble advances the spindle 0·5 mm, each graduation on the thimble is equal to 0·01 mm (one-fiftieth of 0·5 mm), two graduations equal to 0·02 mm and so on.

To read the micrometer add the total reading visible on the sleeve to the reading in hundredths of a millimetre indicated by the graduation on the thimble which coincides with the datum line on the sleeve (*see* Fig. 198).

Vernier micrometer

This is basically the same as the micrometer described above, but it has the addition of a vernier scale on the sleeve. The vernier scale is graduated in five divisions, each representing 0·002 mm.

To read the vernier micrometer, in addition to following the method already described above, it is necessary to note which vernier line coincides with the graduated line on the thimble. This gives the number of thousandths of a millimetre to be added to the final reading (*see* Fig. 199).

Fig. **198.**—Micrometer datum line. Fig. **199.**—Vernier micrometer.

Example 1 (*Fig. 198*)

Highest figure visible above datum line on sleeve	10	10·00 mm
Add reading indicated by the additional sub-division line visible	1	0·50 mm
Add reading indicated by the line on the thimble coinciding with the datum line	16	0·16 mm
Final measurement		10·66 mm

Example 2 (*Fig. 199*)

The measurement to hundredths of a millimetre is the same as above		10·66 mm
Add the reading indicated by the vernier line on the sleeve which is coincident with a line on the thimble	6	0·006 mm
Final measurement		10·666 mm

GLOSSARY

THIS glossary of terms used in lithography covers the subjects dealt with in this book. Terminology varies in different parts of the country, and there is no doubt that the vast American offset field is influencing the particular language used in the trade, especially in the small offset, and web-offset markets. The British Standard 4277 Glossary of Terms used in Offset Lithographic Printing has gone part-way to establishing standard terms, and where necessary these have been adopted in this glossary.

Absorption. Used in ink technology to describe the characteristic of paper to suck into its surface the liquid ink. Also used to describe the manner in which the Kelheim lithographic stone supports greasy drawing ink and moisture.

Actinic light. Light obtained from carbon arcs, and discharge lamps of short wavelength which effects a chemical change in light-sensitive plate coatings.

Additive process. Used to describe the mixing of individual beams of coloured light—red, green and blue—which together constitute white light.

Adsorption. A physical attraction or adhesion of a substance to a surface, such as the manner in which the lithographic image-forming material adheres to the plate surface.

Albumen (*Albumin*). A protein extract from the white of egg. When mixed with a chromate salt it is used as a surface coating solution in platemaking and referred to as "albumen solution" and "albumen plate."

Albumen plate. A surface plate in which the image area is light-hardened albumen.

Alcohol wash (*spirit wash*). A liquid such as anhydrous industrial methylated spirit or anhydrous isopropanol alcohol, used in the production of reversal plates to remove the developing and deep-etch solutions prior to the application of image-forming lacquer.

Alkyd resin drying oils. A synthetic ink vehicle made by reacting glycerine or glycols with various organic acids.

Ammonium dichromate (*bichromate*). A salt produced by neutralising chromic acid with ammonia. Commonly used in lithography to sensitise colloids for platemaking.

Anodised aluminium. This type of plate, used in lithography, has a coating on its surface of a closely packed, uniform layer of aluminium oxide, produced by treating the plate as an anode in an electrolytic bath.

Anti-back-lash gear. A press-plate cylinder gear which is made in two

portions, the wider portion taking the main drive and the narrow portion set to limit back-lash in the gear.

Anti-set-off spray. A device used on the delivery end of the printing-press to prevent ink set-off by projecting a fine spray of liquid or powder at the sheet.

Arc-lamp. A lamp in which the light is obtained by the passage of an electric current at low voltage across an air gap between electrodes.

Asphaltum. A natural pitch which can be dusted in powder form on to the inked plate image to preserve it from chemical attack. Used also as a base for wash-out solution.

Autolithography. The preparation and printing of drawn images on Kelheim stone, or specially prepared metal plates. The whole process is essentially a hand-craft.

Auxiliary reel-stand. A device which holds a reel of paper ready to succeed the one being printed, so enabling rapid changeover.

Back edge. The edge of the press plate opposite to the leading edge.

Back pressure. An American term to denote the pressure between the impression cylinder (back cylinder) and the blanket cylinder on the offset press.

Back separation. The action of an automatic sheet feeder by which the top sheet of the pile is lifted and forwarded by the back edge.

Backing up. Perfecting the sheet by printing the reverse side.

Bad fit. The incorrect positioning of the image on the plate, with the result that it is impossible to make a good alignment with the next colour printed.

Base. A solution with oleophilic qualities which is applied to deep-etch plates to form the image.

Baumé hydrometer. An industrial hydrometer used for determining the relative density of liquids. The abbreviation is written "Bé."

Bearer contact cylinders. Press cylinders which, when correctly set, make rolling contact between the plate and blanket cylinder bearers.

Bearer gap cylinders. Press cylinders which, when correctly set, have a gap between the bearers of plate and blanket cylinders.

Bearers. Hardened steel rings which are situated at both ends of the press cylinders. The bearer is normally the same diameter as the pitch line on the cylinder drive gear.

Bevel gear. A helical or spur gear with the teeth cut to form a cone shape.

Bi-metal plate. A lithographic plate in which the image areas are formed by an oleophilic metal, and the non-image areas are formed by a metal with an affinity for water.

Blanket. A tough resilient covering which transfers the ink image from the plate to the paper. Traditional blankets are made of fabric with a synthetic rubber surface. The blanket is fixed to the intermediate cylinder on the press called the "blanket cylinder."

Blanket bars. Bars to which the blanket is attached, and by which it is tensioned round the cylinder.

Blanket gauge. An instrument for measuring the thickness of a blanket before it is fitted to the cylinder. The instrument takes the form of a bench micrometer with dial.

Blanket-to-blanket press. A perfecting printing-machine which obtains printing pressure by situating the two blanket cylinders so that they oppose each other.

Bleed. That part of the printed image which falls outside the trim area.

Bleed-back. A condition in which one printed colour feeds back into the ink roller train of the second unit when printing wet-on-wet.

Blind image. An image on the lithographic plate which loses its affinity for ink. *See* "Walking-off."

Blistering. (*a*) The local separation of the surface of the blanket from the main body of the material.

(*b*) The blistering of paper caused by the internal rupture of the sheet fibres, either by excessive ink tack or by the expansion of moisture within the sheet when passing through a drier oven.

Blue Key. A form of key in which the image is produced on glass or plastic sheet by photographic means in the colour blue.

Bromide print. A monochrome photographic print on bromide paper used for paste-up purposes, and submission of proofs to the customer.

Bronzing. The process of dusting finely ground metallic powder on to a wet printed base to give a metallic lustre to the finished work.

Brunak solution. A solution formulated by the Lithographic Technical Foundation for application to aluminium plates to prevent oxidation of the surface.

Brush graining. A method of producing a fine grain on the surface of aluminium plates by the action of rotary hard-bristle brushes.

Burn-out mask. A mask prepared to cover work previously printed down on the sensitised plate, and which is then given a further exposure to light, the mask allowing all unwanted work to be exposed out.

Buttery ink. A short ink which is not tacky. It can be identified by its resemblance to butter when worked with a knife.

Bustle wheels. A wheel unit used on web presses to narrow the web by pulling its edges inwards.

Casein. A protein derived from skimmed milk and used as a colloid with ammonium dichromate to make surface plates. Coated papers which contain casein as an adhesive are unsuitable for printing by lithography.

Catch up. A term used to indicate that the non-image areas of the plate are taking ink due solely to insufficient damping of the plate.

Cellulose. A carbohydrate which forms the cell-like structure in vegetable plants.

Cellulose gum (carboxylmethyl cellulose—C.M.C.). A water-soluble gum derived from wood-fibre cellulose, and used as a substitute for gum arabic.

Chalk drawing. A drawing made with a special greasy crayon on to grained transfer paper, stone or metal for autolithography.

Chalking. A term used to denote that the printed ink film has failed to dry correctly on the paper. Chalking is caused by the vehicle being absorbed into the stock too rapidly, leaving unbound pigment on the surface.

Chalk offsets. Printed impressions taken on paper which are dusted with a coloured powder, and transferred to stone or plate to produce a key for artist's drawing.

Chase. The frame of the step and repeat machine into which the photographic film is attached.

Chemical grain. A fine grain produced on the surface of the metal plate by etching with a corrosive chemical.

Chill rollers. Large rollers situated at the exit of the web-press drier which cool the heated ink film causing it to set.

Chromo-lithography. A term used in autolithography to denote the process of reproducing a coloured original by hand-drawn work.

Chucks. Metal plugs inserted into the core of the reel of paper to provide it with a means of support when fitted to the reel-stand.

Circumferential movement. A term used to describe the direction of movement coincident with the periphery of a cylinder, drum or roller. *See* "Lateral movement."

Clean colour. A colour containing not more than two primary colours, and white.

Clumps. Blocks of wood, plastic or metal shaped to fit into the ink-duct and limit the area occupied by the ink.

Coarse grain. A plate grain sufficiently rough to produce a tonal effect when worked on with a lithographic crayon. Generally used for poster-work.

Collimator. A magnifying glass used for aligning close-register flats, in which the line of sight is directed in a straight path perpendicular to the plane of the flat, thus avoiding parallax error.

Colour density. The density of colour as measured through filters of defined spectral characteristics.

Colour saturation. The degree of intensity of a hue.

Colour sequence. The order in which colours are to be printed.

Colour swatch. A small rectangular solid print used to indicate the colour of ink to be matched in printing.

Combers. A sheet separation device which consists of a wheel which has small isolated beads on its periphery.

Compensating rollers. See "Register rollers."

Continuing reaction. A term used to denote the reaction which occurs in the light-sensitive plate coating after it has been exposed to light. The reaction is initiated by the light and continues by chemical means.

Continuous feeder. A type of automatic sheet feeder which can be replenished with stock without interrupting production.

Continuous tone. An image in which the tonal graduation is produced by changes in density.

Contrast. The brightness differences between the light and dark tones of an original or printed image.

Copy. The original matter from which a reproduction is eventually made.

(*a*) Reflection copy: copy which is viewed or photographed by reflected light.

(*b*) Transmission copy: copy which is viewed or photographed by transmitted light.

Copyboard. The unit on the camera which holds the copy.

Core. A cardboard, wood or metal tube, on to which reels of paper are wound.

Counter etch. A weak acid solution used to chemically clean the plate surface prior to coating with light-sensitive material or application of lithographic drawing ink.

Creeping blanket. A blanket which moves forward on the cylinder during the run, caused by incorrect pressure or insufficient blanket tension.

Cronak solution. A similar plate treatment as Brunak, formulated by the Lithographic Technical Foundation for use on zinc plates.

Crop. To cut off an edge, or trim an illustration down to a smaller size.

Cross fold. A fold at right angles to the direction of the running web of paper.

Cross perforation. A perforation at right angles to the direction of the running web of paper.

Cutting marks. Short lines added to the copy to indicate the positions of cutting, slitting or punching to be performed when the work has been printed.

Cylinder gap. Also called the "cylinder depression," it is the gap in the cylinders of the press which houses clamps or grippers.

Cylinder register marks. Marks engraved on the plate cylinder to facilitate rapid and accurate plate positioning.

Dab out (tap out). A method of examining the colour of ink by tapping out a thin film of the ink on to the regular stock with the tip of the finger.

Damper. The roller which applies moisture to the plate by being in contact with it.

Damping distributor. A metal roller which has a lateral reciprocating motion in addition to rotation, and which distributes moisture and applies drive to the dampers.

Damping system. Any mechanism which is designed as a unit to apply moisture to the lithographic plate.

Dancer roller. A sensing roller located close to the reel of paper on the web press to compensate for fluctuations in web tension during the run.

Dandy roll. A specially designed roll which applies the watermark to paper at the wet stage of its manufacture.

Dark reaction. The hardening effect which occurs in coatings of a dichromated colloid independently of its exposure to light.

Deep-etch process. Also called the "positive reversal process," it is a technique of making a lithographic sub-surface plate by forming a colloid stencil after exposure of a sensitised coating through a positive. The metal plate is subsequently etched to form an image slightly below the plate surface.

Densitometer. An electrical instrument designed to accurately measure optical density. The reflection densitometer is used for evaluating the density of opaque reflection copy, such as printed ink films.

Desensitise. A term used to denote two distinct effects produced on the surface of the lithographic plate.

(*a*) To render the plate surface insensitive to ink.

(*b*) To promote a hydrophilic layer on the plate surface.

Desensitising plate etch. A solution which is applied to the plate surface to effect desensitisation, or promote conditions favourable for the desensitising action of gum arabic.

Developer. A solution or chemical agent which removes the unexposed light-sensitive coating from a plate after exposure.

Developing ink. An ink solution applied to the exposed areas of a surface plate such as albumen to render the image oleophilic and visible.

Development. The removal of unexposed coating from the plate by means of a chemical solution or water.

Dichromated coating. Any plate coating which is made from a dichromated colloid.

Dichromated colloid. A solution which contains a chromic salt such as ammonium dichromate and a colloid such as gum arabic.

Dimensional stability. A term used to denote that sheets of film or paper remain correct to size, with variations in temperature and humidity, and during handling and ageing.

Direct lithography. The printing by lithography of stock which is brought into direct contact with the plate or stone to receive impression.

Dirty colour. A colour containing three primary colours or any colour with black.

Discharge lamp. A lamp or tube in which light is produced by an electrical discharge through a gas.

Distributing rollers. The rollers comprising the system between the feed roller and the plate rollers on the press.

Dot. A single element of a half-tone image.

Double cut. Space left in the sheet for two trims of the guillotine to meet the requirements of bleed and size.

Double printing. Printing down from two or more negatives or positives to obtain a single image.

Doubling. The appearance on the printed sheet of two non-coincidental images produced during one impression.

Down-draught sink or trough. A plate-processing sink which has facilities for removing noxious fumes away from the platemaker by drawing them downwards out of the sink.

Drawdown. A method of examining ink by scraping a sample down on to regular stock to produce a film of ink with graduated density.

Draw rollers. Motor-driven roller assemblies which pull the web through the web printing-press.

Driers. Substances which are added to the printing ink to increase the rate of oxidation by catalytic action.

Dry. A condition of a printed ink film which has developed a high rub resistance.

Drying oven. A chamber heated by hot air, or which contains gas flames or equipment for emitting radiation, which accelerates the drying of printed matter.

Dry offset. A printing method using relief plates, in which impression is obtained via a blanket cylinder as in offset lithography.

Dry spray. An anti-set-off spray using dry powder.

Dual reel-stand. A reel-stand capable of holding two reels.

Duct. The ink-trough holding a reservoir of ink at the head of the inking system on the press.

Duct blade. A flexible steel blade which can be adjusted in relation to the duct roller to regulate the thickness of the ink film which it carries during rotation.

Duct roller. A large-diameter roller which meters ink from the ink-duct to the feed roller.

Duotone. A two-colour half-tone print, one colour being dark, the other, light, produced from a single monochromatic original.

Dwell. A term applied to the length of time that the feed roller remains in contact with the ink-duct or fountain roller, during its moving cycle.

Egg albumen. See "Albumen."

Electrolytic grain. A plate grain produced by electrolysis.

Embossed blanket. Local swelling of the blanket surface due to absorption of ink solvents and ingredients.

Emulsification. A term used to describe the dispersion of water as fine droplets in the ink on the press rollers during printing.

Enclosed arc. An arc-lamp in which the electrodes burn within an enclosed space, yielding a higher ultra-violet emission than open arcs.

Engraved blanket. A lowering of the blanket surface in the areas of printing due to the deleterious effect of the ink ingredients.

Etch. The engraving of metal or stone with a corrosive solution. *See* "Plate etch," and "Deep etch."

Everdamp. A type of transfer paper which maintains its moisture content for long periods due to the special coating on the paper.

Face-down feed. Feeding the side of the paper to be printed face down on the feedboard of the printing-press.

Face-up feed. This is the opposite to face-down feed, and is the normal method of feeding.

Fanning. (*a*) A spreading-out condition of the paper as it passes through the press impression.

(*b*) A method of winding sheets to ensure good separation in the feeder.

Feedboard. The surface over which the stock is conveyed to the lays on the press.

Filling in. The spreading of the ink on the printed image causing half-tone dots to join together.

Flame bars. Bars which carry the flame-nozzles in the drying oven.

Flat. The base sheet on to which the various photographic film elements are assembled for exposure to the sensitised plate.

Flat image. An image which lacks contrast.

Flats. The faces of a hexagon- (or similar-) shaped adjusting device operated with a spanner or key.

Fluff. Small and minute particles consisting mainly of paper fibres in loose form.

Fluorescent lamp. A discharge lamp which functions by converting the invisible radiation emitted by the discharge into light by coating the lamp envelope with materials which fluoresce.

Flying ink. A press problem in which a long or tacky ink flies off the rollers in a mist of fine ink droplets.

Flying paster. A reel paster which joins the tail-end of the old reel to the beginning of a new reel without interrupting the production speed of the web press.

Folder. A mechanical device for folding a sheet or web, either as part of the printing-machine or as a separate unit.

Former. A kite-shaped device which makes the first parallel fold in the web folder.

Former fold. A parallel fold made by passing the web over the former.

Forwarding roller. A roller situated immediately in front of the feeder which conveys the sheet forward to the feedboard.

Forwarding suckers. Suckers which are situated on a moving unit to convey the top sheet of the pile to the forwarding roller.

Fountain. The trough in which the damping solution is contained.

Fountain roller. The roller which runs in the fountain trough to convey solution to the feed roller.

Fountain-roller stops. Devices such as squeegees which can be placed in different positions along the fountain roller to limit the amount of solution applied to the feed roller.

Fountain solution. A solution used for damping the lithographic plate.

Fried ink. The effect of reducing the gloss of printed ink caused by excessive temperatures in the drying oven.

Front lays. Adjustable stops situated at the press end of the feedboard to which the leading edge of the sheet is presented.

Geared rider. A reciprocating roller which is also rotated by gear drive.

Gear marks. Parallel marks which appear across the printed sheet coincidental with the pitch of the gear teeth on the cylinder.

Ghosting. A term used to describe a fault in the quality of a print, in which a second lighter image appears on the print as a ghost image. This is due to:

 (*a*) The blanket having an engraved image from a previous run.

 (*b*) The print on the reverse side of the sheet affecting the trapping and drying of the ink, thus leaving an image of reduced gloss as a ghost.

 Not to be confused with a "repeat."

Glazed rollers. The surface hardening of ink rollers due to the absorption of ink solvents and ingredients.

Goldenrod paper. A special paper used for assembly as a negative flat. The paper is coloured yellow or orange and does not permit the transmission of actinic light.

Grain. (*a*) The roughened surface of a lithographic plate or stone.

 (*b*) The direction in which the cellulose fibres of paper predominantly lie.

Grater foil. A special metal foil of limited caliper which is punctured with thousands of small holes, the ragged edge of the holes being very similar to the nutmeg-grater used in a kitchen. The foil is used on transfer cylinders and path rollers to give support to the printed paper without causing set-off or smudging.

Gripper. A finger-like device for holding the sheet in its passage through the printing-machine.

Gripper allowance. That portion of the sheet which is held by the grippers and which cannot as a consequence be printed. Also called the "gripper margin."

Gripper edge. The leading edge of the plate which is fitted into the leading clamp on the plate cylinder.

Gum arabic. A vegetable gum exuded from the bark of the acacia tree which grows in the Middle East and North Africa. The dried lumps (or sorts) of the gum are used extensively for making fount solutions, plate gum solutions, deep-etch coating and desensitising plate etches.

Gumming up (*or Gum out*). A term used to describe the complete operation of applying a thin film of gum to the surface of the plate, rubbing it down

evenly and drying the film. Applications of gum which are not dried on to the plate are not covered by this term.

Gum stencil. A dichromated gum film which has areas of the coating hardened by exposure to light, and other areas developed away to leave a positive or negative acid-resistant stencil on the plate surface.

Gum streaks. Streaks produced across the plate image, especially over half-tones, because of the gum being left in heavy streaks after gumming up the plate. The streaks may result in the image losing its ink receptivity due to deterioration of the image material.

Half-sheet work. See "Work-and-turn."

Half-tone. The representation of the tonal graduations of an image by a series of dots of varying sizes, which are evenly spaced, the sizes of the dots being directly proportional to the tonal areas they represent.

Halo. The area of low density which surrounds the dense core of a half-tone dot.

Heat-set ink. A printing ink specially formulated to dry at high speed in a drying oven.

Helical gear. A gear which has its teeth cut at an angle to the axis of the shaft.

Hickies. A term used to describe the hardened specks of dirt, ink, dried gum, etc. which form imperfections on the printed sheet, by showing as a solid speck with a halo round it. Also called "doughnuts."

Highlight dot. That area of the half-tone image which represents the lightest tone and is formed by very fine dots.

Hue. That attribute of colour by which we classify it as red, blue, green, etc.

Hydrometer. An instrument for measuring the specific gravity of liquids.

Hydrophilic. Greek for "water-loving." The water-receptive, water-attracting quality of the non-image areas of the lithographic plate.

Hydrophobic. Greek for "water-hating." The water-repelling quality of the lithographic image.

Hygrometer. An instrument for measuring the relative humidity of the atmosphere.

Hygroscope. A hydrometer which permits direct readings of relative humidity to be taken.

Imposition. The arranging of pages on the sheet in such a manner that when the sheet is folded and cut the pages run in the correct order.

Impression cylinder. The press cylinder which holds the paper in contact with the blanket cylinder to receive a printed impression.

Impression off. A term used to denote that the impression, blanket and plate cylinders are out of printing contact.

Impression on. A term used to denote that the impression, blanket and plate cylinders are in printing contact with each other.

Inch. A true inch is a term used to denote that when the machine is electrically motivated the cylinders revolve for one imperial inch (25·4 mm) of their circumference and then stop. The inch button has to be depressed each time to revolve the machine by this amount.

Indicator. A dye which changes its colour when influenced by an acid or an alkali solution. A selection of these dyes is used to indicate the pH range.

Infeed rollers. A system of rollers designed to have a positive grip on the web and which are usually driven by a variable-speed motor. The rollers pull the web off the reel and feed it forward to the printing unit.

Ink agitators. A mechanical device fitted to the ink-duct which intermittently moves along its length stirring the ink.

Ink-dot scum. A type of plate oxidation peculiar to aluminium plates, which consists of numbers of sharply defined dots scattered over the plate.

Ink drum. A large diameter drum included in the ink train of some ink roller systems.

Ink in. A term used when processing deep-etch plates to describe the application of special ink to the image.

Inking system. The system of rollers which convey the ink from the duct to the plate. Often called an "ink train," and an "ink pyramid."

Inkometer. An instrument which measures the length and tack of an ink and gives related readings in numerical terms.

Insertion device. A mechanism taking the form of swing-arm, or rotary-arm transfer grippers, or feed-roll mechanism which positively inserts the sheet into the impression cylinder grippers from the feedboard.

Integrating light meter. An instrument which measures a controlled quantity of light, and which will ensure that the exposure is exact despite fluctuations in the intensity of the light during the exposure period.

Jaw folder. A type of folder in which the paper is folded at a right angle by thrusting the section between folding jaws. *See* "Nip and tuck folder."

Joggers. A mechanism located at the delivery pile which gently pushes each delivery sheet to a predetermined position with the rest of the pile.

Key. A master outline of an image which is used to locate the position of the image colours, for hand drawing or photolithographic planning.

Key colour. The colour of the multicolour set which is used to act as a key.

Kiss impression. A term used to describe the lightest possible contact between the press cylinders consistent with good impression.

Lacquer. (*a*) An oleophilic solution applied to deep-etch plates to form the image areas.

(*b*) An oleophilic solution which is used to form a reinforcing film on the image areas of a presensitised plate.

Lap. A term used in poster printing to indicate the margin allowed for one sheet of the poster to cover the edge of the adjacent sheet.

Lateral movement. A term used to describe a direction of movement which is parallel to the axis of a cylinder, drum or roller. *See* "Circumferential movement."

Lateral reversal. To turn an image from left to right so that wording will appear reversed as seen in a mirror.

Leading edge. That edge of the press plate or sheet at which printing impression begins.

Licking. A term used to denote that the back edge of the printed sheet is touching some part of the press on its path to the delivery, causing smudging, etc.

Lifting. The ability of a surface to accept a printed film of ink satisfactorily.

Light integrator. *See* "Integrating light meter."

Line-work. Copy or reproduction consisting of solid elements only, without half-tone.

Litho. An abbreviated term often used as a prefix to words which are related to lithography, such as "litho plates," "litho ink," "litho department."

Litho crayon. A crayon made of oleophilic substances such as soap and tallow, which is used for crayon drawing in autolithography.

Lithography. A term derived from the Greek words *lithos* which means "stone" and *graphe* which means "writing," applied to Senefelder's printing process which was originally invented in the use of Kelheim limestone, and later developed in the use of metal plates. Lithography is a planographic printing process in which the image and the non-image areas of the printing surface are on the same plane. Selective inking is obtained on the principle that the greasy image formed on the plate will repel moisture; the plate surface is damped and the image repels the moisture and remains dry. When the ink rollers are passed over the surface the greasy ink transfers to the dry areas only, thus inking the image. The term "lithography," however, may be applied to any planographic printing process in which the selective inking of the image is obtained by chemical means.

Senefelder's printing process was called "chemical printing" long before the title "lithography" was given to it.

Livering. A chemical change which takes place in ink which has been in storage for a long period, leaving it with a liver-like consistency.

Long ink. A stiff or soft ink which stretches out into strings when pulled apart.

Makeready. The preparation of the printing-machine for a specific job.

Masking out. The covering of areas of a coated plate with opaque paper, to prevent light falling on them during exposure when printing down.

Mercury vapour lamp. A discharge lamp in which an electrical discharge takes place through a vapour of mercury.

Metal decorating press. A lithographic printing press for printing on sheet metal.

Metering unit. A measuring device for controlling the flow of materials such as oil or powder.

Middle-tone. A term used to describe the neutral tones between highlight and shadow tones of a half-tone image.

Misregister. The appearance of a printed image out of its correct position due to the sheet being incorrectly registered in the press at the time of printing.

Modular unit. A printing-press designed and manufactured in a single one-piece unit, whether it be a single- or multicolour press. *See* "Tandem press."

Moiré. An unwanted pattern effect created by the screen angles of half-tone dots or the angles of line patterns, when they are superimposed.

Molleton. A cotton fabric having a surface nap which consists of short loops of cotton, used for covering dampers.

Monochrome. An original or reproduction image in a single colour.

Montage. An assembly of related pieces of copy to form a composite single copy.

Near-side. A term indicating that side of the printing-press from which the pressman performs the main operations of his work. When facing the press at the feeder end the near-side is the left side.

Negative. A photographic image with tonal values reversed relative to the original.

Nesting. The positioning of irregular images, such as labels, during planning, so as to utilise a sheet of stock in the most economical manner.

Notch bars. Locating bars with notches on the horizontal and vertical booms of the step and repeat machine.

Nip and tuck folder. A type of folder in which the paper is folded at right angles by thrusting the section between folding jaws. Also called a "jaw folder."

Non-blinding lacquer. An image-forming lacquer which does not lose its oleophilic qualities during normal press usage.

No-sheet detector. A sensing mechanism which automatically trips the press out of impression in the event of a late or absent sheet during printing.

Offset letterpress. Also called "dry offset," this term is used to denote a rotary letterpress process using relief plates, with a blanket cylinder to transfer the image to the paper.

Offset lithography. The common form of lithographic printing in which the image is transferred to the stock via a blanket cylinder. *See* "Direct lithography."

Opacity, opaque. Not permitting light to pass through. The opposite of "transparent."

Opaquing. The application of an opaque water-soluble paint to photographic film to prevent light passing through those areas.

Open arc. An arc-lamp in which the electrodes burn in the open air.

Overdraw. The enlarging of a particular colour image to allow slight overlapping of a second colour. Used to give latitude in the fitting of one colour with another.

Overprint. An additional print superimposed over existing printed work.

Oxidation. A term used to describe the minute spots of surface corrosion which occur on lithographic plates and which have a deleterious effect on printing quality.

Packing. The paper or plastic sheets of varying caliper which are placed under plate, blanket or impression cylinder covering, to alter cylinder diameter or alter the pressure between the cylinders.

Packing gauge. A magnetised metal block which has a micrometer dial located at one end. The block is attached to the plate or blanket cylinder when packed, and the dial adjusted to give a micrometer measurement of the difference in the surface level of the packed cylinder and the cylinder bearer.

Paper conditioning. The process by which the moisture content of paper is adjusted to the level required for the printing operation.

Paper stretch. The changing of the dimensions of a sheet of paper. Usually in the use of long-grain paper the expression refers to stretch from the leading edge to back edge of the sheet.

Parallax. The displacement of one film layer over another film layer during planning due to the combined films being viewed from different positions.

Parallel fold. A fold in paper which is parallel to a previous fold, or parallel to the leading edge of the sheet.

Paste drier. An ink-drying paste containing metallic salts, which is formulated to dry the ink film without hindering the trapping of the second colour ink film.

Paster. Equipment which applies adhesive to the web to join the tail-end of the old reel to the beginning of the new reel.

Paste-up. The assembly of various elements of copy to make a single copy for the camera.

Patral solution. A solution prepared by P.A.T.R.A. (now P.I.R.A.) for application to aluminium plates to prevent oxidation of the surface and to improve desensitisation.

Perfecting. Printing both sides of the stock in one pass through the printing-press.

Perfector. A press which contains two printing units for perfecting. *See also* "Blanket-to-blanket press."

Photolithography. The photographic means by which the plate used in lithography is made, as distinct from autolithographic techniques.

Photo scum. Scum deposited on the non-image areas of the plate during the process of photolithographic platemaking. *See* "Residual coating" and "Scum."

Picking. A condition which is caused by the tacky ink pulling the surface fibres of the paper (or coating on the paper) away from the surface, leaving unprinted areas on the sheet.

Pick-tester. An instrument for measuring the pick resistance of paper.

Pigment. A substance which is added to the ink vehicle to give colour to the ink.

Pile shift. A device for raising or lowering the pile of stock in the press feeder or delivery.

Planographic printing. A generic term used to describe those printing processes such as lithography and collotype, in which the image is on the same plane as the non-image areas of the printing surface.

Plastic plate. A lithographic plate which has a base of plastic, or a plate made of plastic with a base of paper. Both types of plate are used in small offset lithography.

Plate cylinder. The cylinder of the lithographic press which carries the printing plate.

Plate etch. A solution applied to the lithographic plate to effect or promote desensitisation of the non-image areas. *See* "Desensitisation" and "Desensitising solution."

Plate inking rollers. Those rollers of the inking system which apply ink to the plate. Wrongly called "forme rollers" in American publications.

Polymerisation. The chemical combination of several molecules to form a more complex molecule with different characteristics than the original substance.

Positive. A photographic image in which the tonal values are the same as the original copy.

Post-treatment. A plate treatment applied after the lithographic plate has been made.

Pre-coated plate. A plate supplied by the manufacturer which has an absorbent coating on its surface and which is made light-sensitive by the platemaker when a special solution is applied to the plate surface with a sponge.

Pre-loader. A piece of equipment consisting of a platform and sheet-stacking guides, with which a pile is prepared before use in the automatic feeder.

Pre-makeready. A term used to describe those operations which are performed before a fresh job is done on a press, and which may be unrelated to any particular type of work connected with the fresh job.

Prep or preparation. A term used to describe the preparatory operations required before coating a plate with a light-sensitive coating. Often loosely applied to the solution used for chemically cleaning the plate surface. *See* "Counter etch."

Presensitised plate. A lithographic plate supplied by the manufacturer with a light-sensitive coating on its surface, ready for exposure.

Pre-treatment. A plate treatment applied to the plate before platemaking to facilitate easier development, and to ensure that the plate is thoroughly prepared for processing.

Print density. The measurement of the reflection density of a printed ink film obtained with the use of a densitometer.

Printing down. A photolithographic expression used to describe the process of exposing the light-sensitive plate through the flat in a vacuum frame.

Printing in battery. Printing successive colours of the same job on different presses.

Printing pressure. Also properly called "interference," the force with which one cylinder opposes another cylinder when in contact. Pressmen always refer to printing pressure in terms of linear measurement (mm) and not in terms of pressure (N/m^2).

Printing to size. Reproducing the image on the plate to the same dimensions as the printed image.

Print-out mask. See "Burn-out mask."

Process colours. The three subtractive primary colours, yellow, cyan and magenta, and black, which are used to reproduce by printing the range of colours in the original.

Progressive proofs. A set of colour printed proofs which comprises one print of each colour, and a print of the combination of subsequent colours as they are printed in sequence.

Proof. A reproduction produced by photomechanics or printing, made with the express purpose of checking colour, size, layout, etc., before the job is finally passed to the production line.

Proofing-press. A printing-machine constructed to print proofs.

Pulling solids. Printing trial sheets on the lithographic press without the use of dampers, thus rolling up the plate with a solid ink film. This method is used for testing cylinder settings and blanket condition.

Punch register. A system for obtaining register between photographic film flats and lithographic plates, also plate bender and plate cylinder clamps, by the use of punched holes and corresponding pins or dowels.

Racking. The placing of wet printed sheets on racks in small batches to prevent the sheets from setting off while drying.

Reciprocating roller. A roller in the ink or damping system of the lithographic press which has a limited intermittent lateral movement during rotation.

Reducer. A varnish or solvent added to an ink to make it of softer consistency.

Reel-fed machine. A machine which prints on paper supplied in a continuous ribbon or web and drawn from a reel.

Reflection copy. Copy which is viewed or photographed by means of light reflected from its surface.

Reflection densitometer. See "Densitometer."

Refusal. The failure of one printed ink film to take satisfactorily on another.

Register. The accurate positioning of printed matter in relation to the stock and to other printed colours.

Register marks. Fine lines, crosses or similar guides, located on original copy to facilitate rapid register during subsequent planning, platemaking and printing.

Register motor. An auxiliary electrical motor which drives the register rollers on a web press.

Register rollers (compensator rollers). A system of rollers (usually two) capable of limited advance and retard motion which control the position of the printed web as it enters another printing unit or web folder.

Relative humidity (r.h.). The measure of the amount of water vapour in the atmosphere at a certain temperature, compared with the maximum amount of water vapour which the atmosphere can hold at that temperature.

Repeat. Also wrongly called "ghosting," this term is used to describe the faint image outline seen in printed work (usually solid areas) which is caused by poor ink film recovery on the plate rollers. The fault is an indication of poor ink storage capacity in the roller pyramid.

Reproduction pull (repro). A good-quality print on white paper used for paste-up copy or camera copy.

Residual coating. A very fine broken layer of surface coating which is left on the non-image areas of the plate after development, and which will cause scumming when printed. *See* "Photo scum."

Reticulation. Often occurring when a wet film of ink is printed on to a previously printed ink film which has dried to a smooth glossy finish. Reticulation is the drawing together of the ink into minute beads, giving the print a mottled appearance.

Reversal process. A platemaking process in which the image is formed on the plate by the use of a positive. Strictly related to the deep-etch process.

Rider. A small-diameter roller resting in contact with another roller by its own weight, and not directly connected with the distribution of the ink.

Roller stripping. The failure of ink to cover sections of steel rollers in the ink pyramid because they have become desensitised by chemicals in the fountain solution.

Rolling up. A method of inking the image on a lithographic plate with rollers on the press or with a hand roller on a bench. Usually performed to aid visual inspection of the image, or preparatory to putting the plate in store.

R.T.F. An abbreviation of "roller-top-of-former," the roller immediately above the former on a web folder.

Rubbing up. A method of inking a plate image by applying the ink on a cloth with a rubbing action while the plate is moistened.

Rub resistance. The degree to which a dry print will resist smearing by friction.

Ruling up. The action of checking the accuracy of the image position with a calibrated rule.

Running. Also called "running on," this term describes the continuous production of the printing-machine.

Running-in wheels. Small wheel assemblies located over the feedboard, for controlling the forward movement of the sheets.

Safelight. An illuminating light source which provides light of a non-actinic nature, in which light-sensitive materials can be handled safely.

Sandblasting. A method of graining the surface of the lithographic plate by impelling abrasive particles, such as sand, against the plate.

Scavenger rollers. Small-diameter rollers often included in the ink roller train which function by appropriating from the other inkers, much of the paper fluff and lint, and waterlogged ink. Their main task is to keep the roller system clean. Scavenger rollers have also been used in the damper system to keep the dampers free from ink during the run.

Scrubbing. A machine fault which results in uneven and early wear of plate and blanket.

Scum, Scumming. Minute particles of ink which adhere to the non-image areas of the plate. Scum occurs for a number of reasons: *see* "Photo scum," "Oxidation," "Residual coating."

Sensitivity guide. A strip of photographic film consisting of a series of graduated, continuous-tone steps, each step having a number, and used for controlling exposure.

Set. A term used to describe the manner in which a printed film of ink gels and gains a surface dryness sufficient to prevent set-off under normal conditions.

Set-off. The transfer of a wet film of printed ink to a facing sheet in the delivery pile.

Shaking up. The operation of separating and getting air between the sheets by winding the sheets by hand.

Sharpening image. A term used to denote that the image is losing its printing area at the edges; the opposite to "thickening image."

Sheet-fed machine. A printing-machine which uses stock cut in sheet form.

Sheeter. A device for cutting a web into sheets.

Sheet work. Printing both sides of the sheet, using different plates for each side.

Short ink. An ink which when pulled apart breaks without stretching or stringing.

Show through. The degree to which the printed ink film is visible from the reverse side of the sheet, due to the low opacity of the paper.

Side lay. A mechanism located on the feedboard which moves the side of the sheet to its predetermined position before the grippers take the sheet.

Single-sheet feeder. An automatic device for separating sheets from the pile and forwarding each sheet with space between each succeeding sheet corresponding to the cylinder gap.

Skeleton wheels. Large-diameter discs located on a shaft, which act as sheet supports during transfer or delivery of the printed sheet.

Slitter. A rotary knife used for cutting a web or sheet while it is in motion.

Slow-downs. A device for retarding the forward speed of the sheet as it is conveyed to the front lays.

Small offset machine. A lithographic printing-machine which takes a maximum size sheet of approximately 375 × 500 mm.

Soft ink. A low-tack ink.

Spirit off. Washing the deep-etch plate with alcohol wash.

Static neutraliser. A device fitted to the printing-machine for dissipating static electricity in the paper.

Step and repeat machine. A printing-down machine which produces multiple images from a negative or positive, by stepping each image in accurately predetermined positions.

Stiffness of ink. The degree to which an ink resists stirring.

Stream feeder. An automatic device for separating sheets from the pile and forwarding the sheets in a continual stream with their edges overlapping the rear sheet.

Strike through. A term to denote that the printed ink film has penetrated the paper to such a degree that it is seen on the reverse side. Do not confuse with "show through."

Stripping. (*a*) The assembly of photographic elements on film to make one single flat.

(*b*) A term denoting that the metal rollers in the ink roller train have become desensitised and will not accept ink.

Sub-surface plate. A term used to denote that the image-forming material on the lithographic plate is situated below the surface, slightly intaglio to the non-image areas.

Suckers. Cone-shaped discs which adhere to the sheet by vacuum pressure. The term is loosely applied to the unit mechanism which houses the suckers.

Surface plate. A term used to denote that the image-forming material on the lithographic plate is situated on the surface in slight relief to the non-image areas.

Surprint (*double printing*). A method of printing down by using multiple flats which, when exposed one after the other in position, give a single image with superimposed elements. By this method line and half-tone images can be combined from separate negatives.

Sword hygroscope. A sword-shaped instrument designed to insert into a pile of paper between the sheets to determine its moisture content.

Tack. The sticky nature of ink, governed by viscosity and adhesion of the ink, which resists being pulled apart or split between two separate surfaces.

Tackmeter. An instrument designed to measure the ink tack properties.

Tail and hook. A term used to describe the curling of the back edge of paper due to the manner in which the paper is distorted as it leaves the blanket.

Tandem press. A press which consists of two or more modular units coupled together in line to form a single press.

Tandem reel-stand. A reel-stand accommodating a number of reels positioned one behind another.

Tension roller. See "Dancer roller."

Thixotropy. A condition of many lithographic inks which, when left in a container, thicken and form a light gel structure which can be quickly broken down by stirring to produce a fluid consistency. Thixotropy is the major cause of an ink hanging back in the ink-duct during the run.

Three-point-register. A system of obtaining register by laying two adjacent sides of a rectangle to three points, two points are located on the long edge and one point is located on the short edge.

Tight register work. Printing images which require precision to superimpose them in relation to images previously printed.

Tint. An ink with a low intensity of colour, often obtained by dispersing a small quantity of full-strength ink in a colourless medium such as white, or a transparent or semi-transparent pomade.

Tinting. A lightly coloured tint which prints over the entire non-image areas of the sheet, due to the ink pigment becoming mixed in the damping solution of the press. This should not be confused with "scum."

Tint medium. An ink extender which has a refractive index similar to the average ink vehicle, giving it a transparent or semi-transparent appearance.

Transfer. A print made on specially coated paper which is capable of being transferred to another surface.

Transfer paper. A paper which has a coating on its surface (such as starch, or gelatine) which will permit an inked image formed on it to be transferred to another surface.

Transmission copy. Copy which is photographed or viewed by transmitted light.

Transposition. A term used commonly in lithographic stonework to describe the changing of the image from positive to negative, *i.e.* the image is made non-printing, and the non-image areas are made to print.

Trapping. The acceptance of one printed ink film upon another.

Tri-metal plate. A lithographic printing plate in which the two lithographic surface metals are supported on a third base metal.

Trip (tripping). A term used to denote that the printing-machine when in the

process of printing resumes its non-printing attitude, *i.e.* the cylinders move out of contact with each other and all attendant systems are suspended.

Tungsten filament lamp. A lamp in which light is produced by means of a heated filament made of tungsten rising to such a temperature with the passage of electricity that it glows.

Turner bars. Highly polished bars which are set at an angle in the path of the web to redirect it.

Two-sheet detector. A sensing device which detects the passage of two or more sheets down the feedboard of the machine, and which is designed to trip the press to prevent damage to the cylinder dressings.

Underblanket. A special blanket fitted under the printing blanket on the press blanket cylinder.

Under-colour removal. The subtraction of colour density from the dark areas of the multicolour image in the cyan, yellow and magenta separations, leaving the black separation to obtain the necessary density.

Vacuum back. A platen board with numerous holes in its surface by which a plate is held in contact by suction. Usually found on vertical step and repeat machines.

Vacuum frame. A printing-down frame consisting of a beaded rubber blanket which is brought into contact with a plate-glass lid. The enclosed air is being drawn out by an exhaust pump causing the blanket to collapse to the glass, making an airless contact between the film and plate situated on the blanket.

Varnish. A viscous liquid which acts as a carrier for the pigment of ink.

Vignette. A continuous graduation of density from light to dark tone.

Viscosity. A term often used in relation to printing inks, which indicates their resistance to flow. Short inks have high viscosity, tacky inks are less viscous. This must not be confused with "thixotropy."

Walking off. A breakdown of the image areas of the lithographic plate, in which the actual image disappears during the press run. Compare with "blinding image."

Warm colour. A colour with a red hue, such as orange, chrome-yellow and scarlet.

Washing. The extraction of pigment colouring from the ink by the fountain solution on the press during the run. Washing is the antecedent to tinting.

Washing out. The removal of ink from the image of a gummed plate with a solvent.

Washing up. Cleaning the ink from the inking rollers of the press.

Wash-out solution. The application of an oleophilic solution to the image areas of the plate subsequent to washing out the image ink with a solvent. Asphaltum solution is commonly known as "wash-out solution."

Waste (*wasters*). Sheets of the same dimensions and substance as the regular stock which are used for makeready printing.

Web cleaner. A device for removing loose dust and lint from the web before it passes into the printing unit of the press.

Web lead rollers. The rollers which direct the web into the nip of the blanket cylinder.

Web offset. Lithographic printing on to a continuous web of paper by the offset principle.

Wet-on-wet printing. The printing of one wet film of ink on to another wet film in one pass through the machine.

Wet spray. An anti-set-off spray in which the spray particles are suspended in a liquid.

Wet wash-out. The application of wash-out solution to the plate image while the non-image areas are damped with water at the same time.

Whirler. A platemaking machine used for applying and drying light-sensitive coatings on lithographic plates.

Wipe-on coating. A light-sensitive coating solution applied to the lithographic plate by hand, without the use of a whirler.

Work and tumble. Printing one side of the sheet, then turning the sheet over on the long cross to give a new gripper edge but the same side lay, and printing with the same plate.

Work and turn. Also called "half-sheet work," one side of the sheet is printed and the sheet turned over on the short cross to retain the same front- and side-lay edges, and the second side printed from the same plate.

Work and twist. Printing one side of the sheet, turning it round to give new gripper and side-lay edges, and printing the same side from the same plate.

Working sharp. The deterioration of the image during a press run in which fine lines and highlight half-tone dots become finer.

Xenon lamp. A discharge lamp in which the electrical discharge takes place in xenon gas.

BIBLIOGRAPHY

THIS Bibliography has been selected and categorised to provide the student with further information on the subjects covered in this book.

Science
PATEMAN, F. and YOUNG, L. C. *Printing Science.* Pitman, 1963.
COUPE, R. R. *Science of Printing Technology.* Cassell, 1966.
MARSHALL, G. R. *An Introduction to Science for Printers.* Heinemann, 1963.
HARTSUCH, P. J. *Chemistry of Lithography.* Lithographic Technical Foundation now called Graphic Arts Technical Foundation (G.A.T.F.), 1959.

Planning
DECKTER, J. *Practical Photo-Offset Stripping.* Lith-offset Publishing Co.
HALPERN, B. R. *Colour Stripping for Offset Lithography.* G.A.T.F., 1955.

Platemaking
TORY, B. E. *Photolithography.* Pitman, 1953.
SAYRE, H. *Photography and Platemaking for Lithography.* Lithographic Textbooks Publishing Co., 1944.
REED, R. F. *Offset Platemaking* (two volumes). G.A.T.F., 1967.

Machine design and operation
LATHAM, C. W. *Lithographic Offset Press Operating.* G.A.T.F., 1955.
LATHAM, C. W. *Advanced Pressmanship.* G.A.T.F., 1963.
SAYRE, H. *Single Colour Offset Machine.* Lithographic Textbooks Publishing Co., 1944.
REED, R. F. *Web Offset Troubles.* G.A.T.F., 1962.
WATERS, A. F. *Web Offset: A Technical Survey.* P.A.T.R.A. (now P.I.R.A.), 1965.
BRAGDON, C. R. *Metal Decorating from Start to Finishes.* Bond Wheelwright, 1961.
CUMMING, R. F. and KILLICK, W. F. *Single Colour Lithographic Machine Operating.* Pergamon, 1969.

Paper
BOLAM, F. (Editor). *Papermaking.* Paper and Boardmakers Association, 1949.

CLAPPERTON, R. H. and HENDERSON, W. *Modern Paper Making.* Blacknell, 1964.

REED, R. F. *What a Lithographer Should Know About Paper.* G.A.T.F., 1959.

Ink

ASKEW, F. A. (Editor). *Printing Ink Manual.* Heffer, 1961.

APPS, E. A. *Printing Ink Technology.* Leonard Hill Books, 1958.

REED, R. F. *What a Lithographer Should Know About Ink.* G.A.T.F., 1960.

General lithography

CHAMBERS, E. *Offset Photolithography.* Benn, 1967.

LAWSON, L. E. *Offset Lithography.* Vista Books, 1963.

CARTWRIGHT, H. M. *Ilford Graphic Arts Manual: Vol. 2. Photolithography.* Ilford, 1966.

WHETTON, H. (Editor). *Practical Printing and Binding.* Odhams Books Ltd., 1965.

SHAPIRO, C. *The Lithographer's Manual.* G.A.T.F., 1968.

TORY, B. E. *Offset Lithography.* Pitman.

SANSOM, B. W. *Lithography: Principles and Practice.* Pitman, 1960.

MONTAGUE, N. *Lithography.* Pitman.

Lithography in 1960. Conference Reports. P.A.T.R.A., 1960.

CURWEN, H. *Processes of Graphic Reproduction in Printing.* Faber, 1966.

MERTLE, J. S. and MONSEN, G. L. *Photomechanics and Printing.* Mertle Publishing Co., 1957.

The Penrose Annual. Lund Humphries & Co. Ltd.

British Standard 4277, 1968. *Glossary of Terms Used in Offset Lithographic Printing.*

INDEX